How to Draw

Flowers
& Trees

In Simple Steps

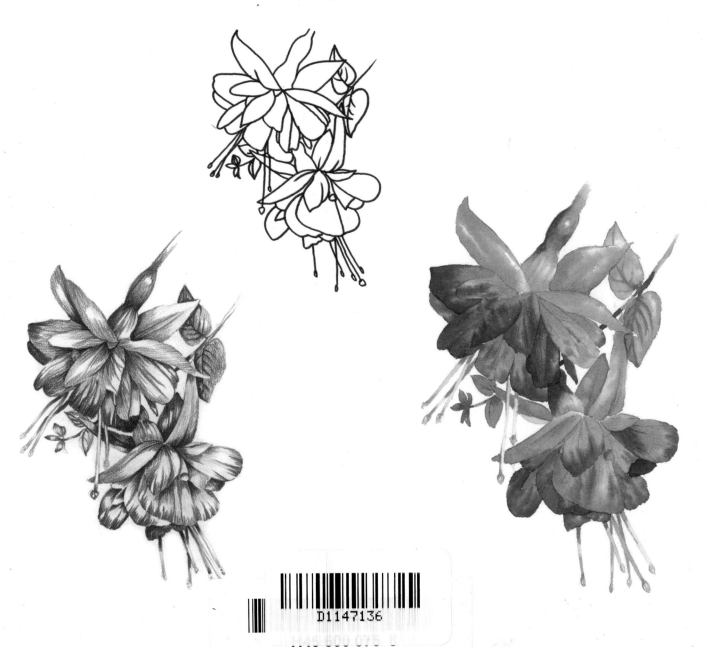

First published in Great Britain 2012

Search Press Limited
Wellwood, North Farm Road,
Tunbridge Wells, Kent TN2 3DR

How to Draw Flowers & Trees is a compendium volume of illustrations taken from the How to Draw series:
How to Draw Flowers; How to Draw Garden Flowers;
How to Draw Exotic Flowers; How to Draw Wild Flowers;
How to Draw Trees.

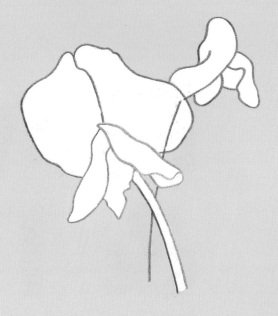

ISBN: 978-1-84448-8766

Printed in China

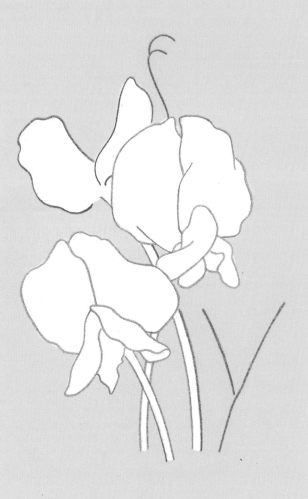

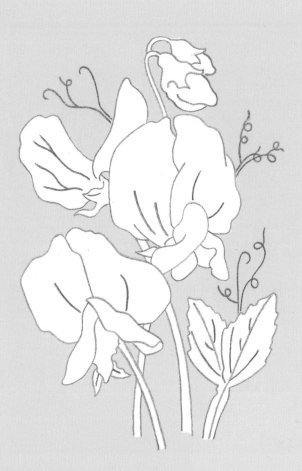

How to Draw

Flowers & Trees

In Simple Steps

Janet Whittle, Penny Brown,
Denis John-Naylor

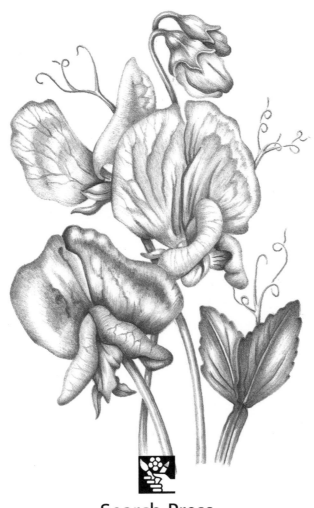

Search Press

Contents

Introduction

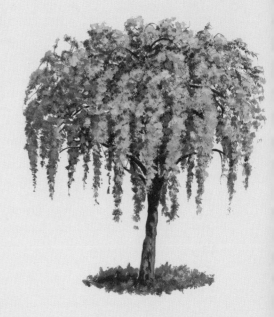

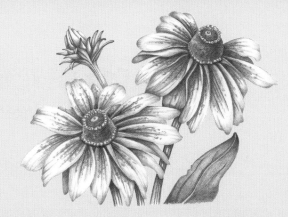

Exotic Flowers

Wild Flowers

Trees

Introduction

Flowers and trees are fascinating subjects for drawing. All the projects in this book have been chosen for their 'wow' factor, whether they are easy to draw blooms or interestingly textured trees. There is a good mix of simple subjects and others which are slightly more intricate; these will be more of a challenge, but as your understanding of form progresses with practice, you will find that the end results will be more impressive. The variety of sizes, shapes and colours will be invaluable as reference when you branch out and try your own ideas.

Each drawing takes you through a sequence of steps, which are followed by a tonal drawing then a finished coloured image. The aim is to encourage you to draw by reducing images down to simple shapes; as a result the whole process becomes much easier. The compositions are easy to start with and some are a little more complex, but the step-by-step illustrations build up the images and should see you safely through your first attempts to draw them, with the coloured stage included to show the final stage.

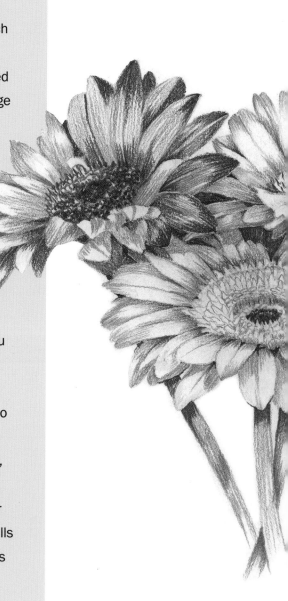

In the first step one colour is used, and another colour is introduced in the second and subsequent stages to illustrate what has gone before. Two colours have been used so that you can follow the progression easily. When copying the steps, you should use a fairly soft HB, or B pencil. Do not press too heavily until you have finished the composition so that any unwanted lines can be erased.

When you are happy with the result, you can shade in the tonal values to create depth. Having established the areas of light and dark, if you want to paint the flower or tree, draw the image again and apply colour instead, following the same tonal values as the drawing.

However you choose to draw these flowers and trees and whatever your style, if you follow these guidelines you will soon improve your drawing skills and become more confident. We hope some of your favourites are here as they are without a doubt some of ours, and putting them together in this next collection has been a pleasure which we can now share with you all.

Happy Drawing!

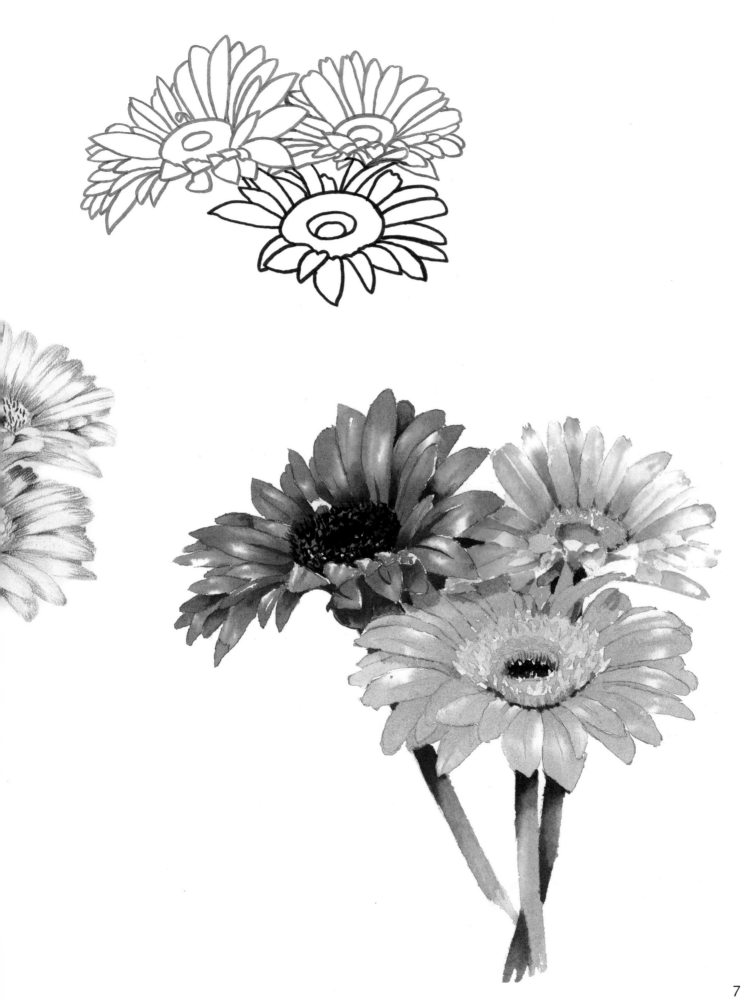

Popular Flowers

Flowers are an inspiring subject for artists and offer exciting challenges, whether you want to draw a simple group of snowdrops, a beautiful water lily or a host of golden daffodils. A stunning selection of popular flowers are included in this chapter, with basic shapes evolving into tonal drawings and colourful finished images. Included are field poppies, roses, pansies, foxgloves, honeysuckle, nasturtiums and more. As you grow in confidence you will soon start to develop your own style of drawing and begin to notice different types of flowers, with their unique shapes and colours.

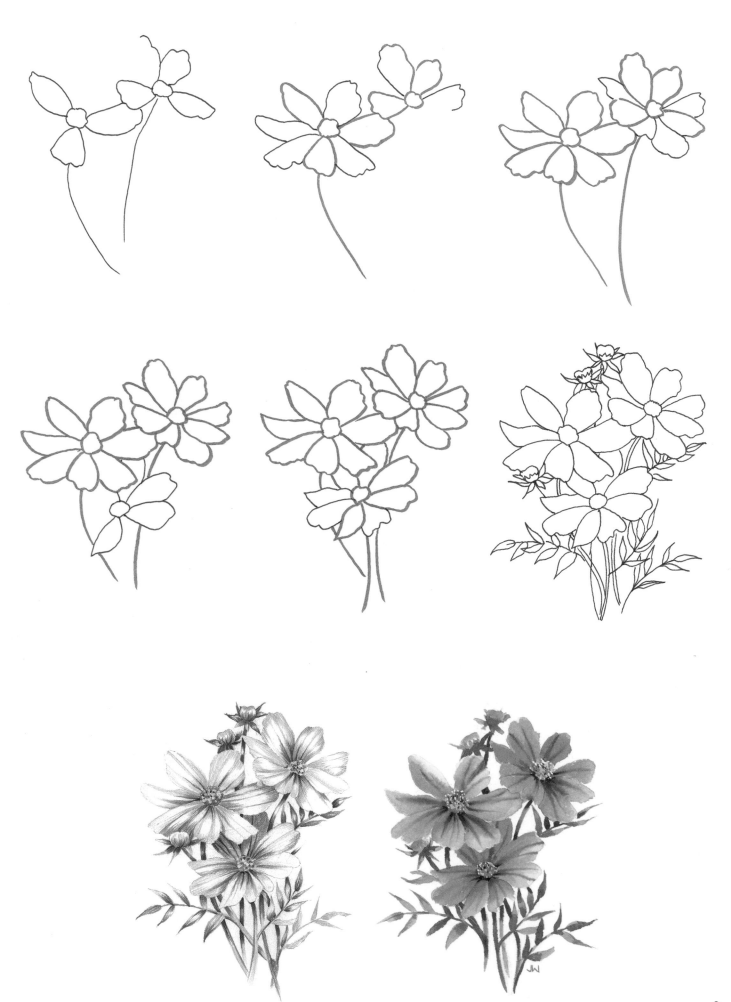

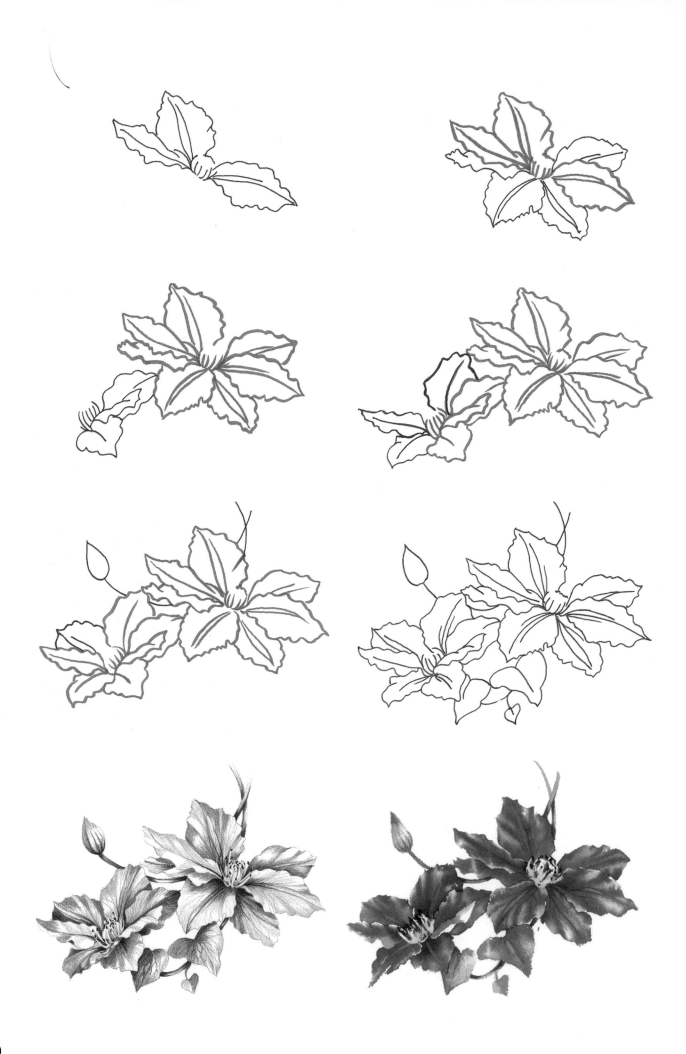

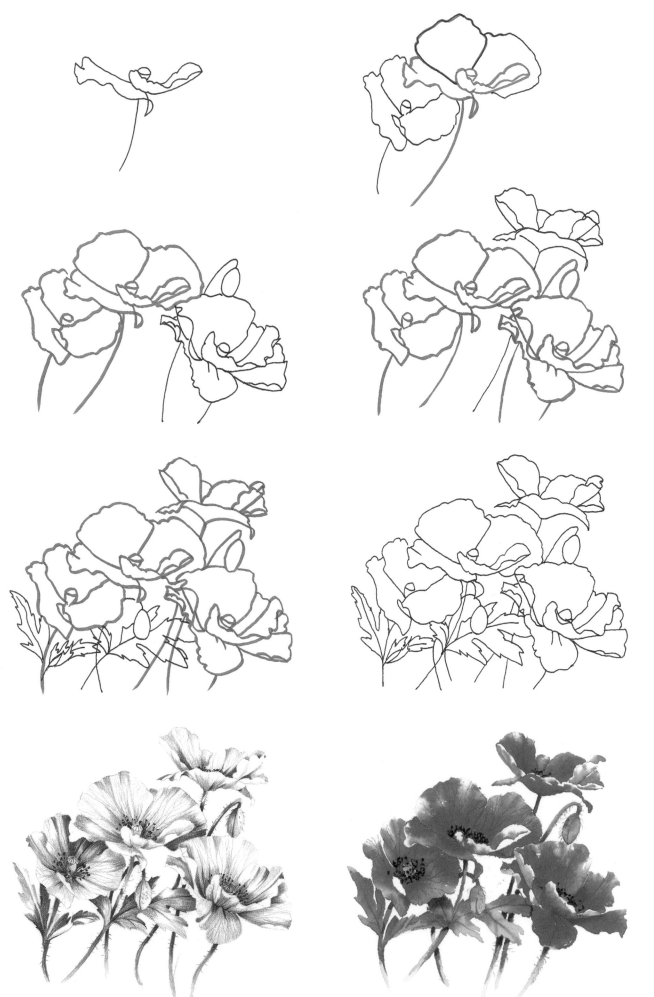

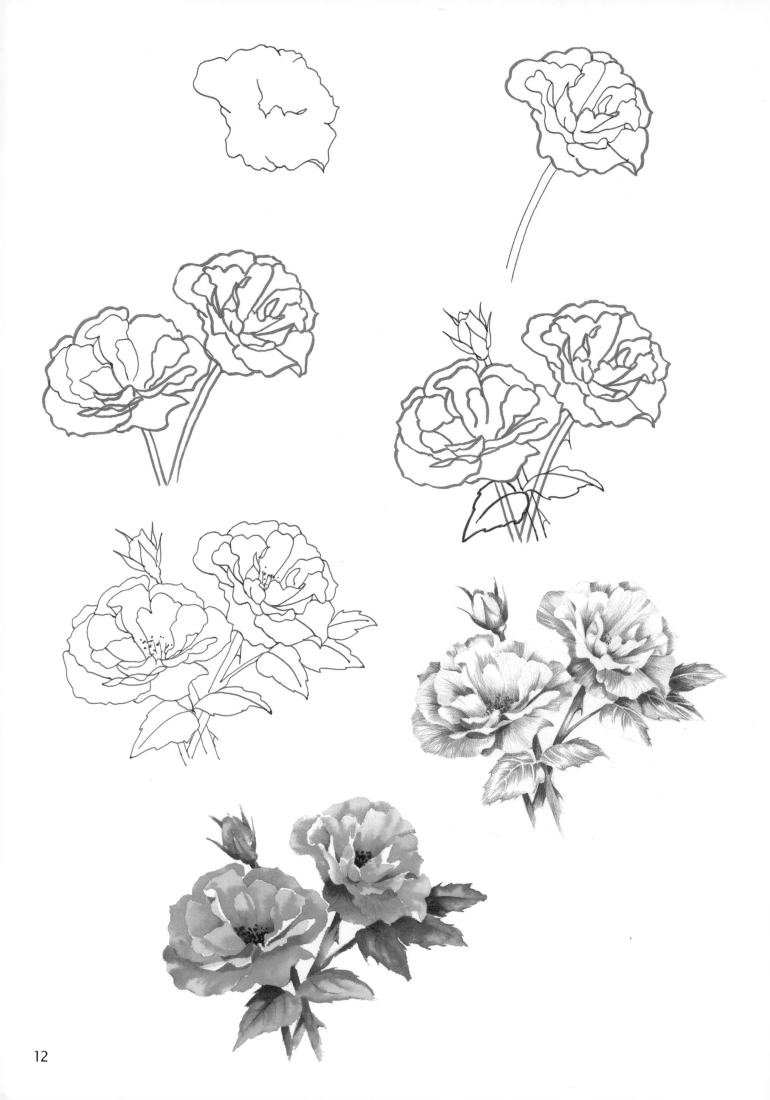

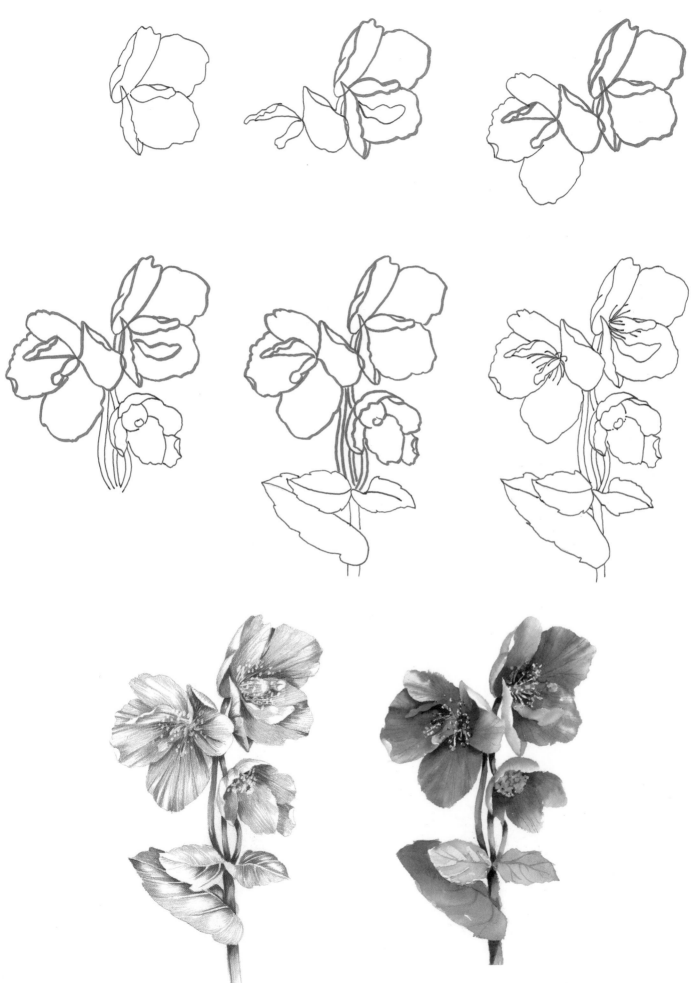

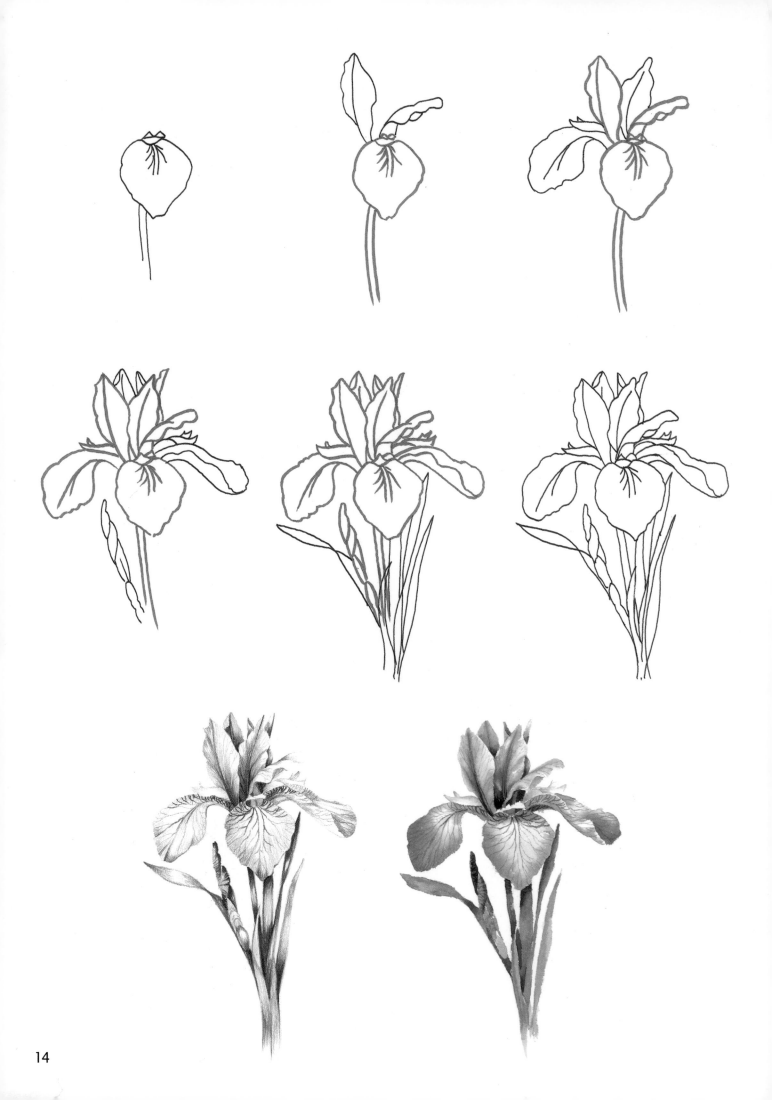

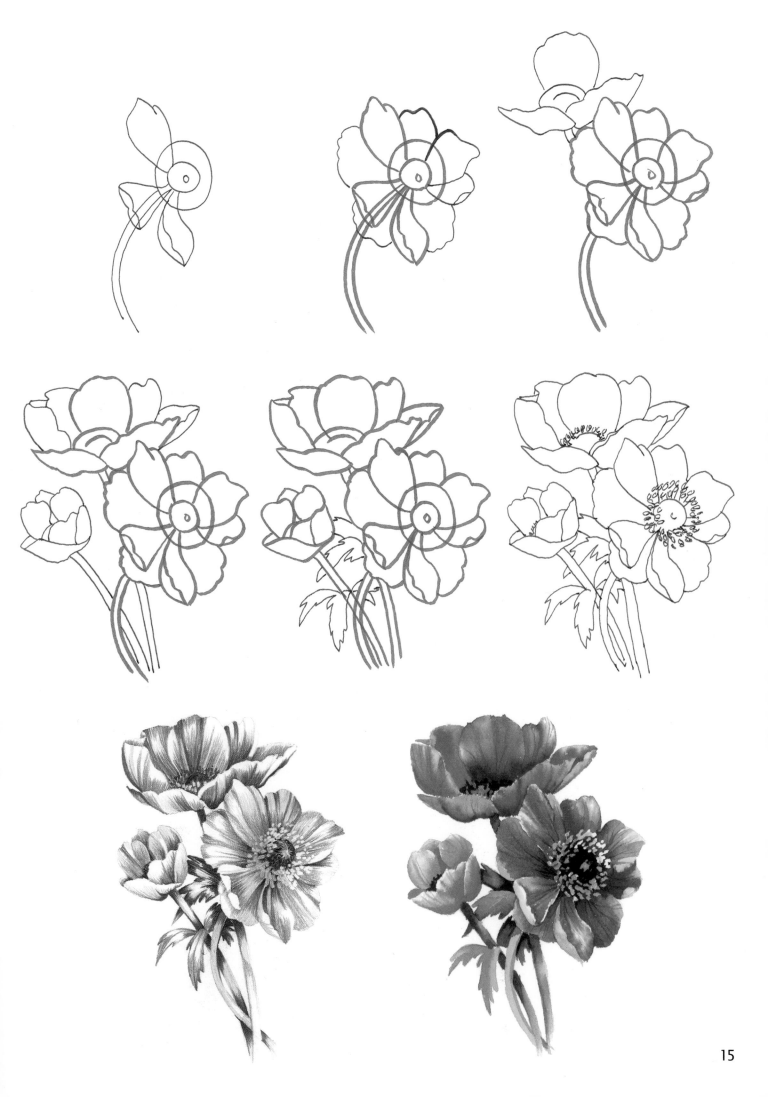

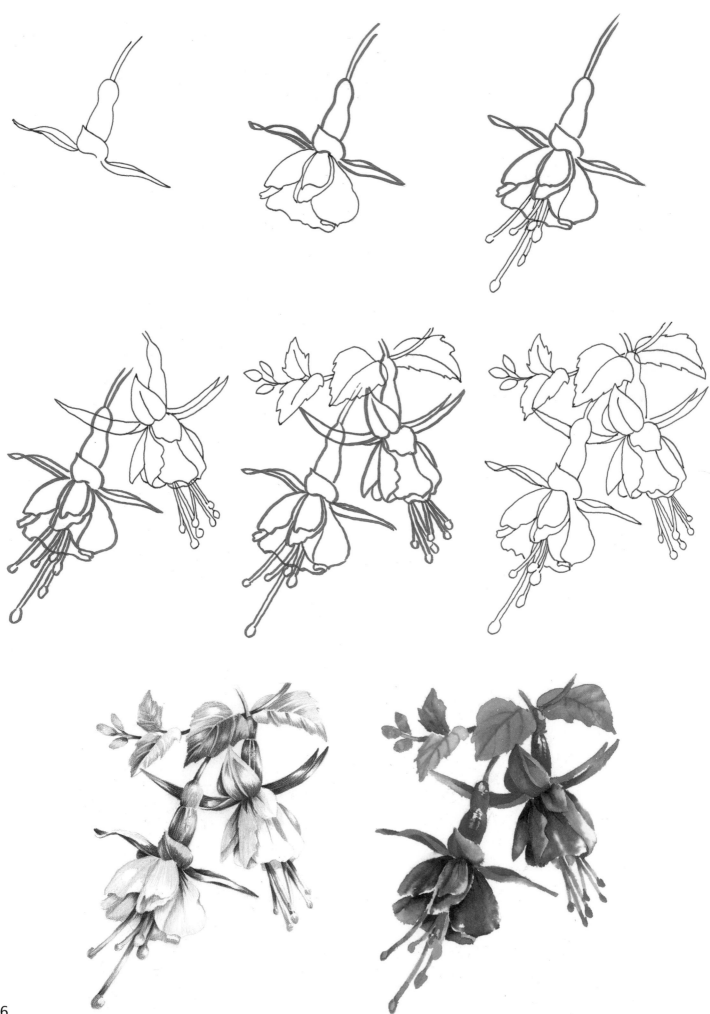

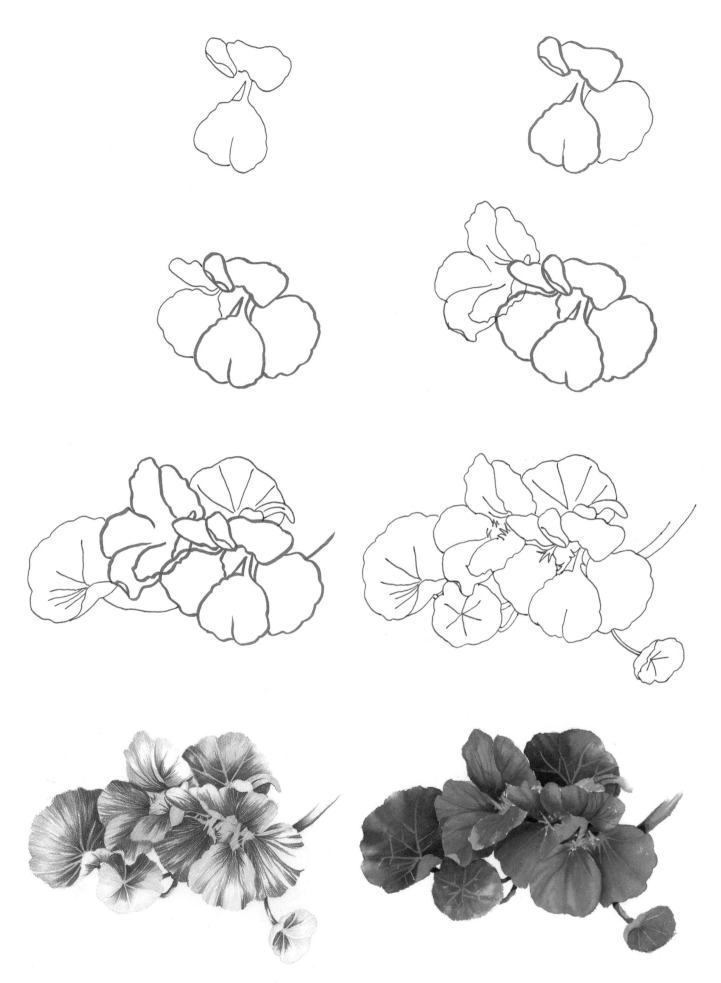

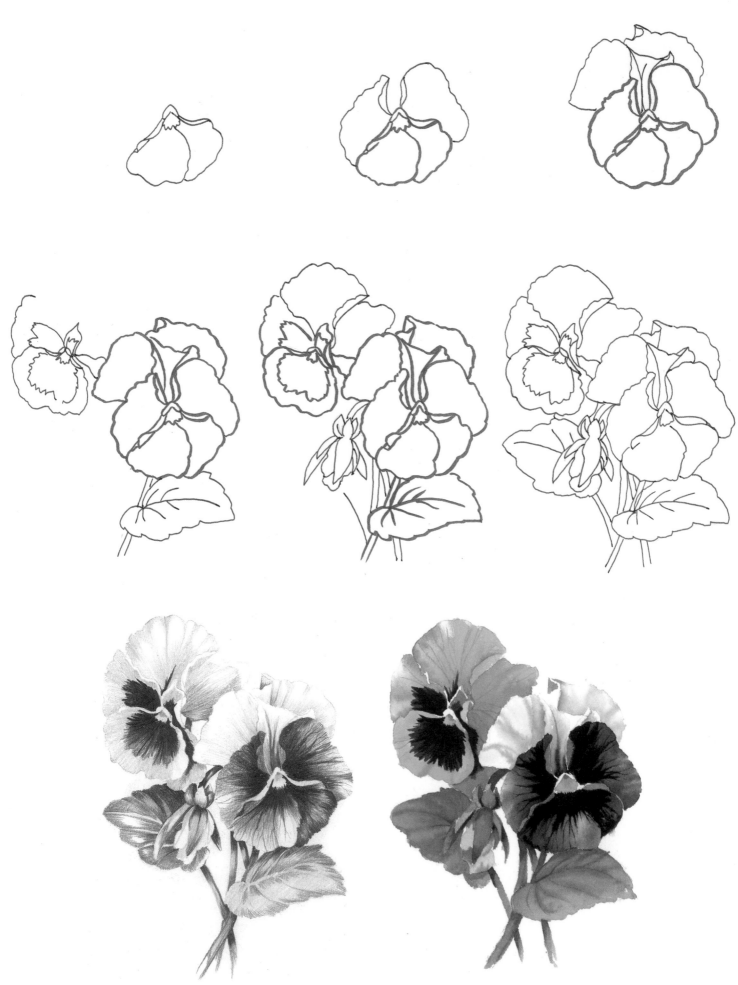

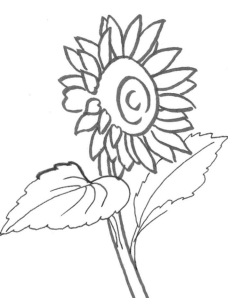
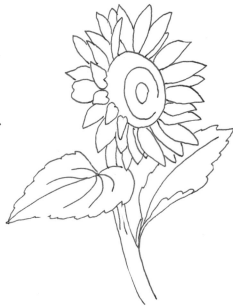

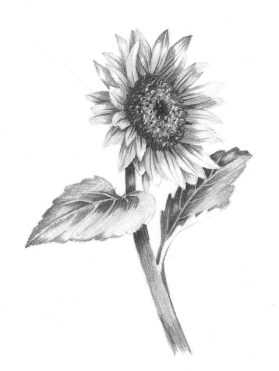
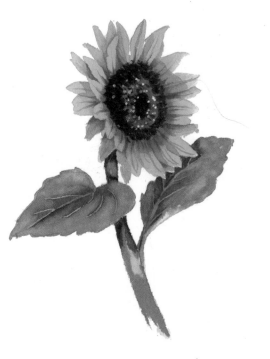

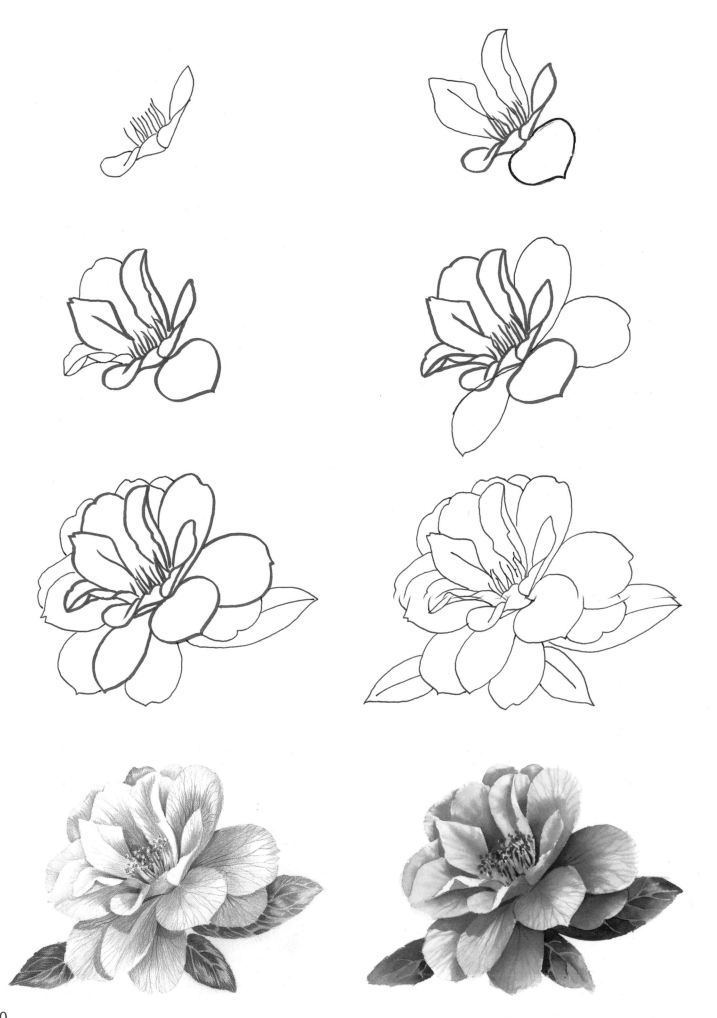

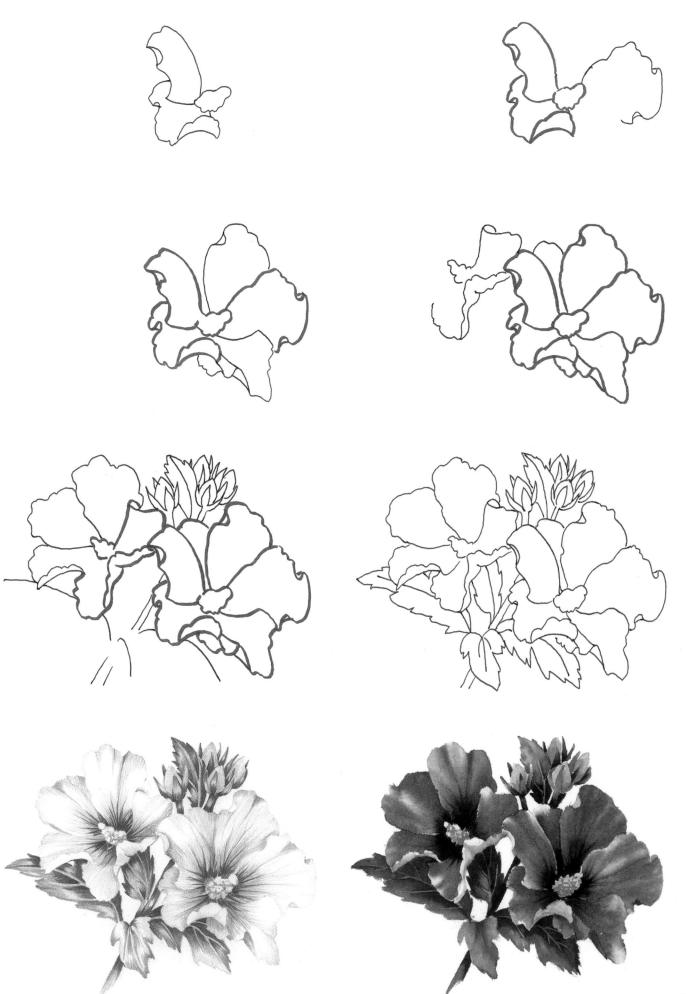

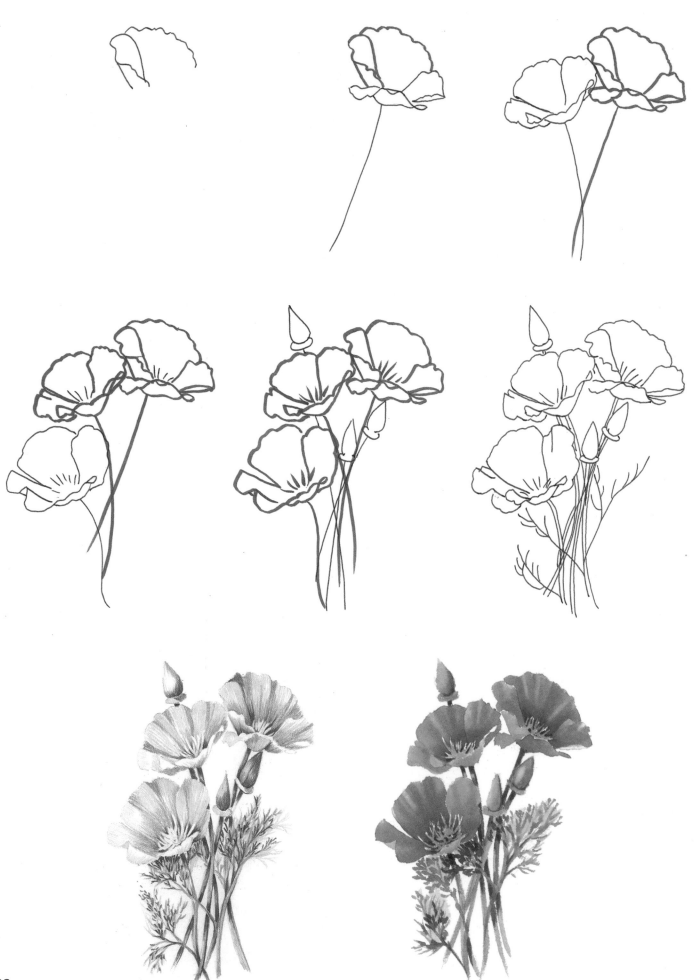

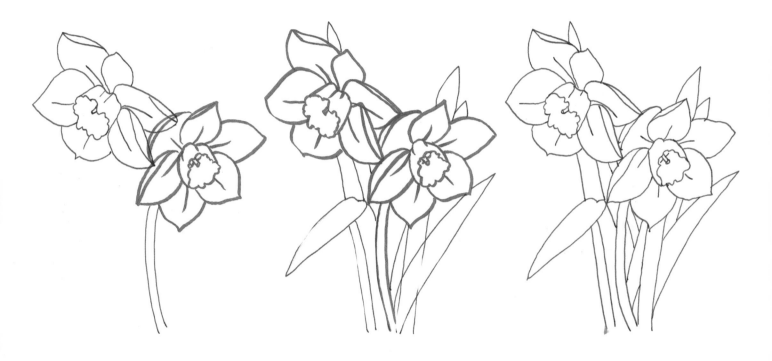

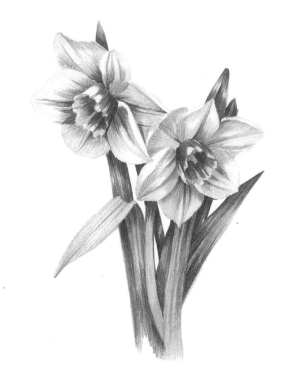
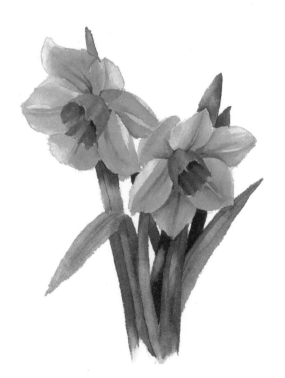

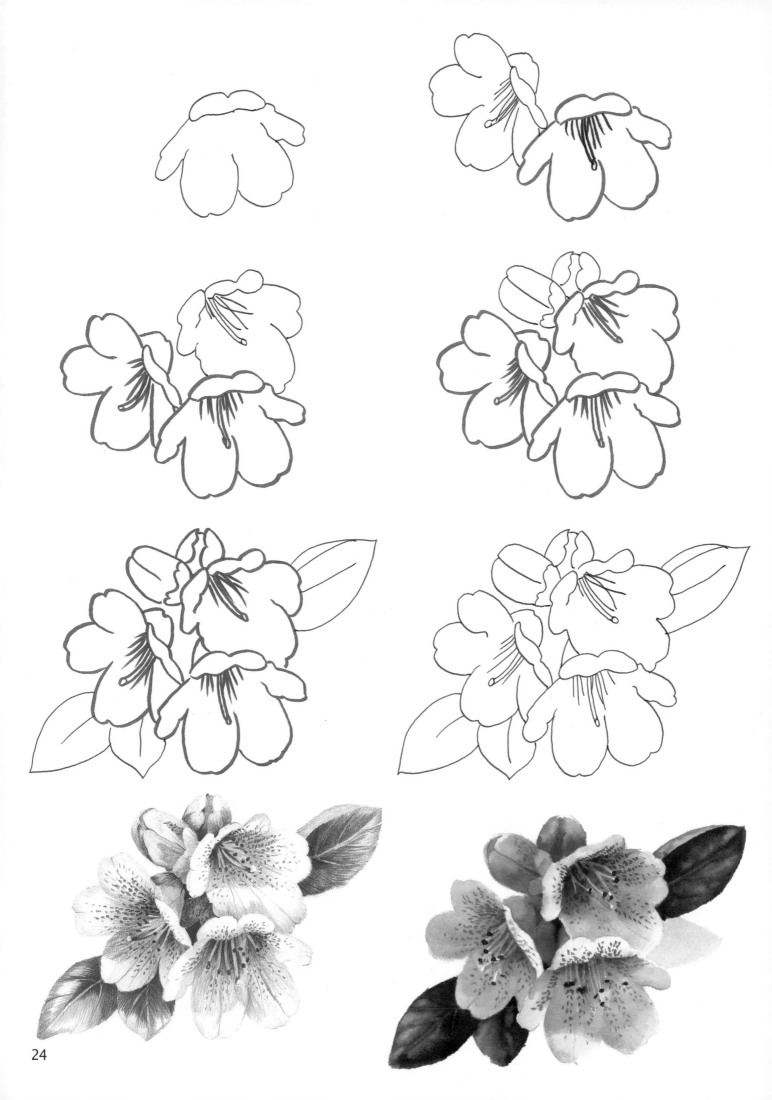

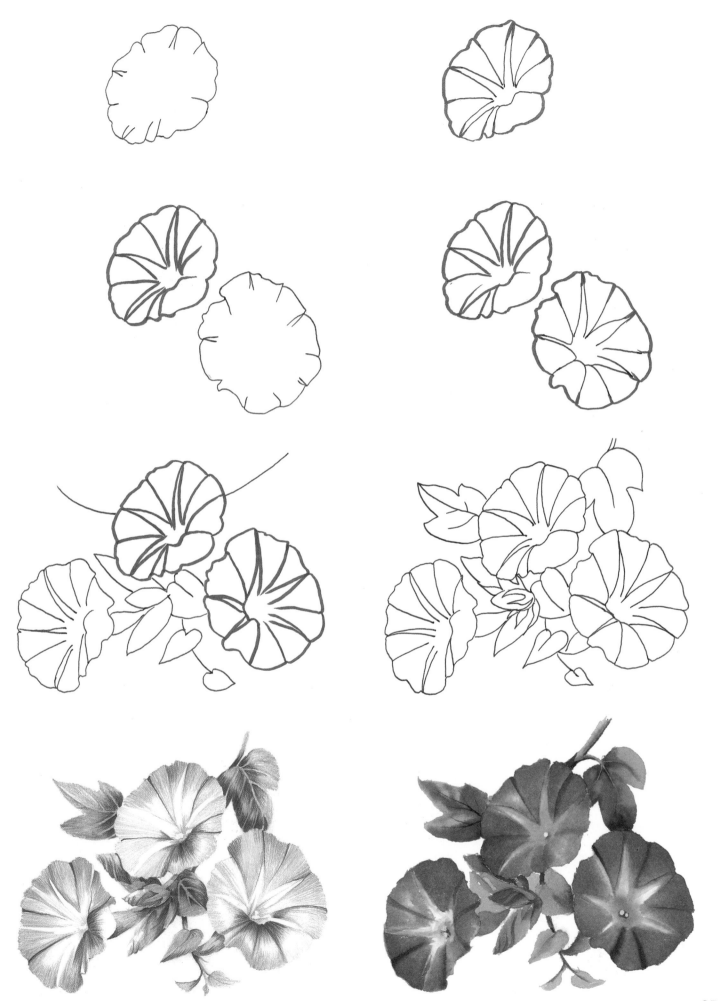

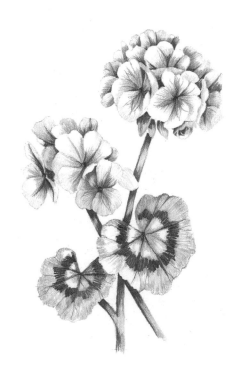
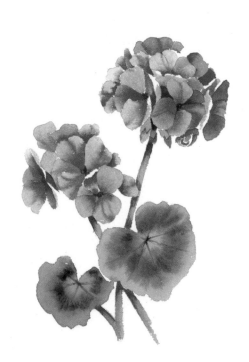

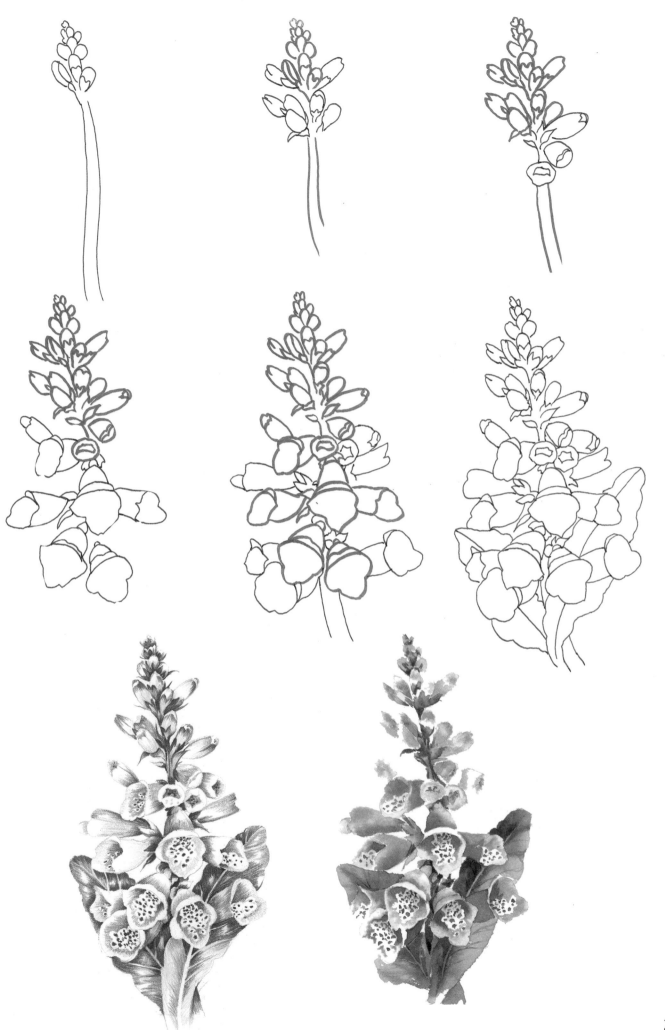

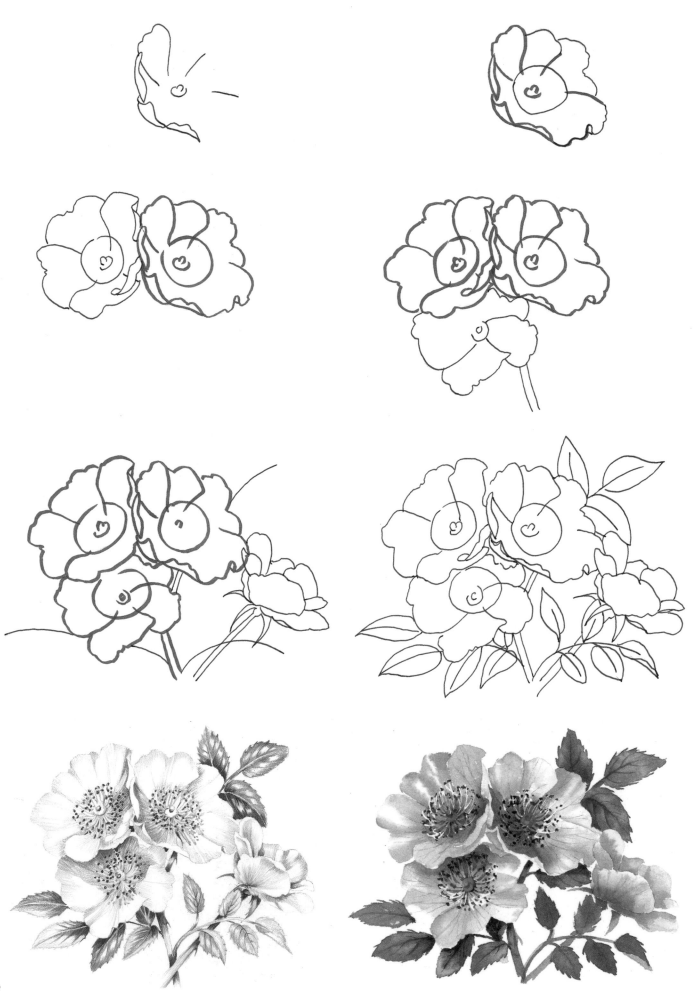

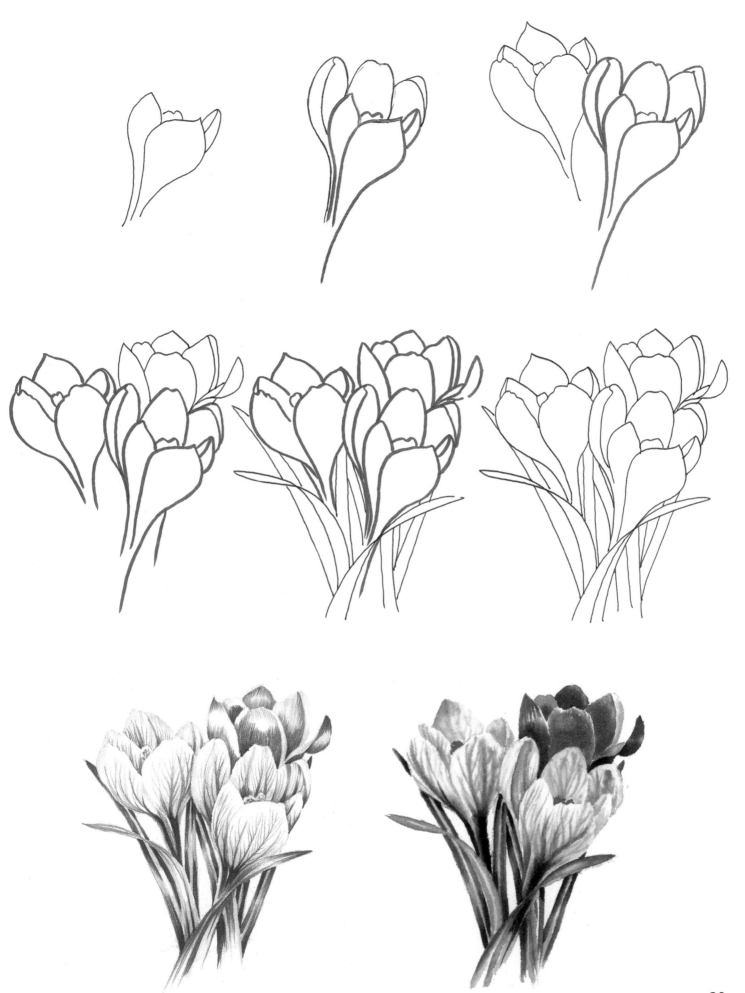

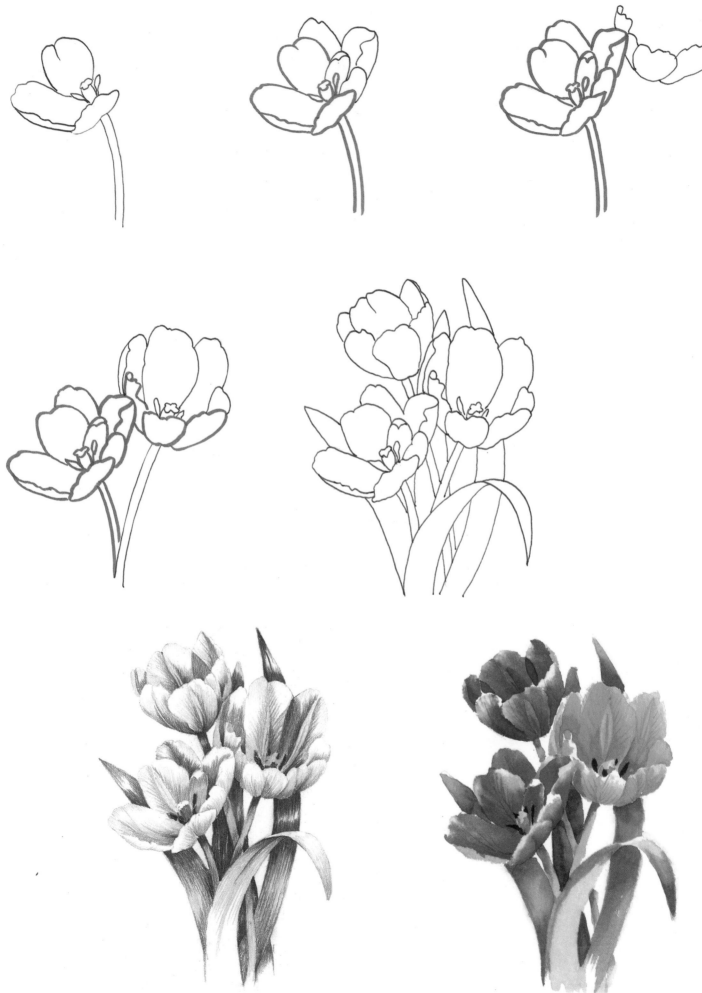

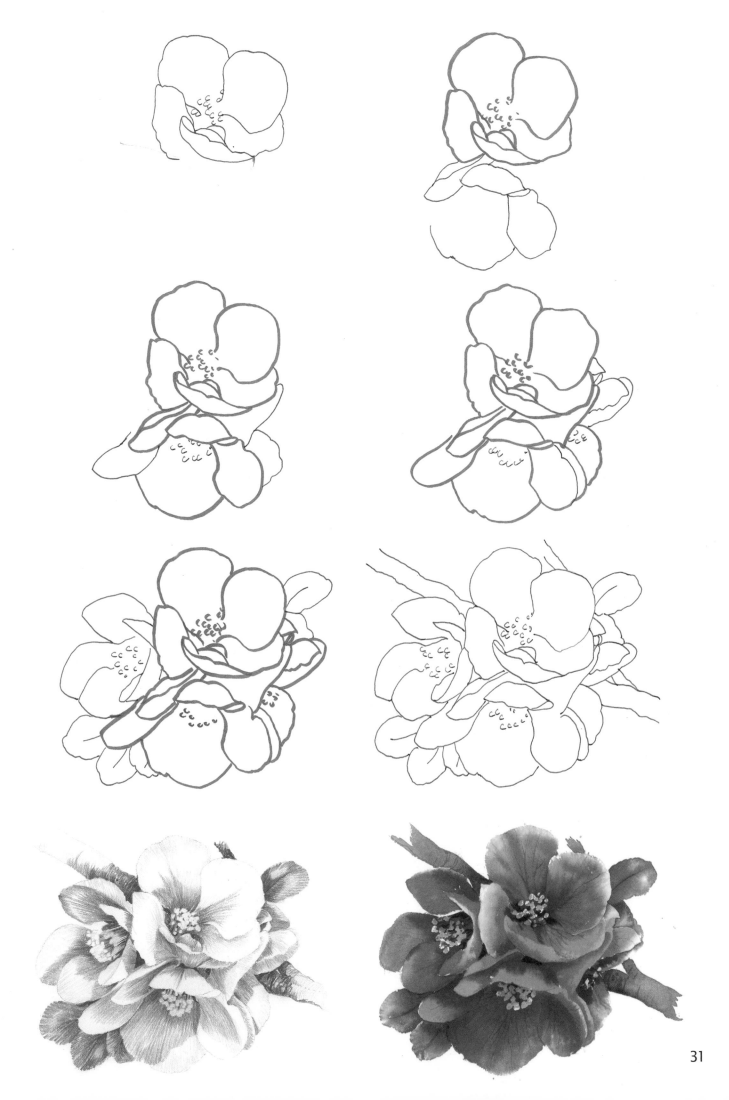

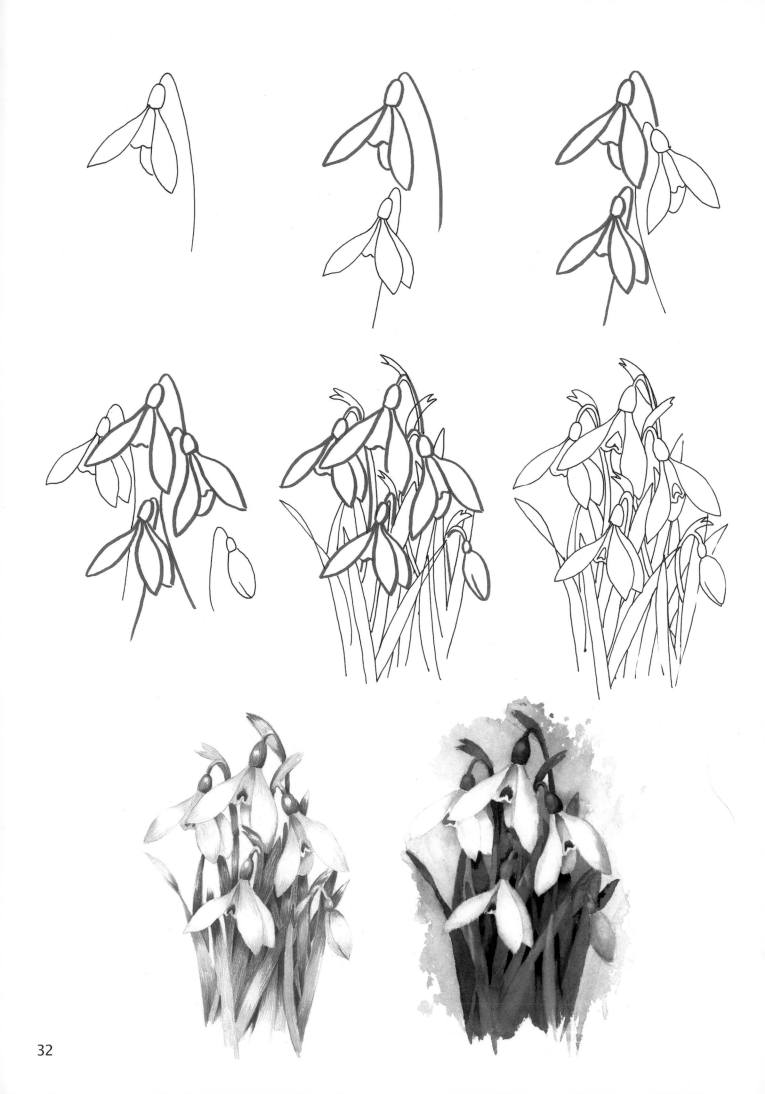

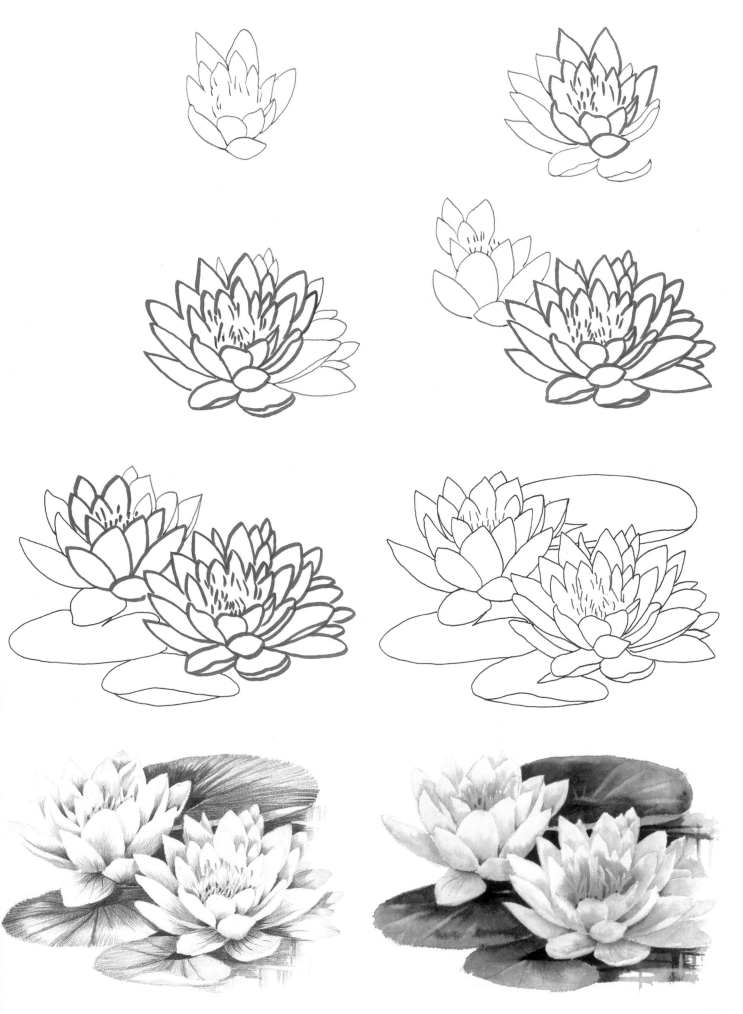

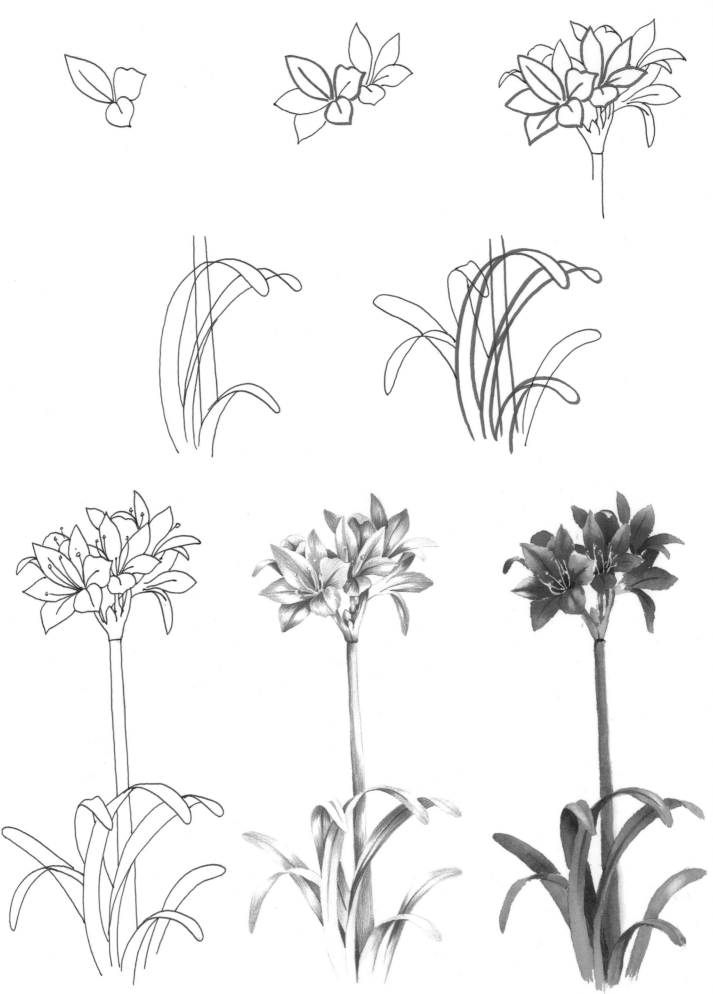

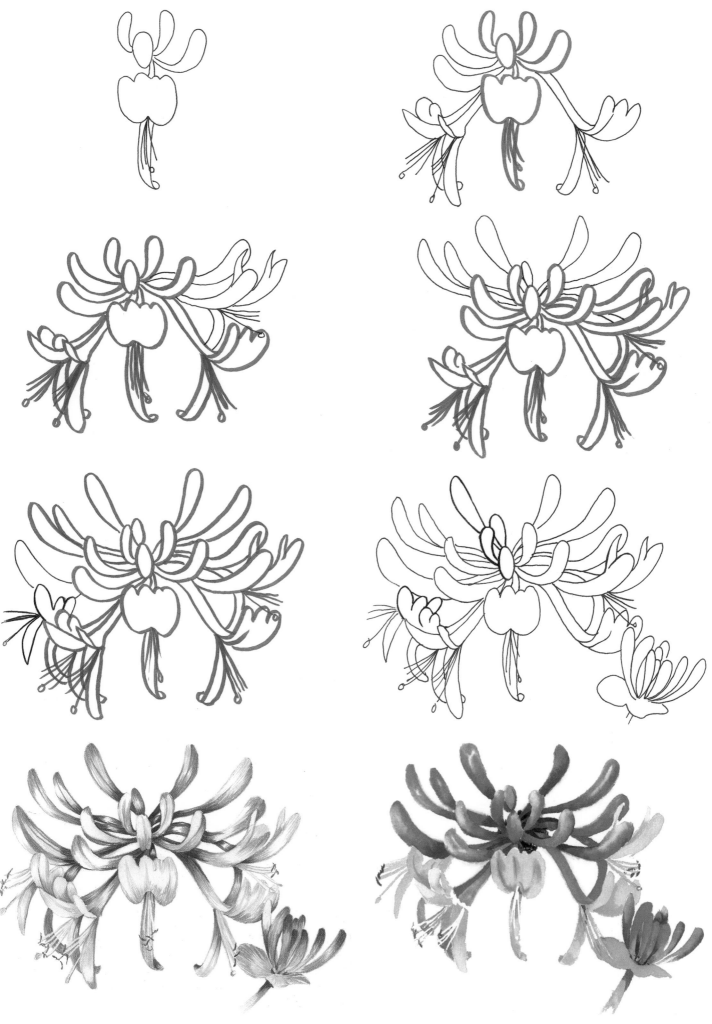

Garden Flowers

In this chapter you will find a wonderful selection of garden flowers from rock rose, sweet pea and dahlia to the more exotic Peruvian lily, quince and tiger flower. There are cut flowers such as freesia, shrubs like magnolia stellata, and climbers like clematis alpina. By developing your drawing skills as you follow the step-by-step flowers, you will soon be able to tackle more complicated designs and will eventually be inspired to work on your own pictures. Start by working on the simpler compositions, and feel free to use tracing paper from time to time to help with any tricky details.

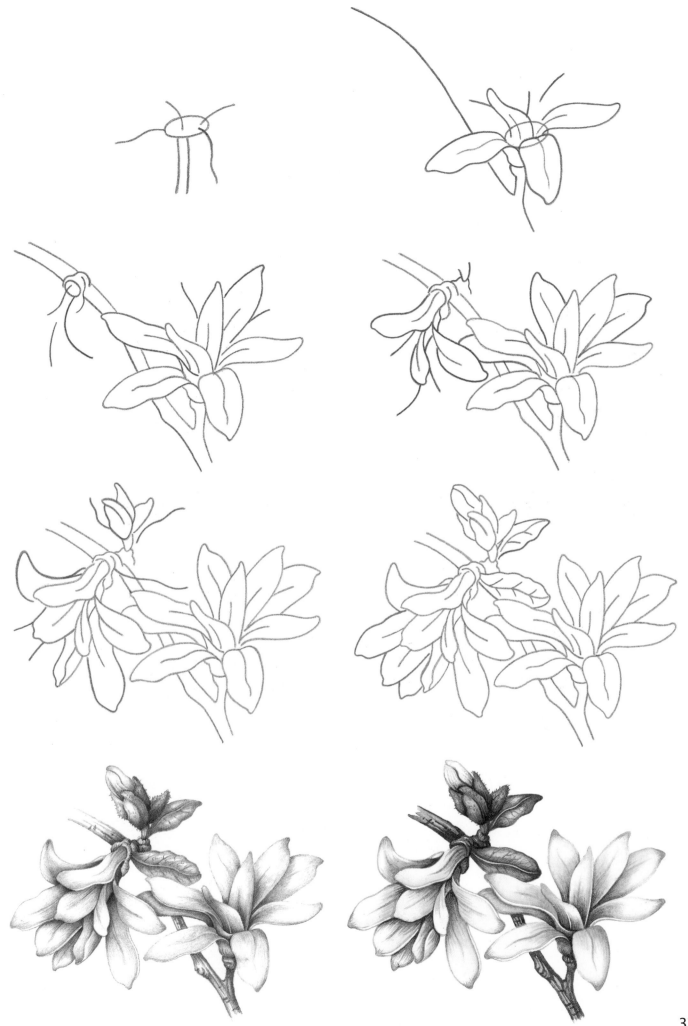

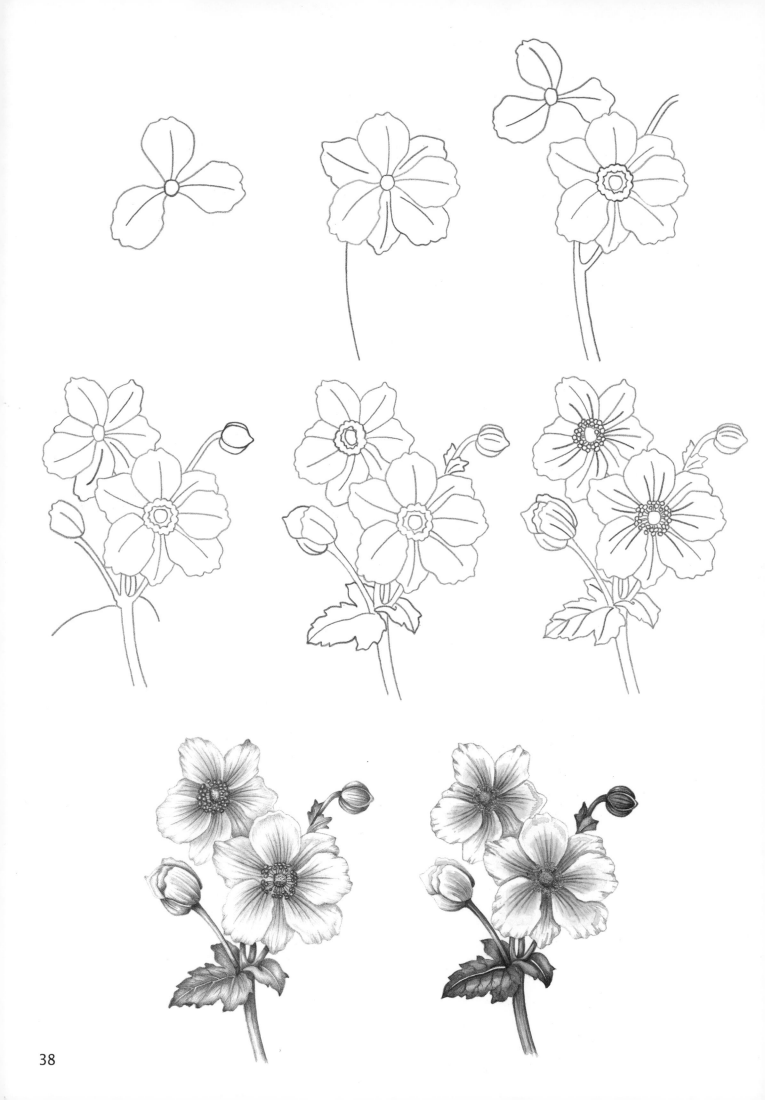

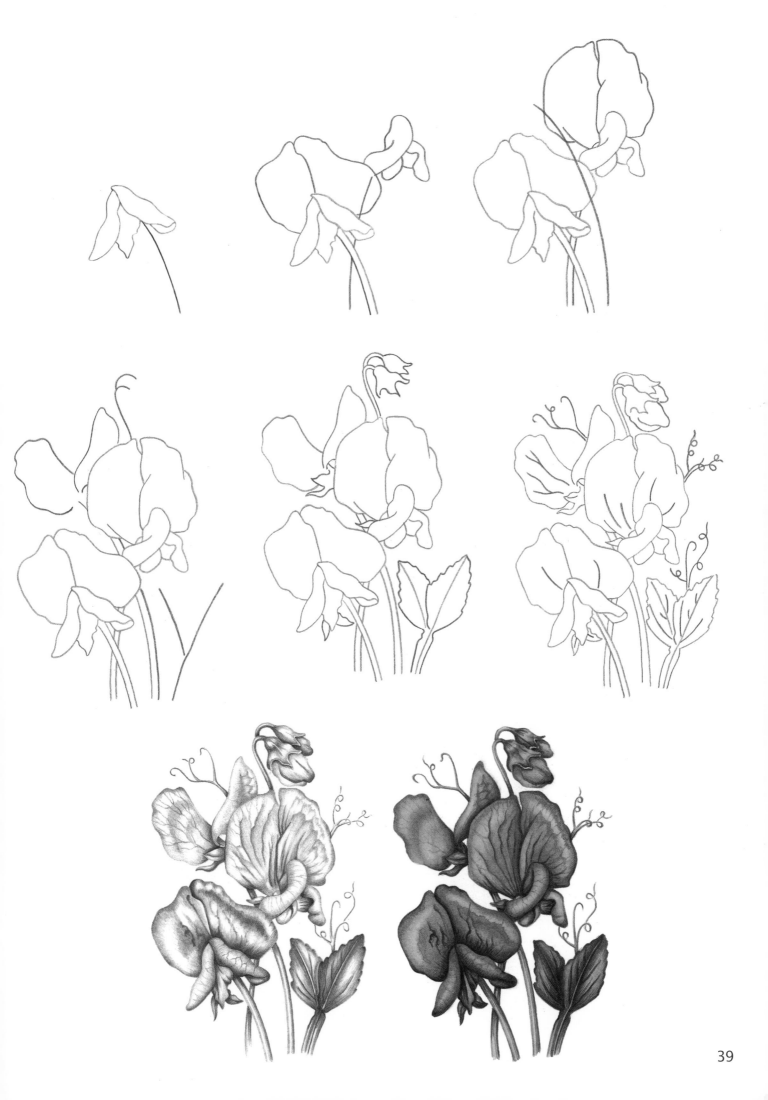

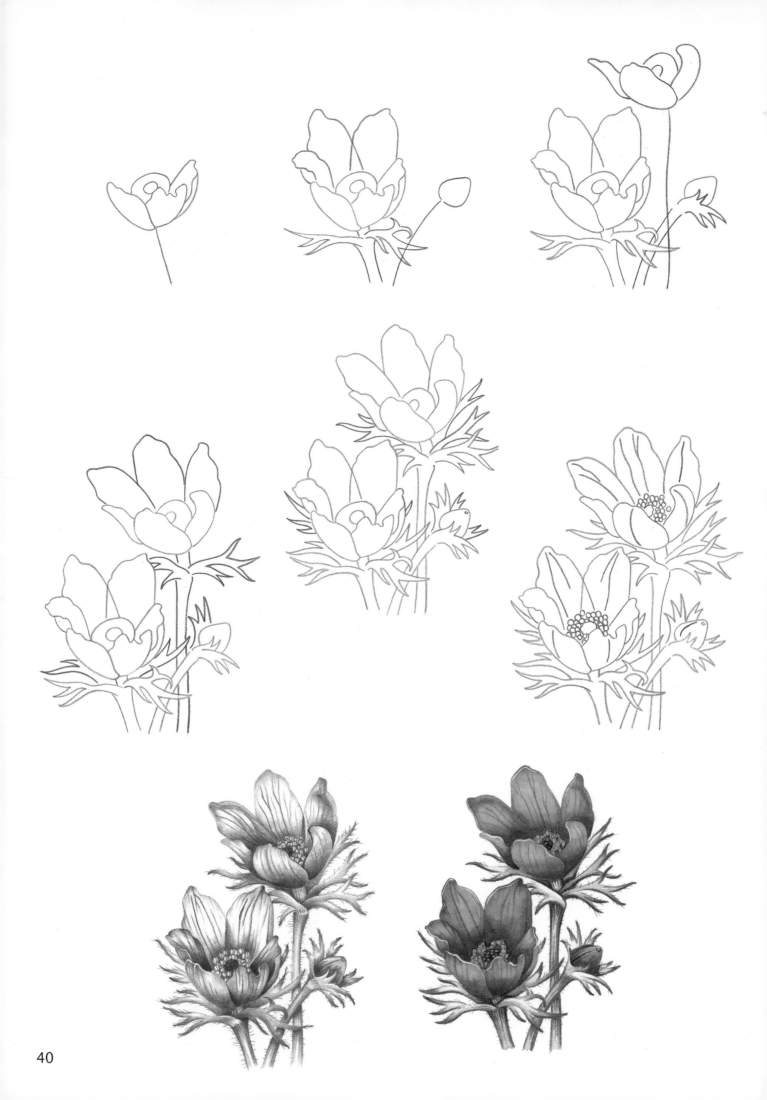

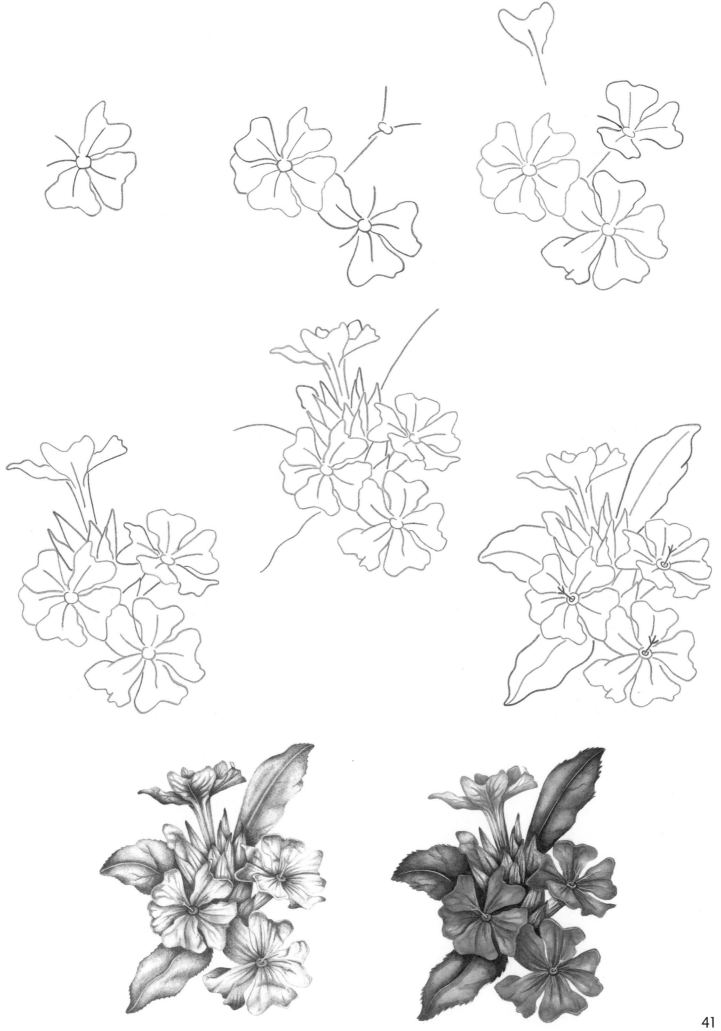

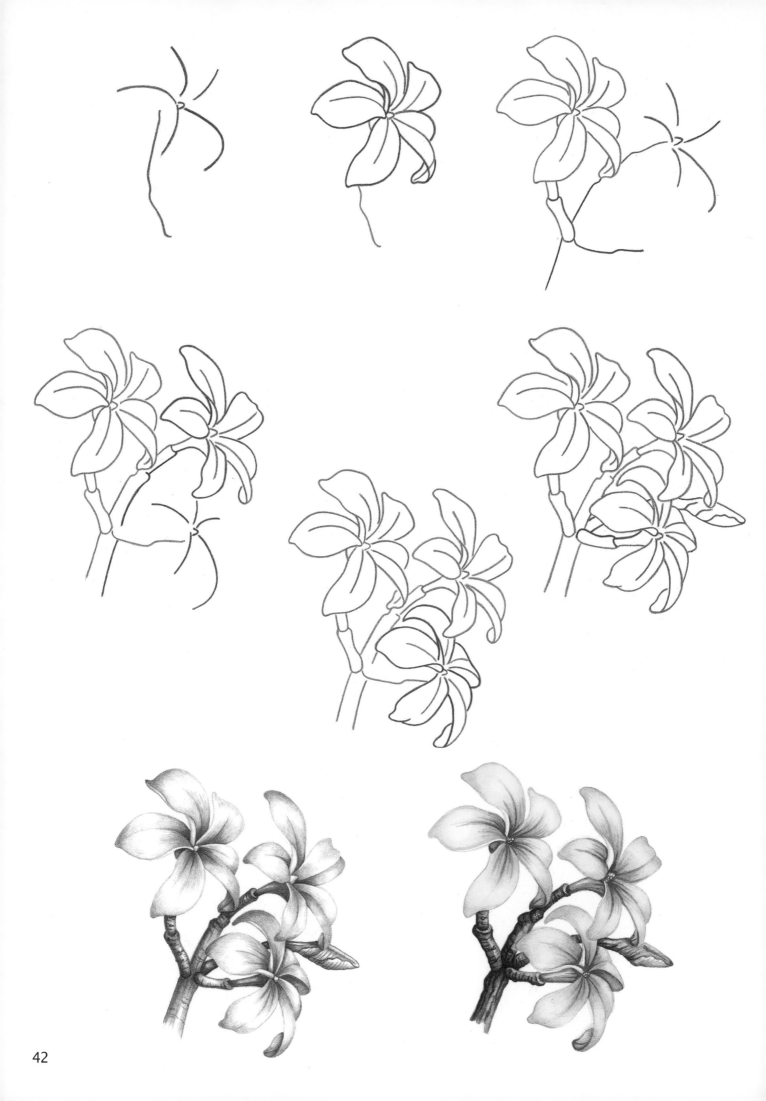

42

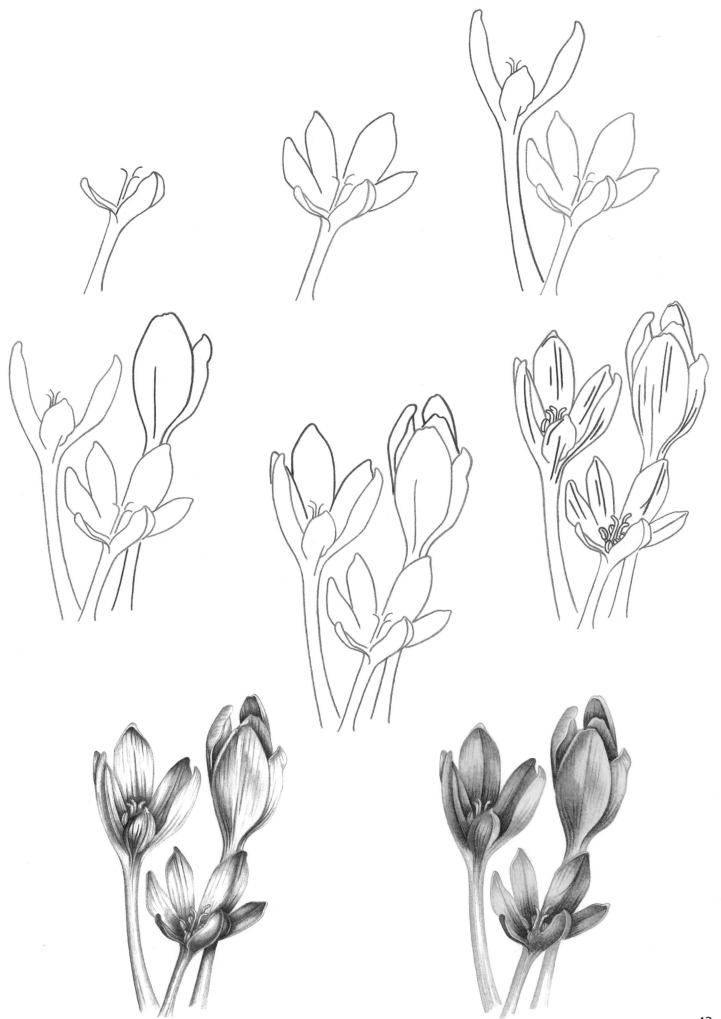

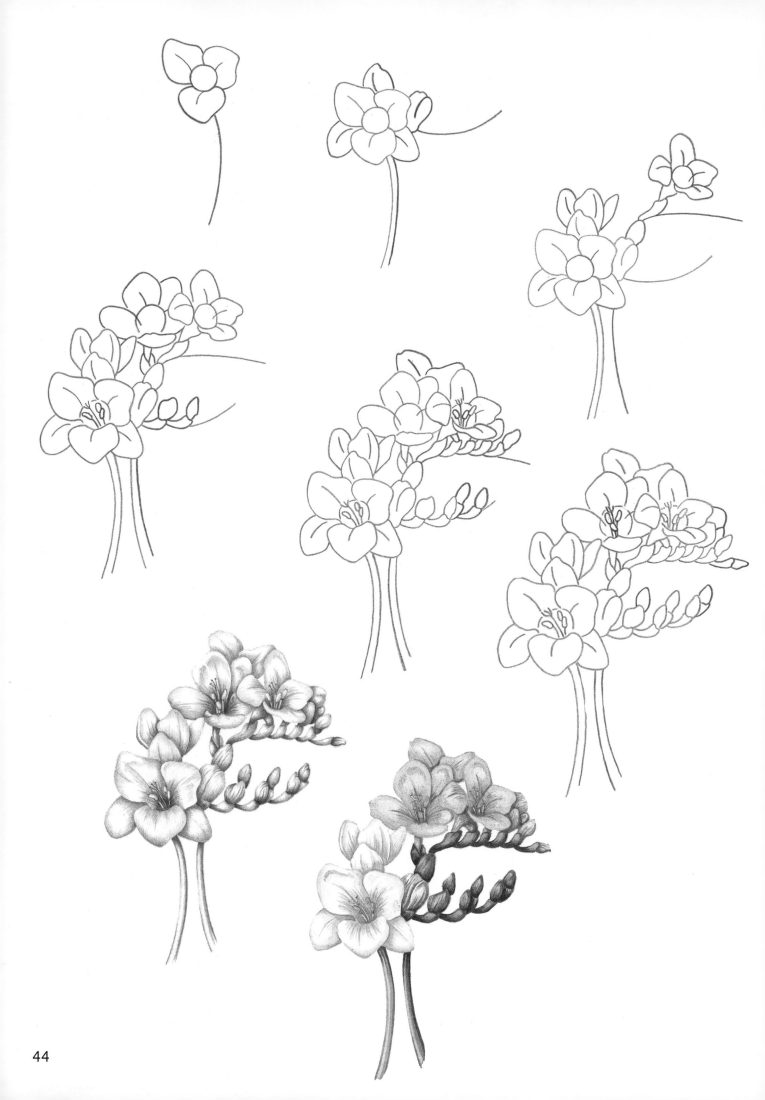

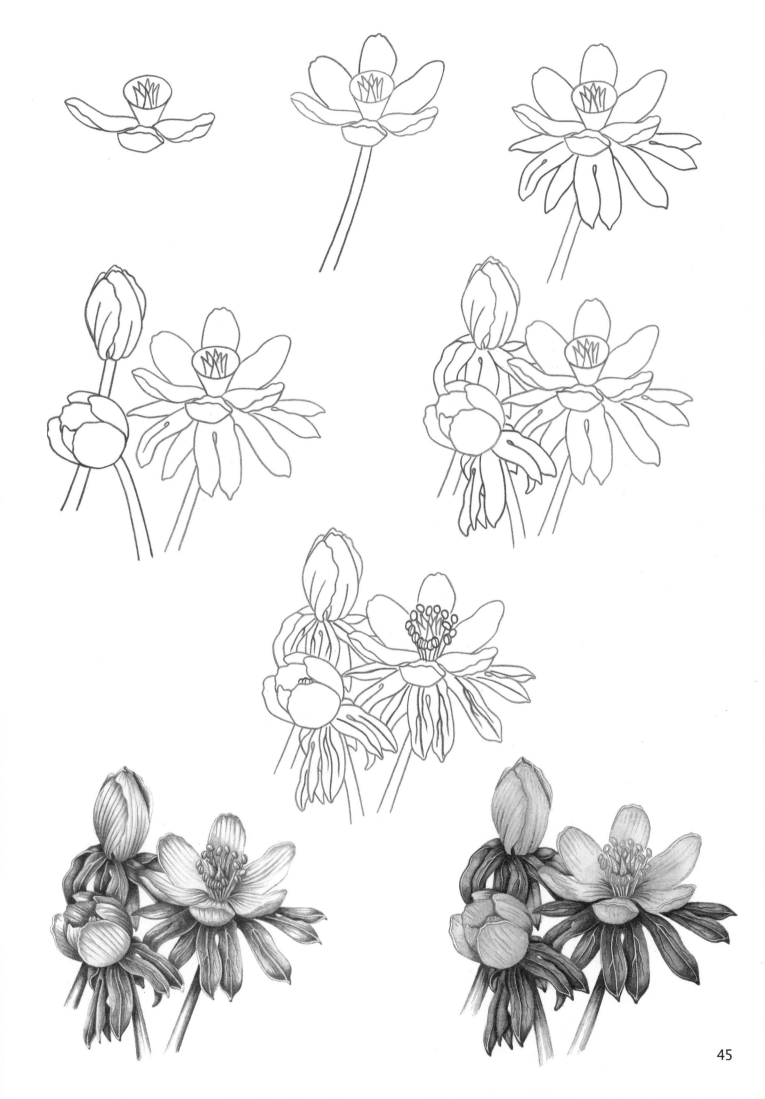

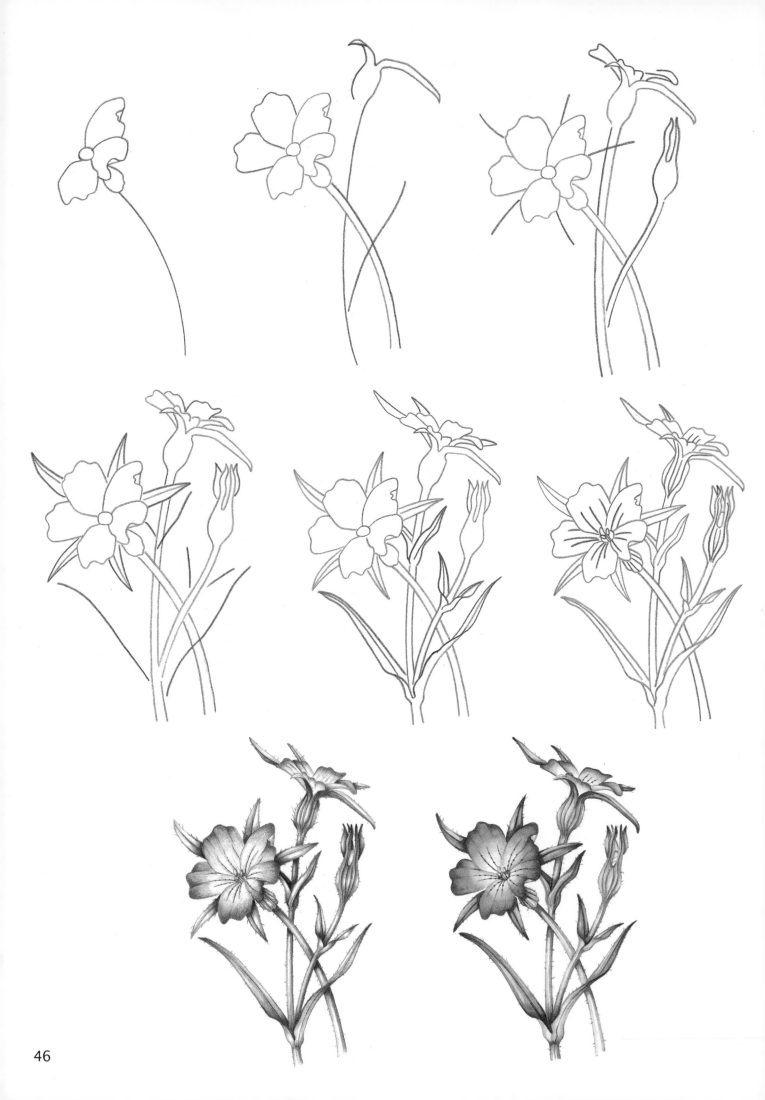

46

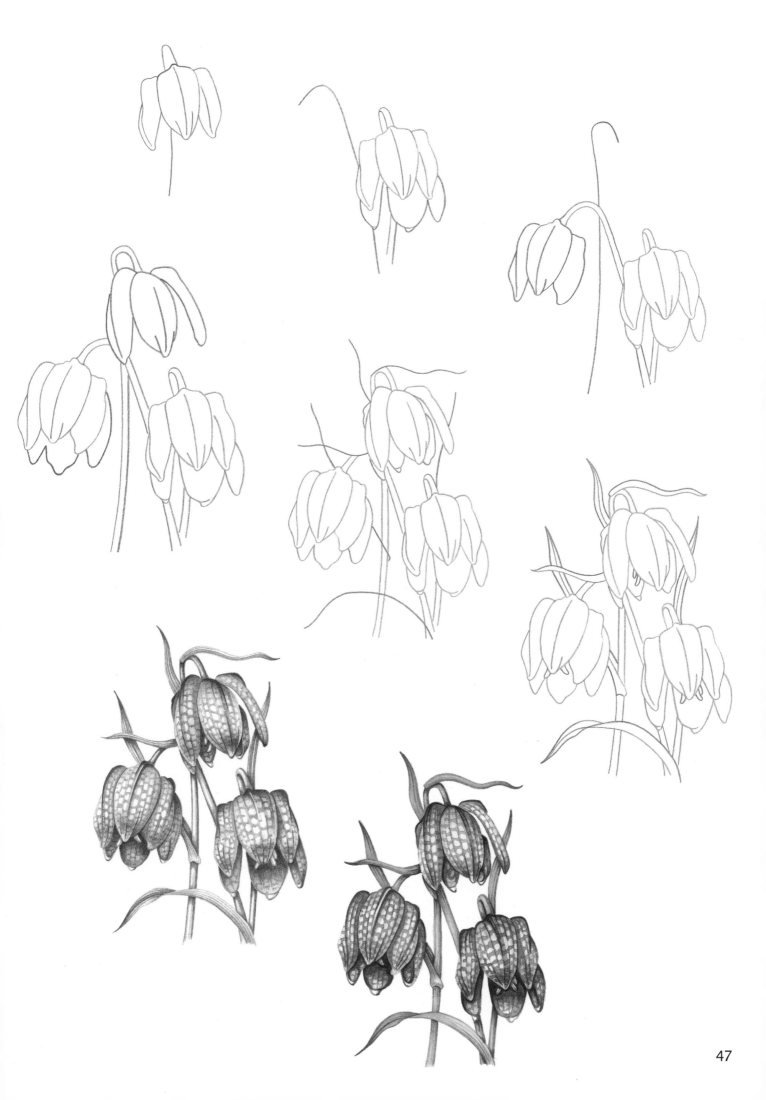

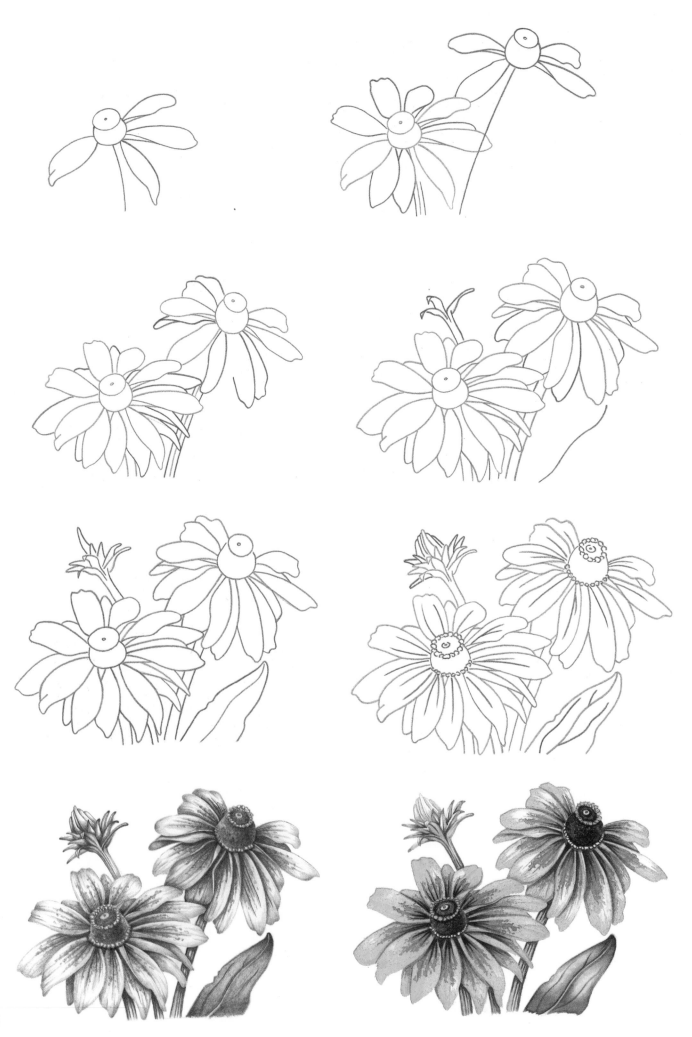

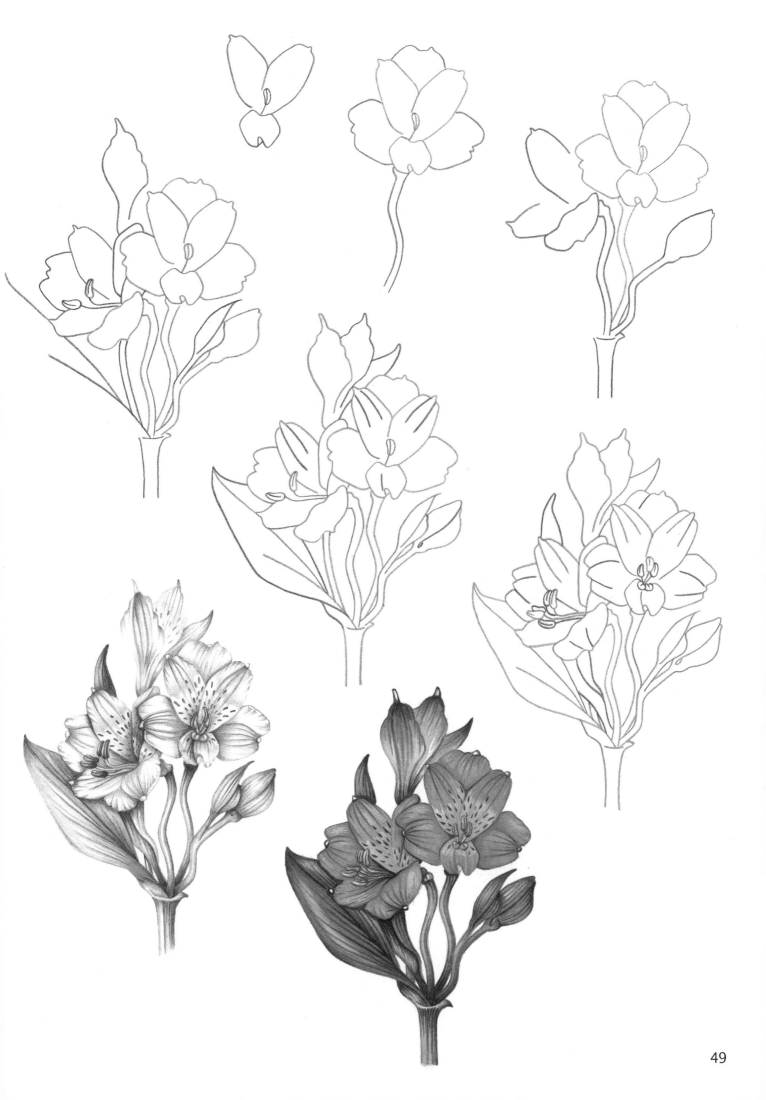

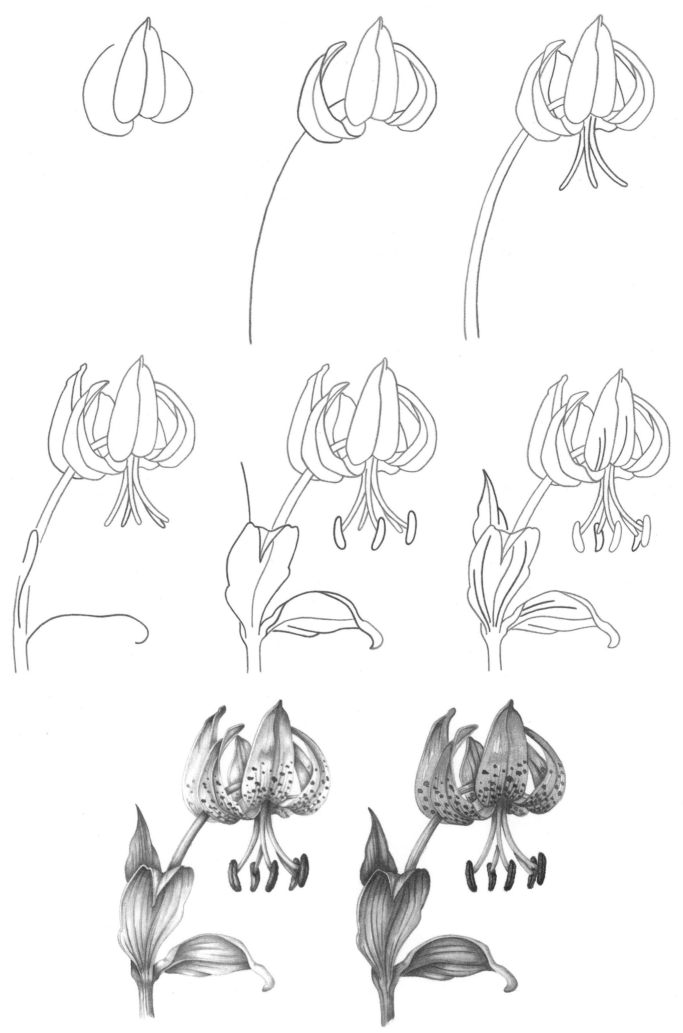

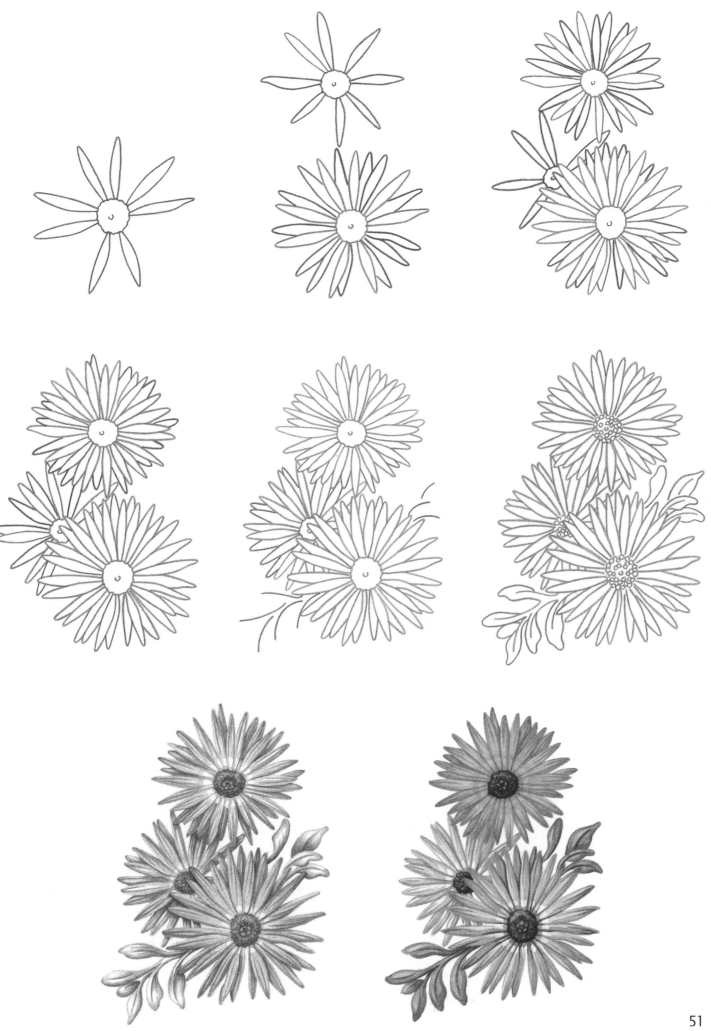

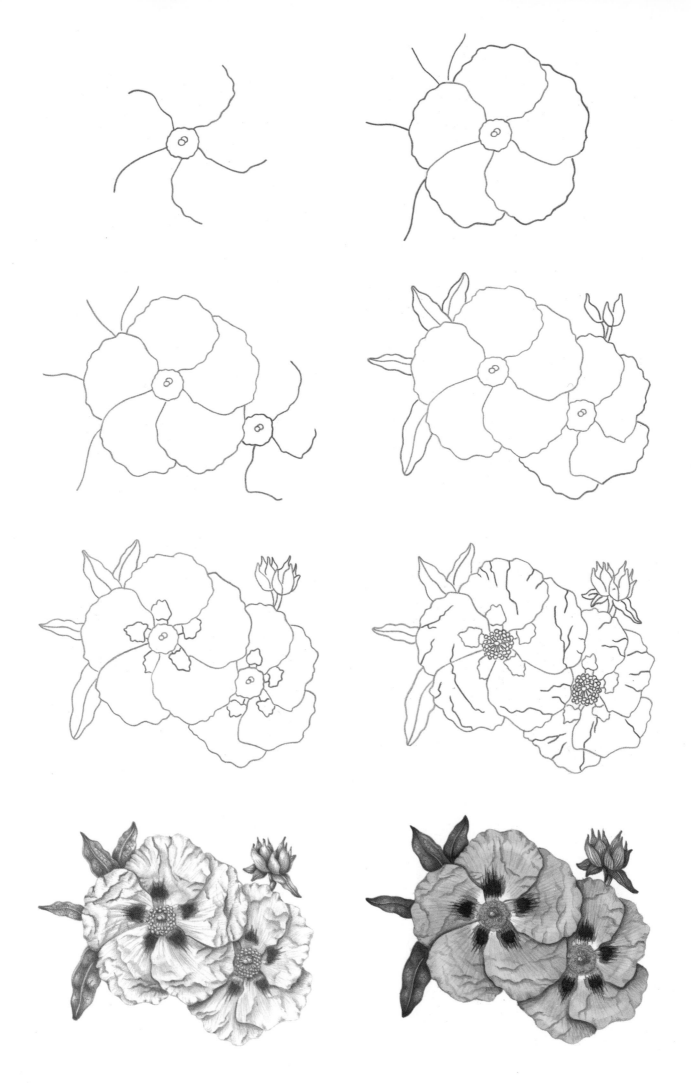

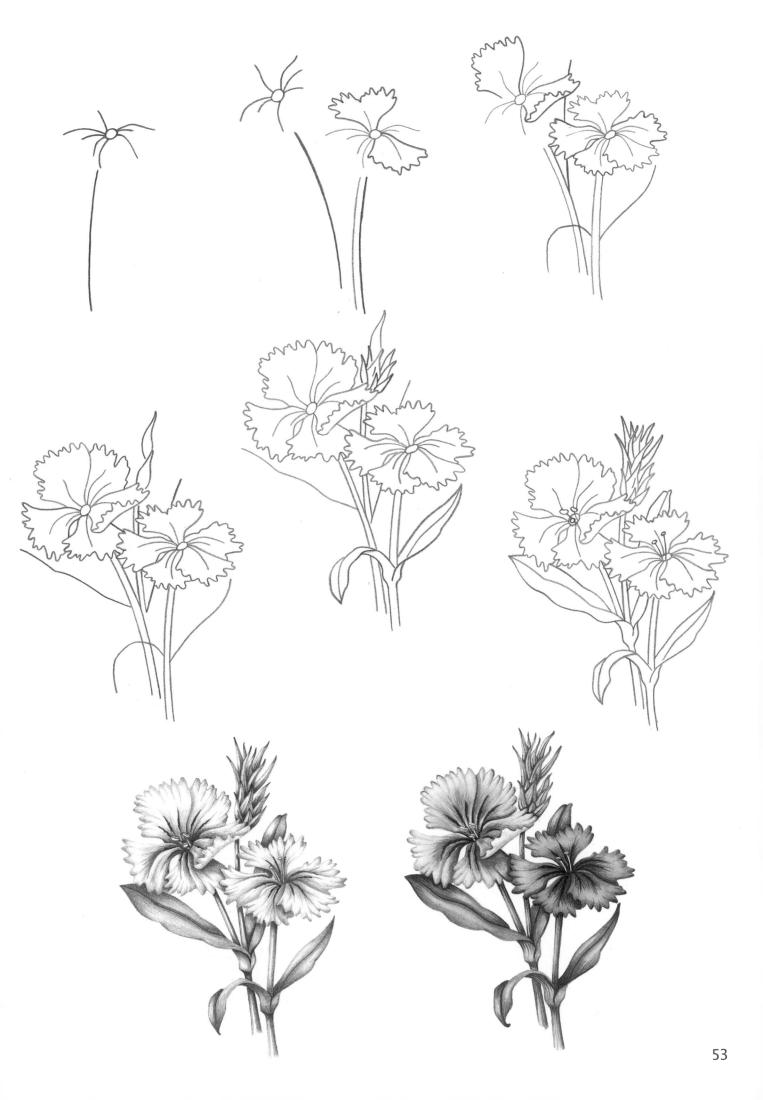

53

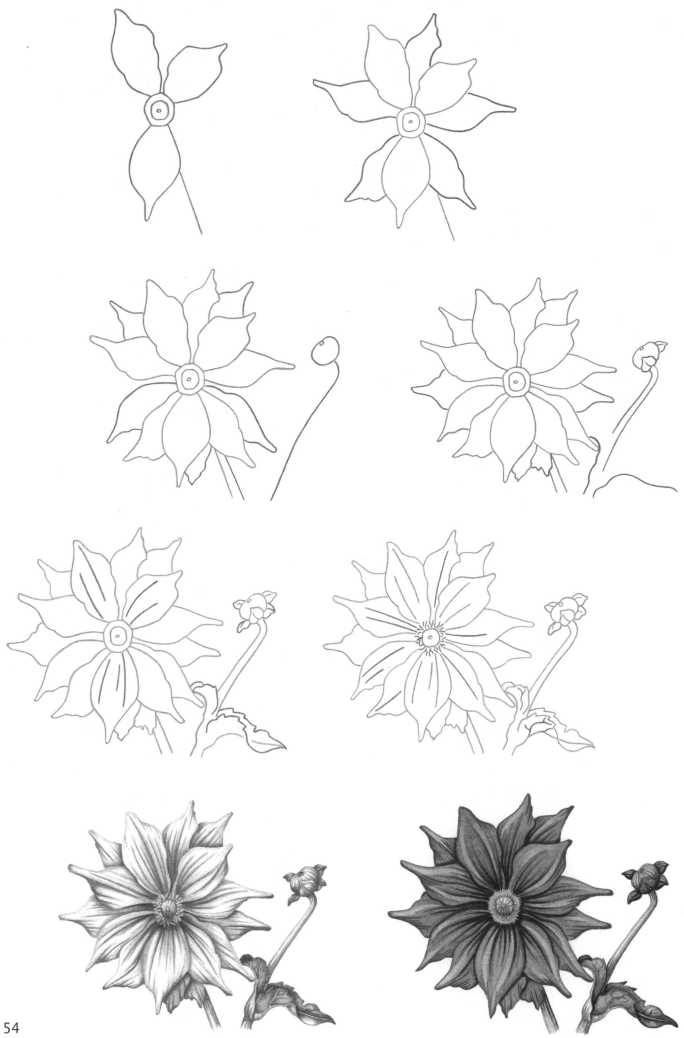

54

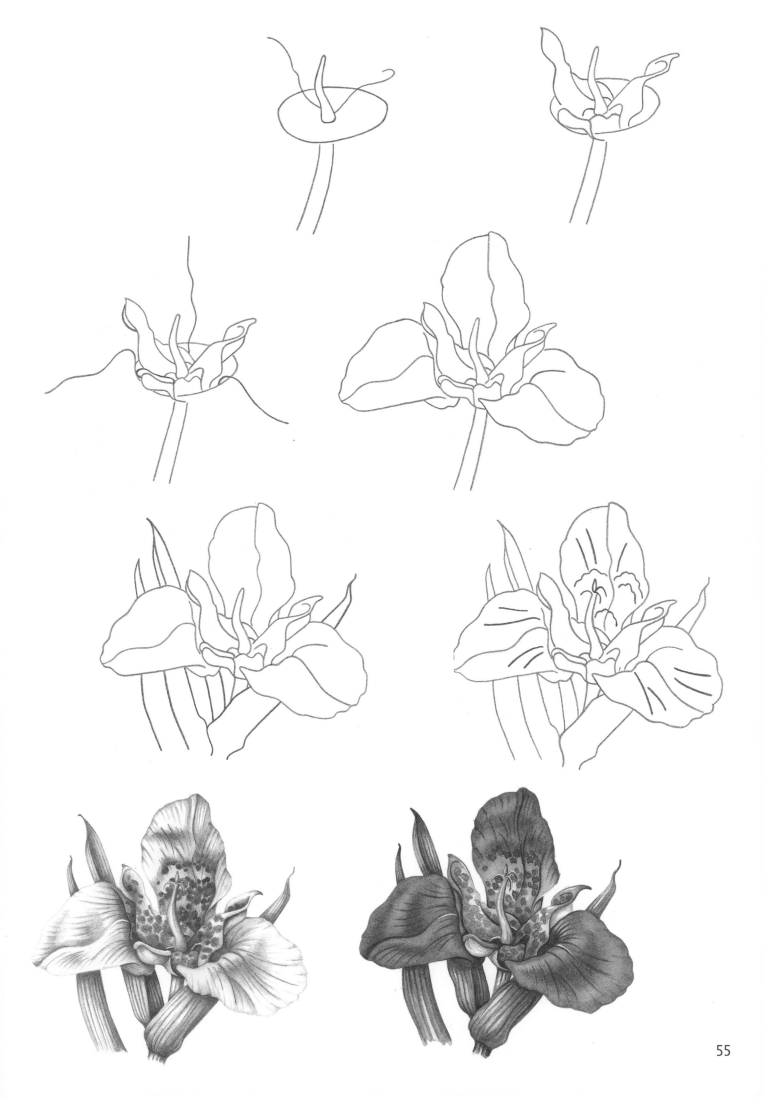

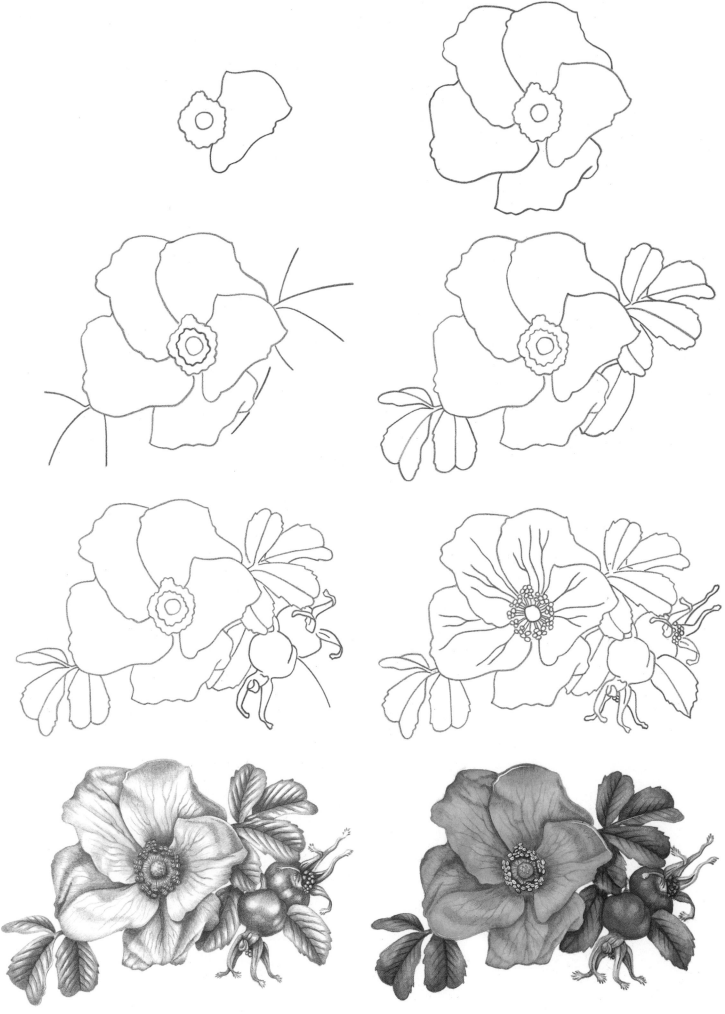

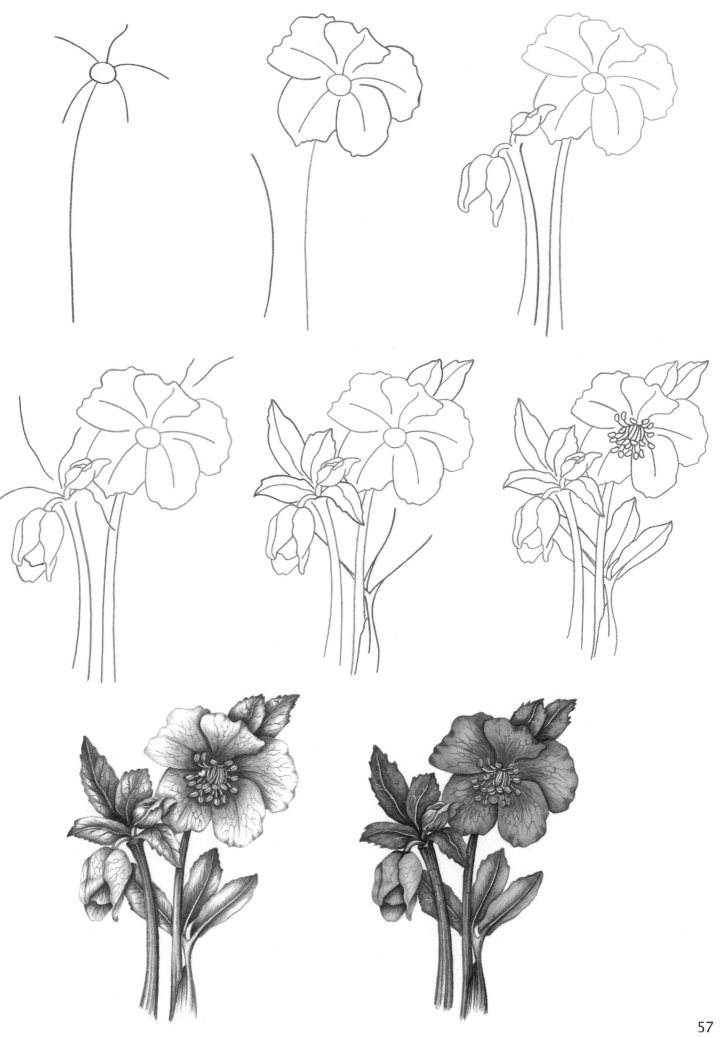

57

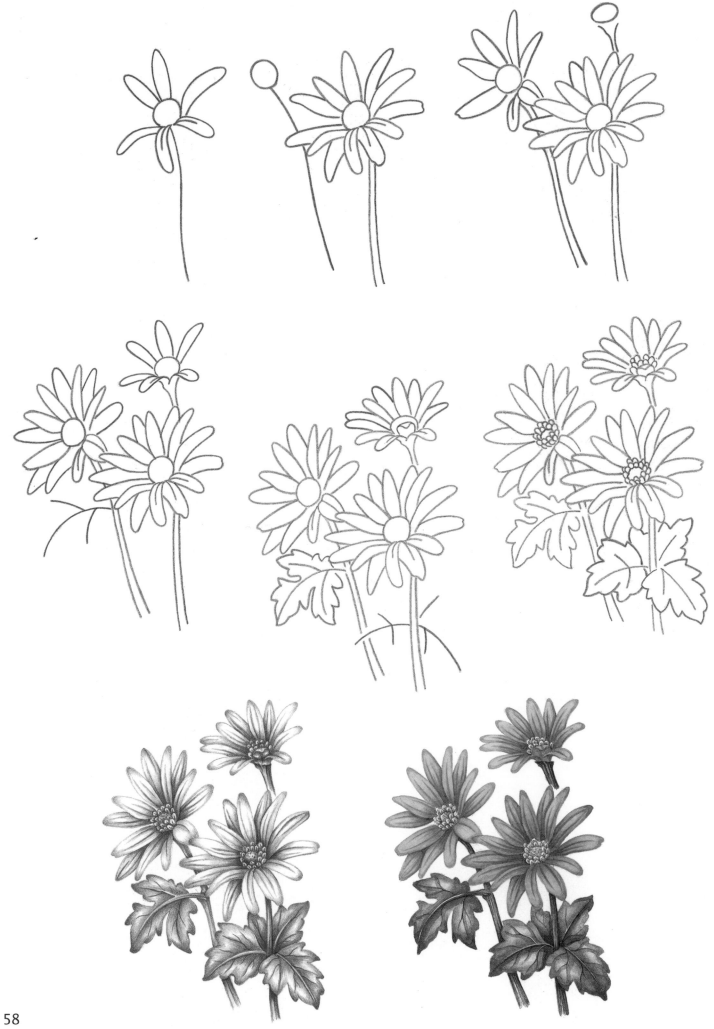

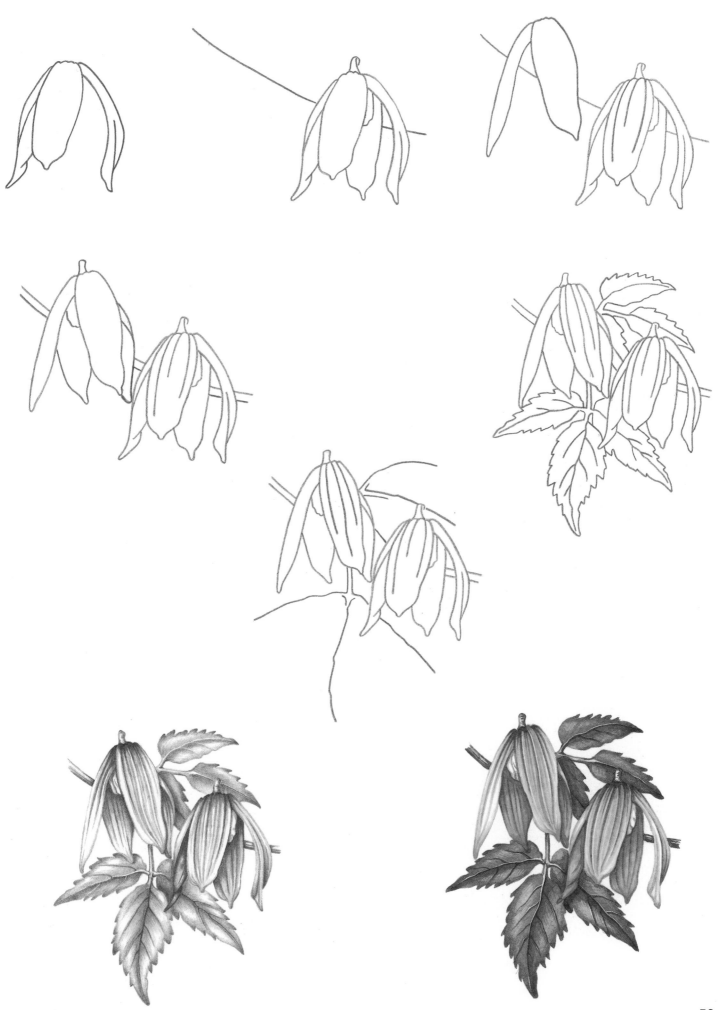

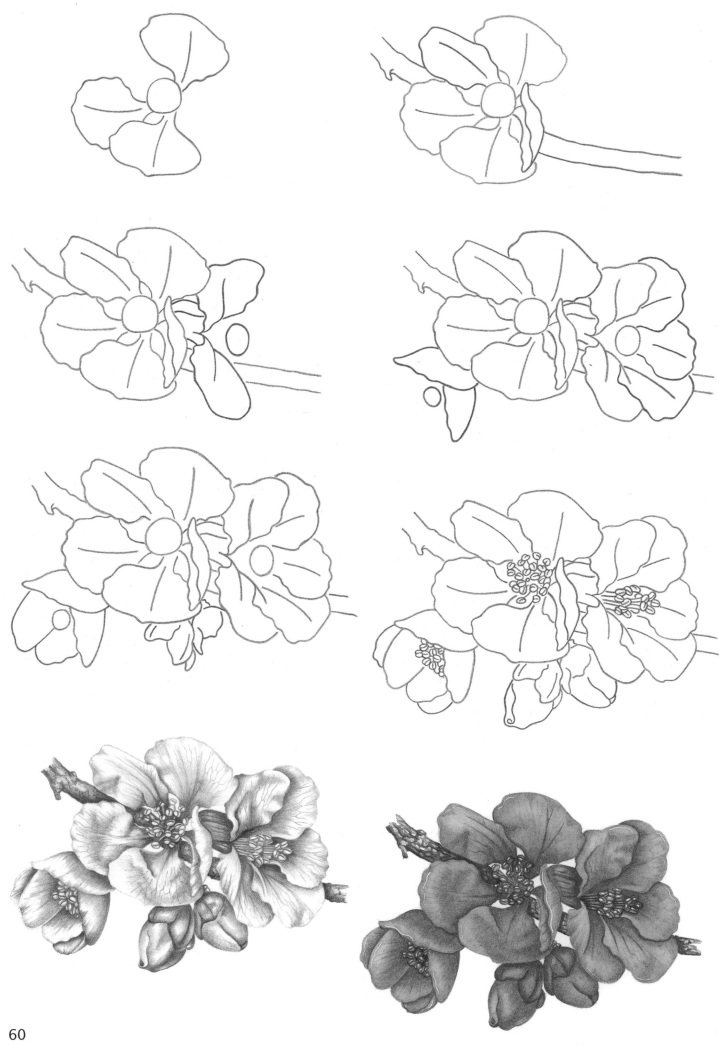

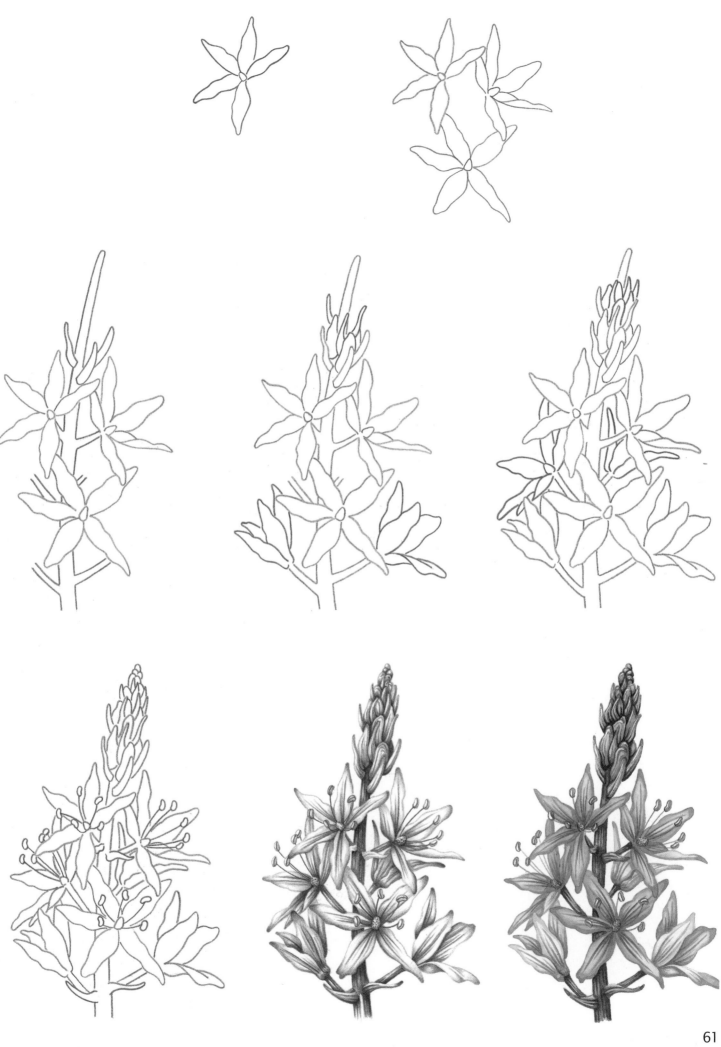

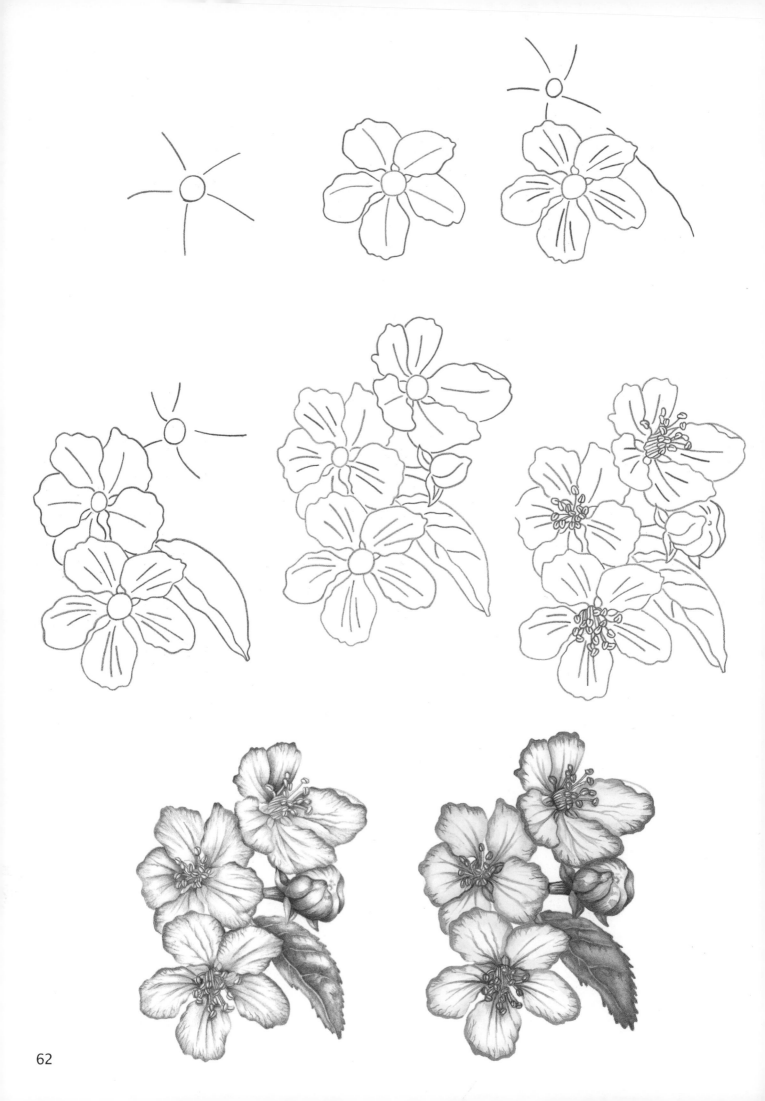

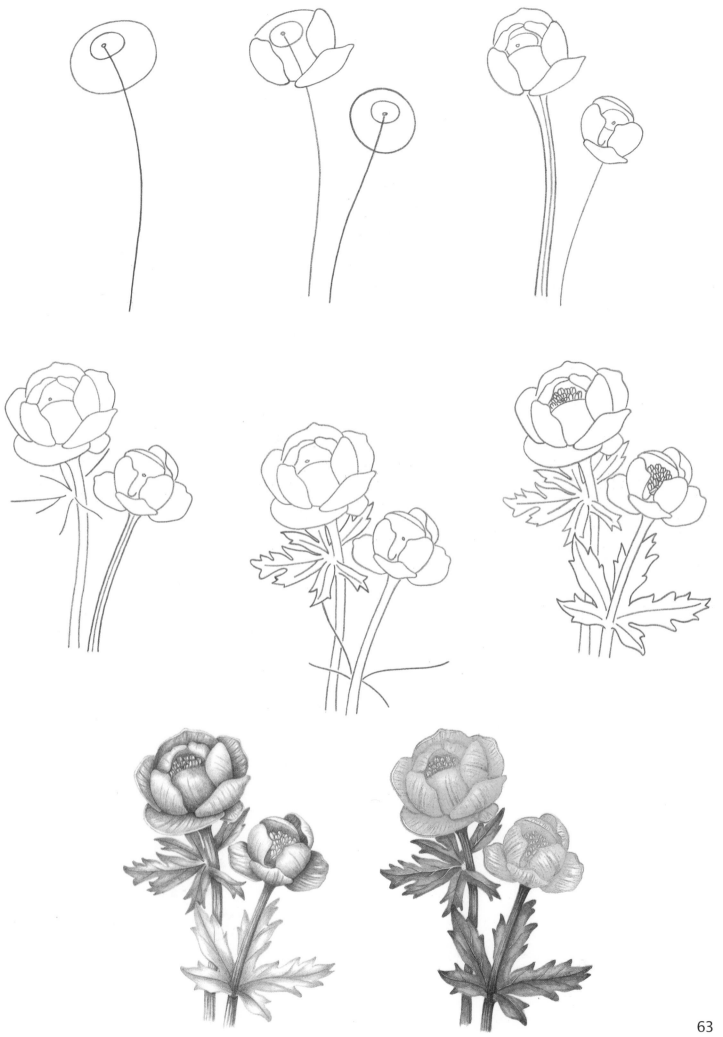

Exotic Flowers

The flowers in this chapter have been chosen as much for their claim to be exotic as for their beauty. Their form and vibrant colours will stand out in any garden and they are a must-have for any enthusiast. Ranging from the simple to the more intricate, there are twenty seven of these flowers, including elegant irises, passion flowers, vibrant fuchsias, gorgeous daisies, golden daffodils and more. It is easy to start - all you need is a little confidence, a sharpened pencil and a few sheets of drawing paper.

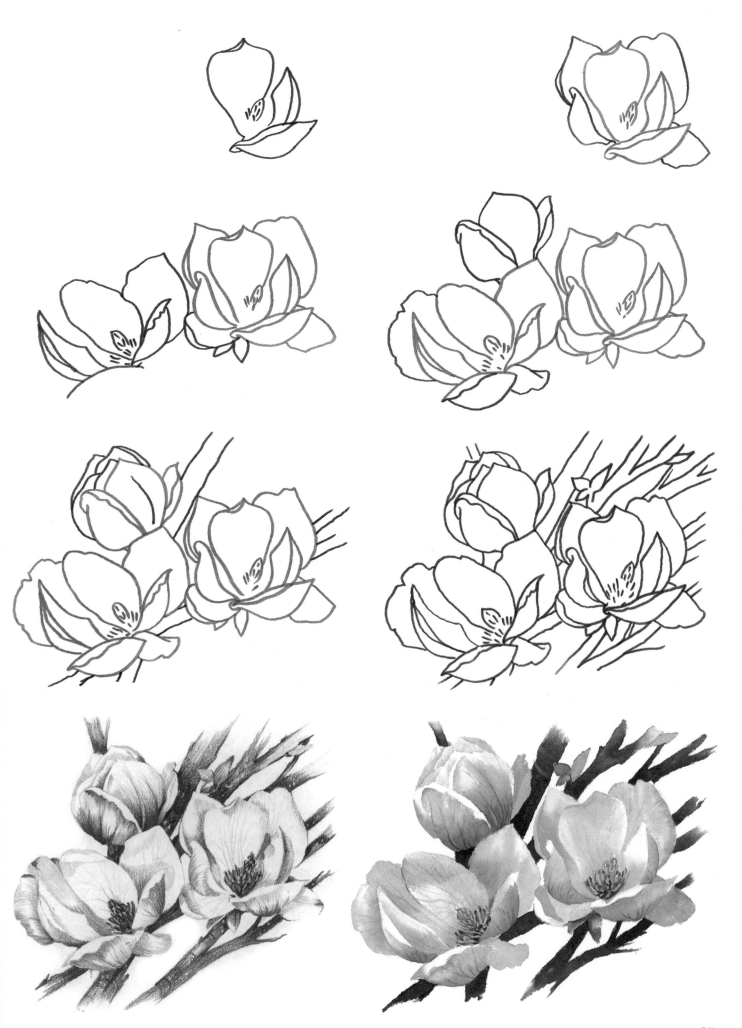

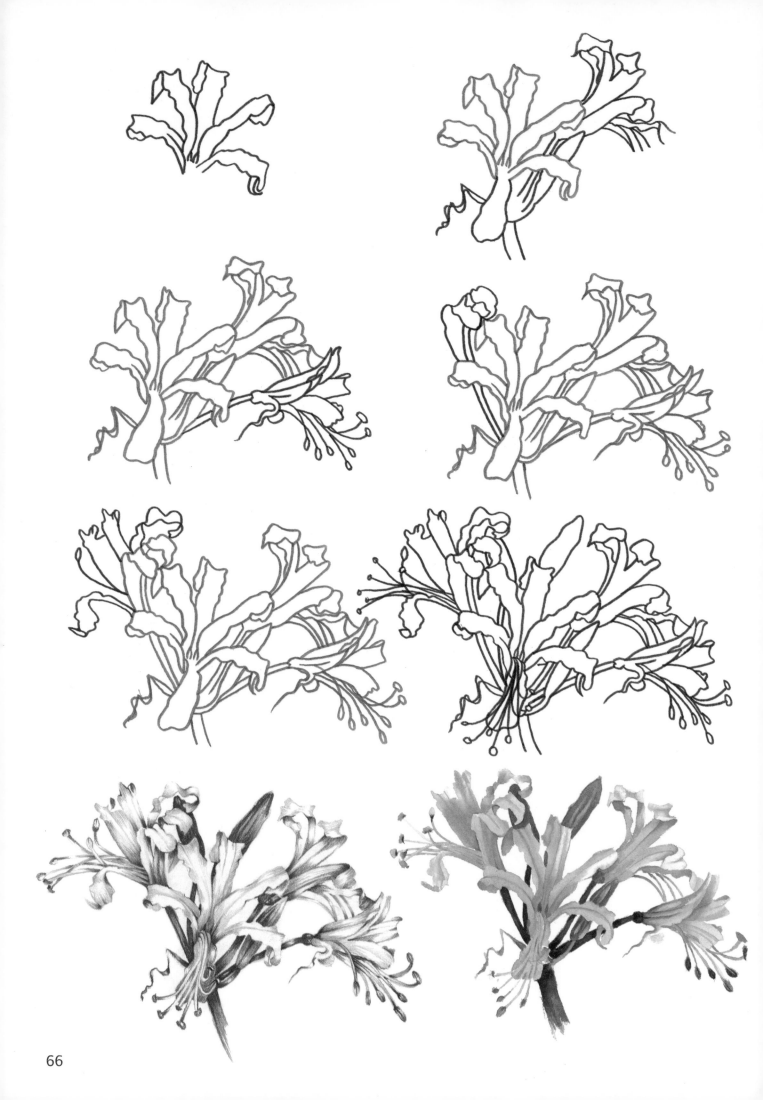

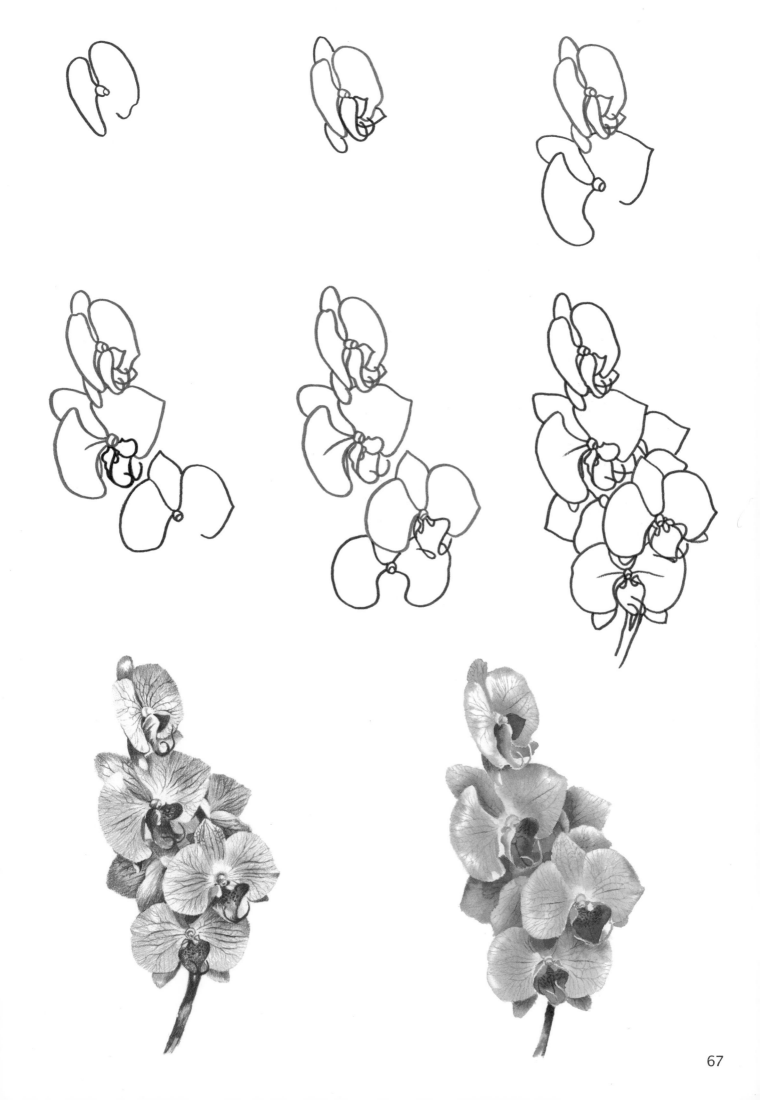

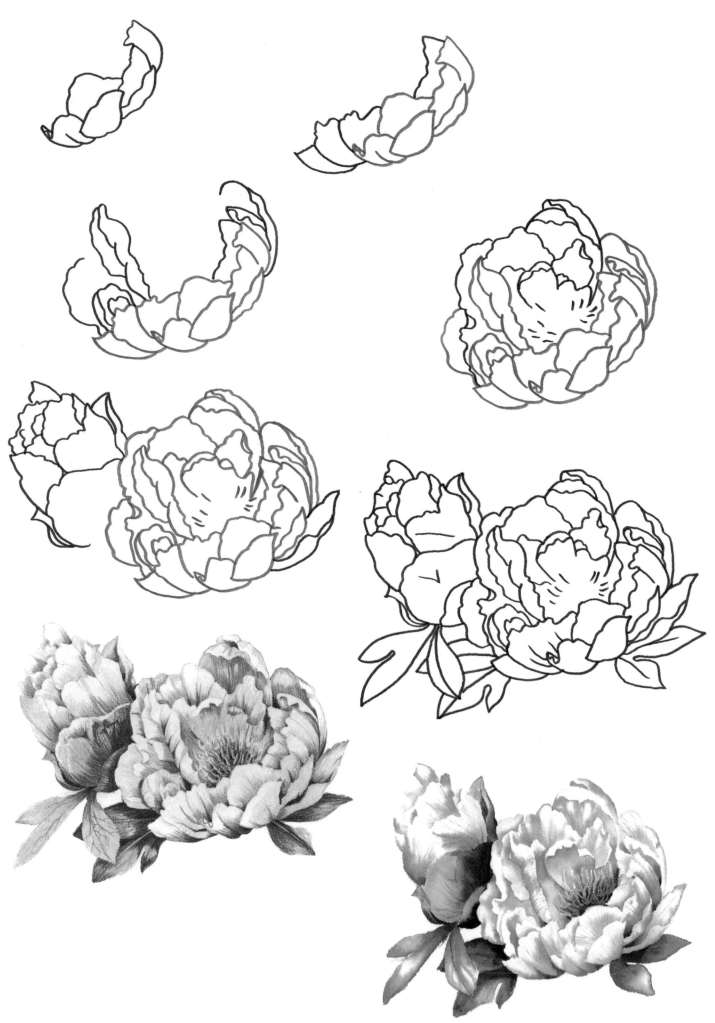

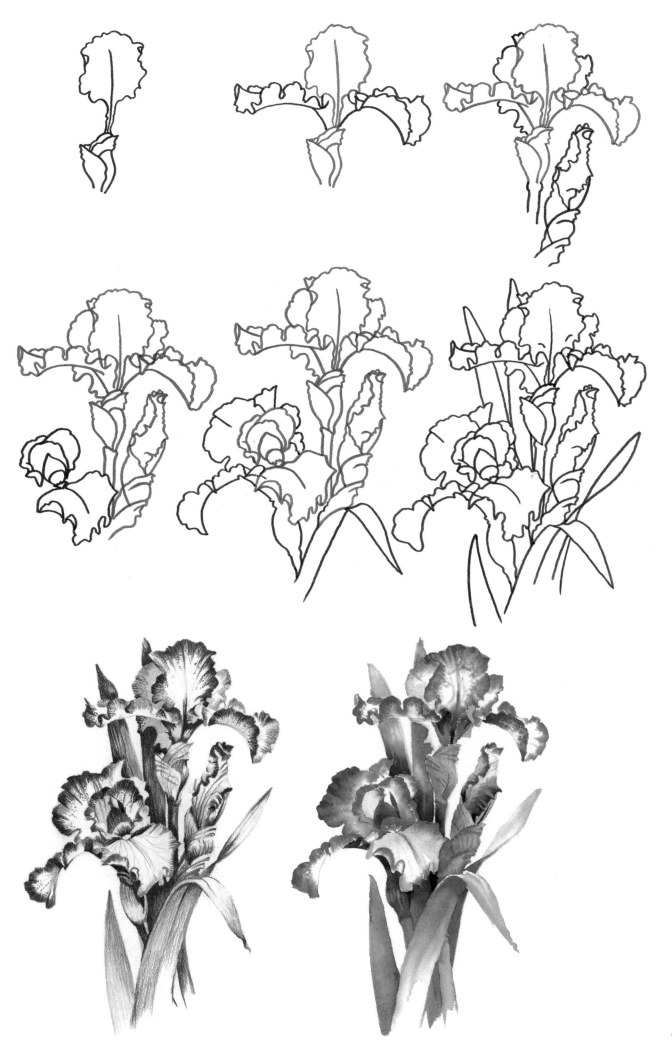

69

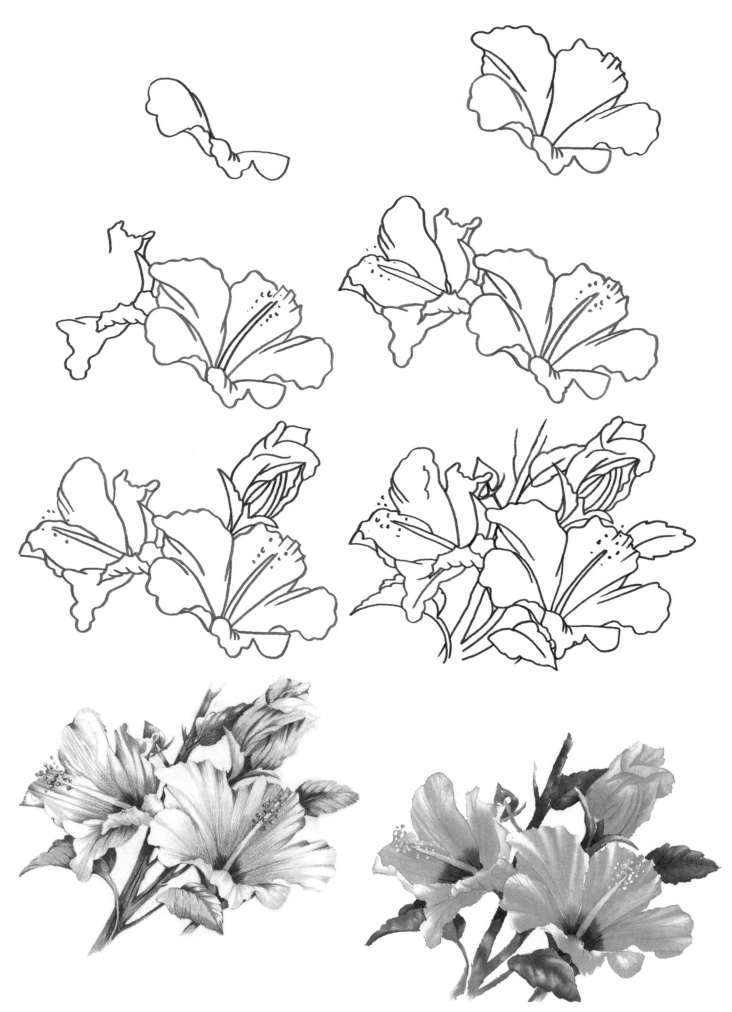

70

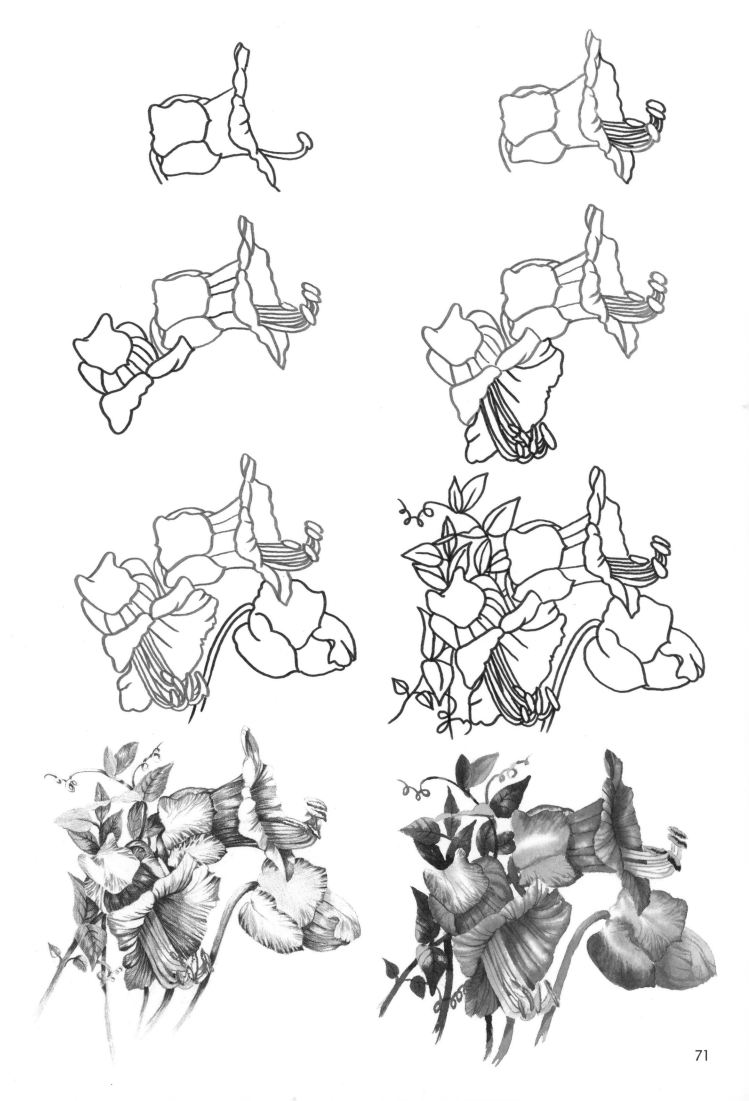

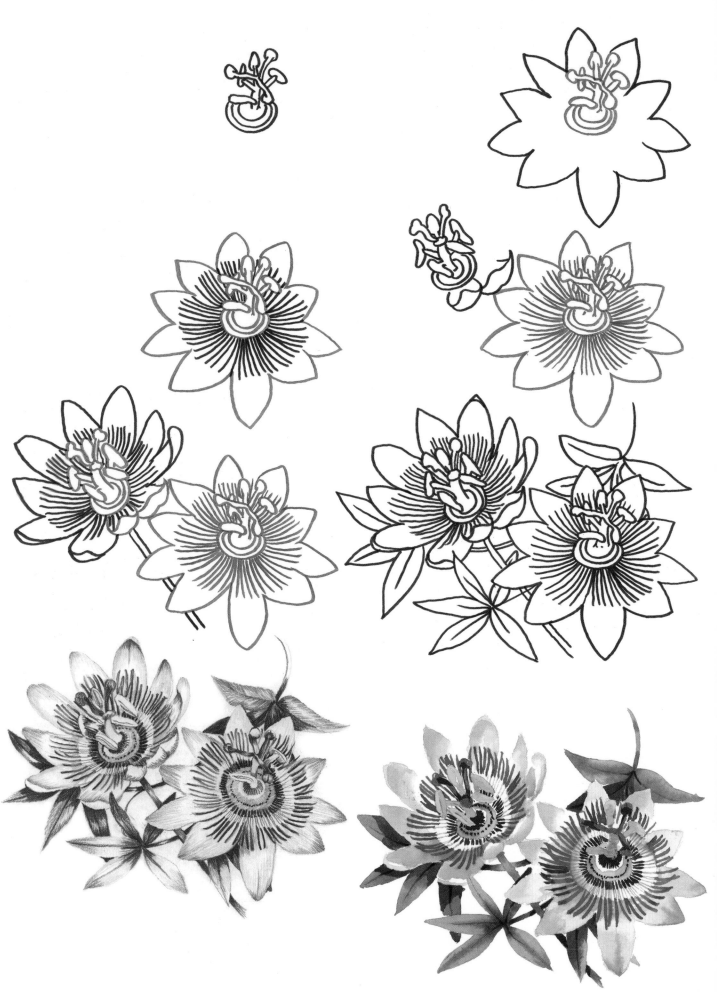

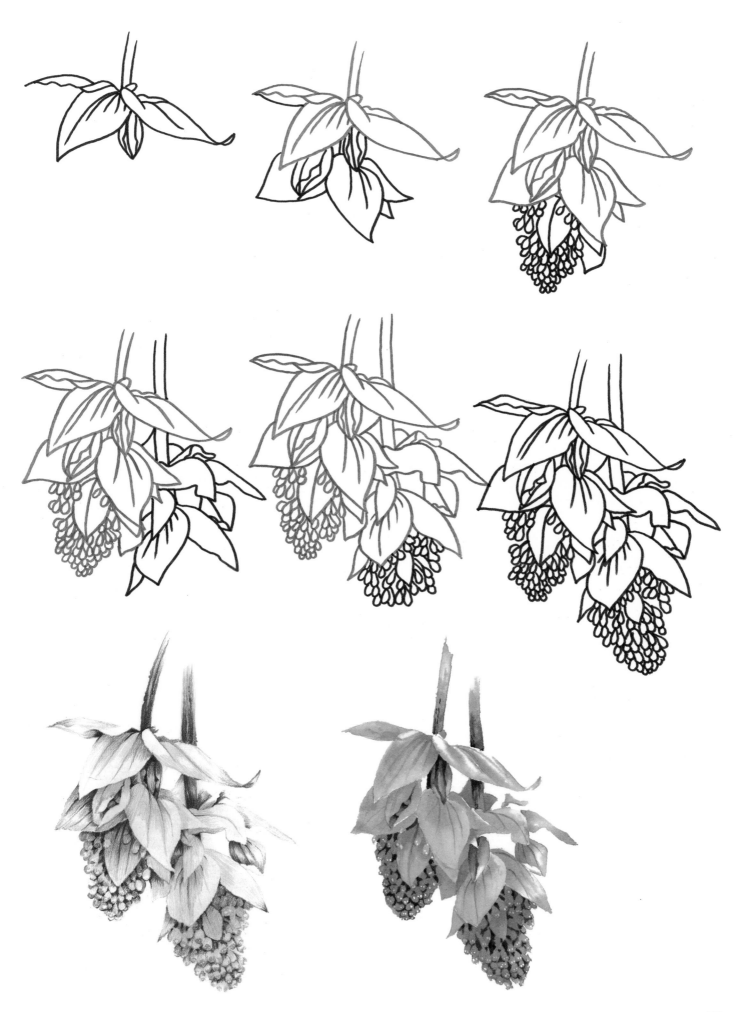

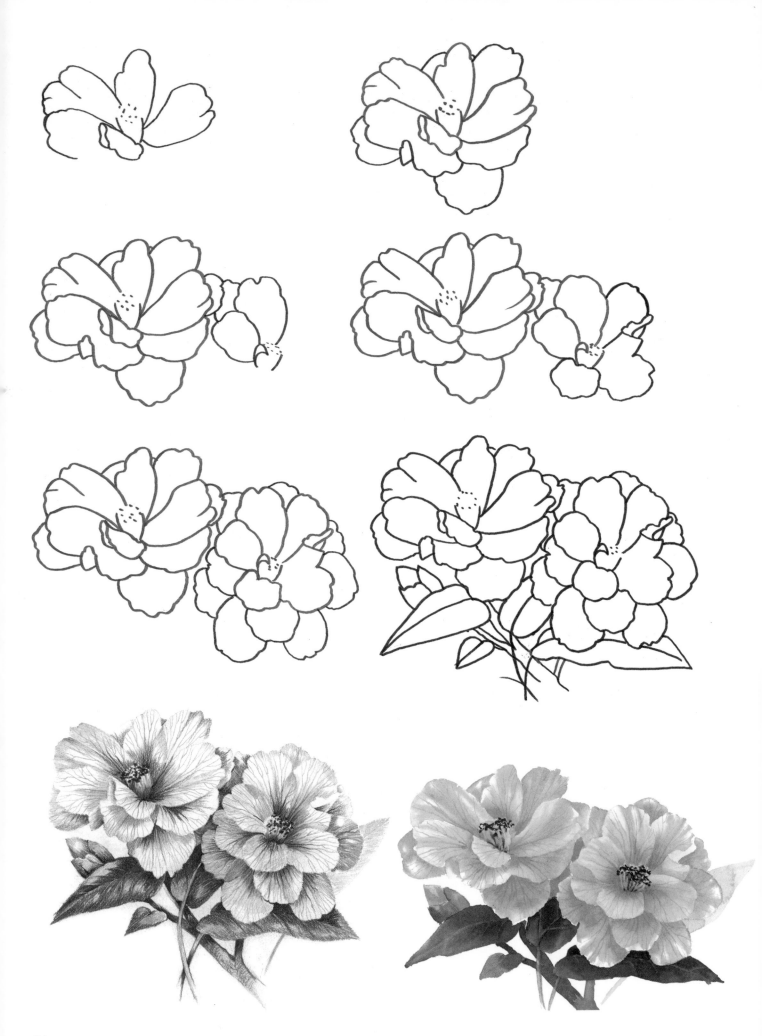

74

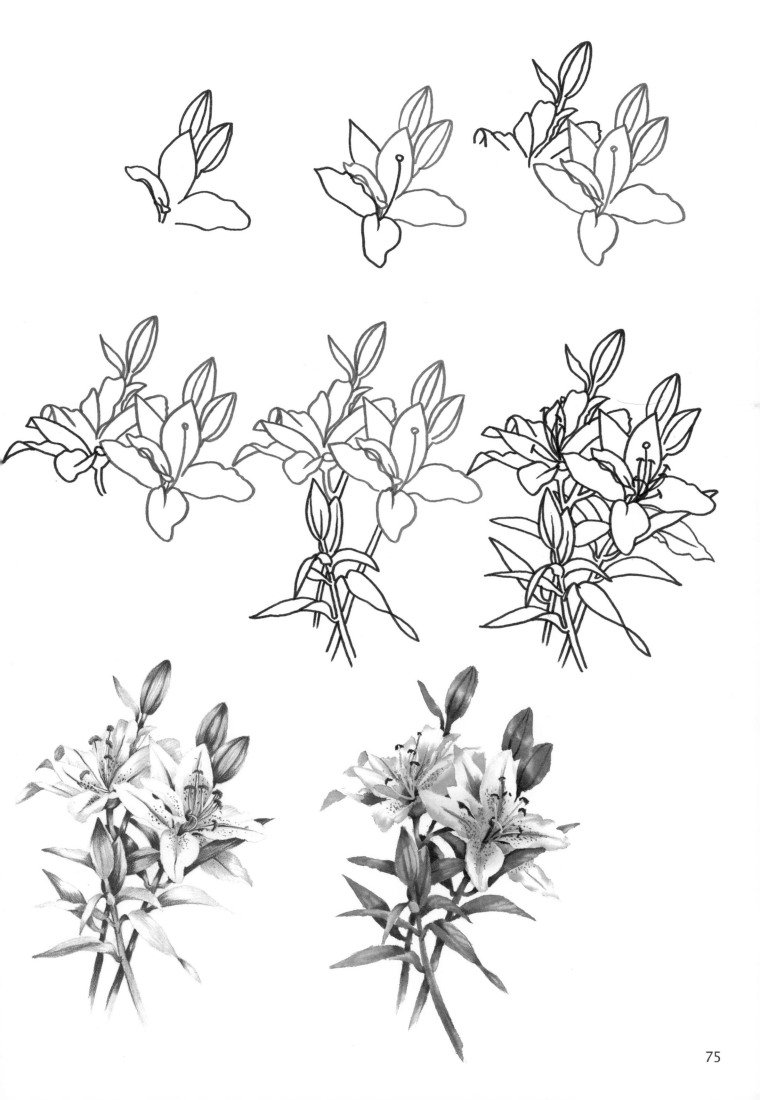

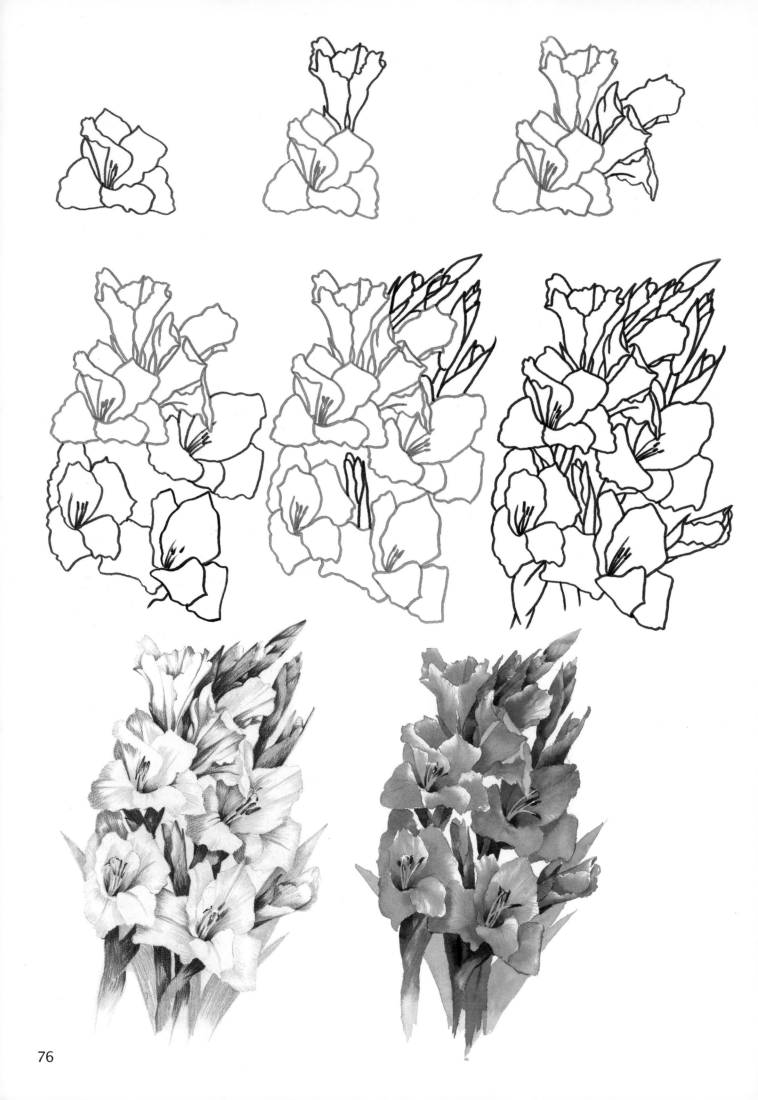

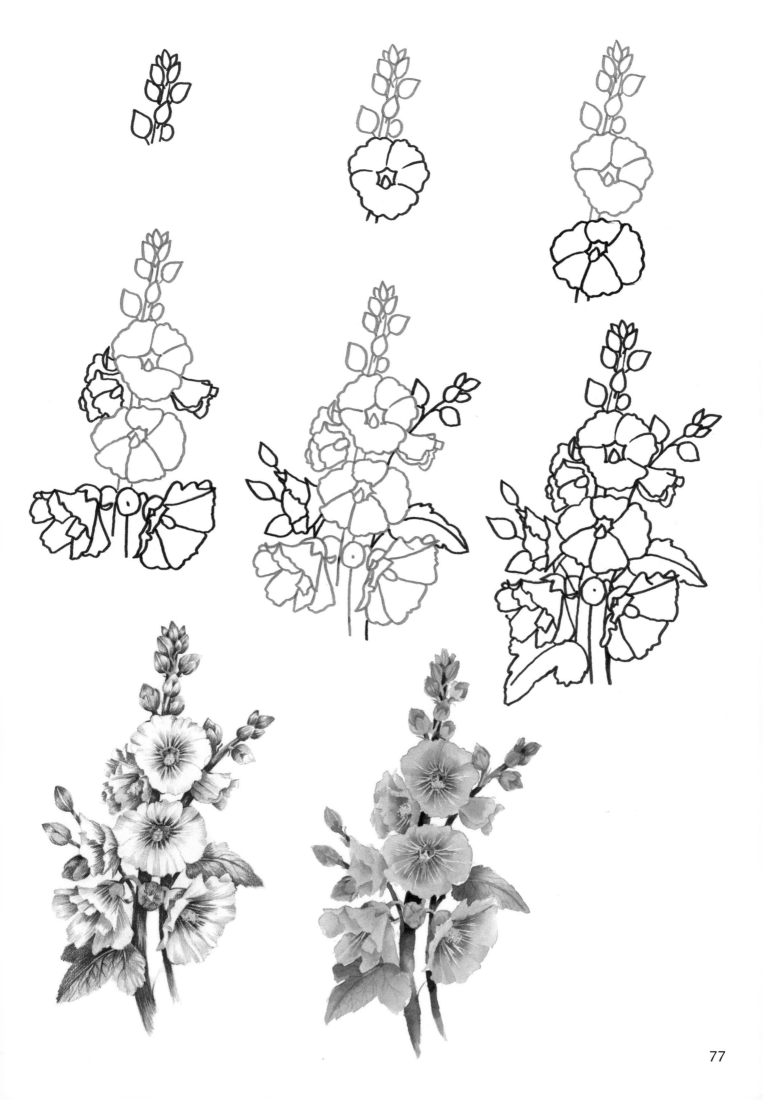

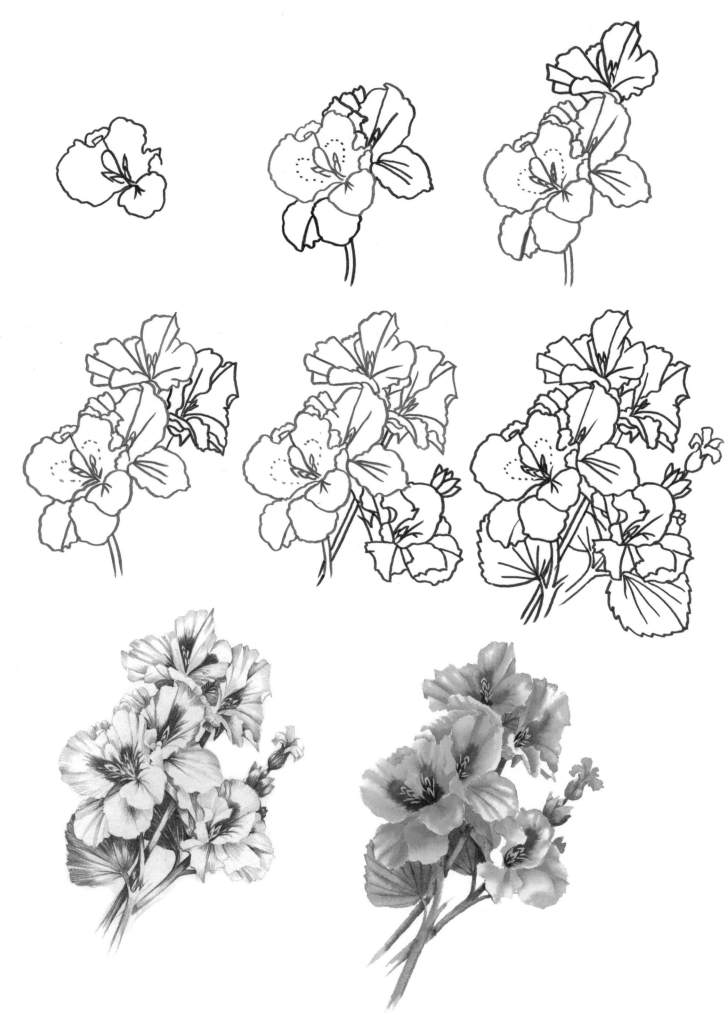

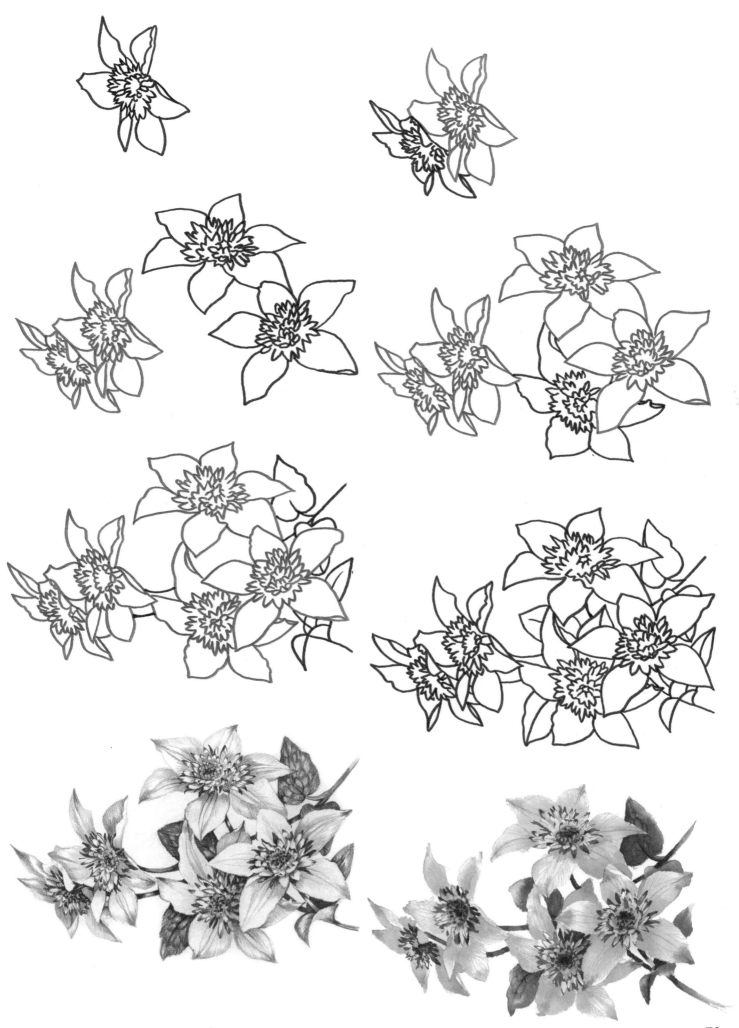

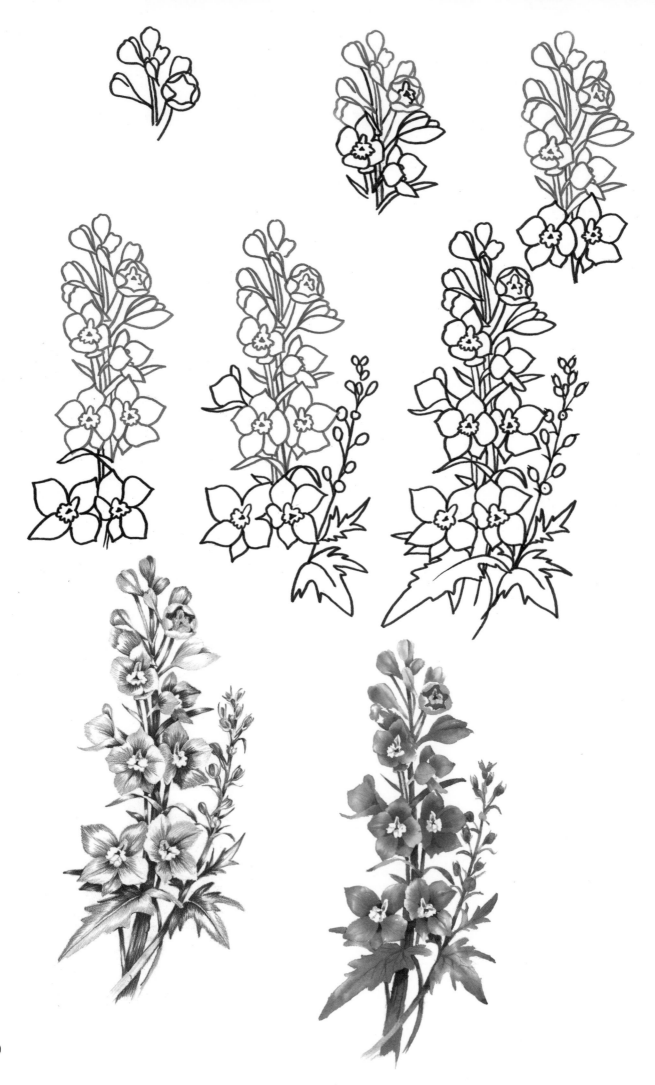

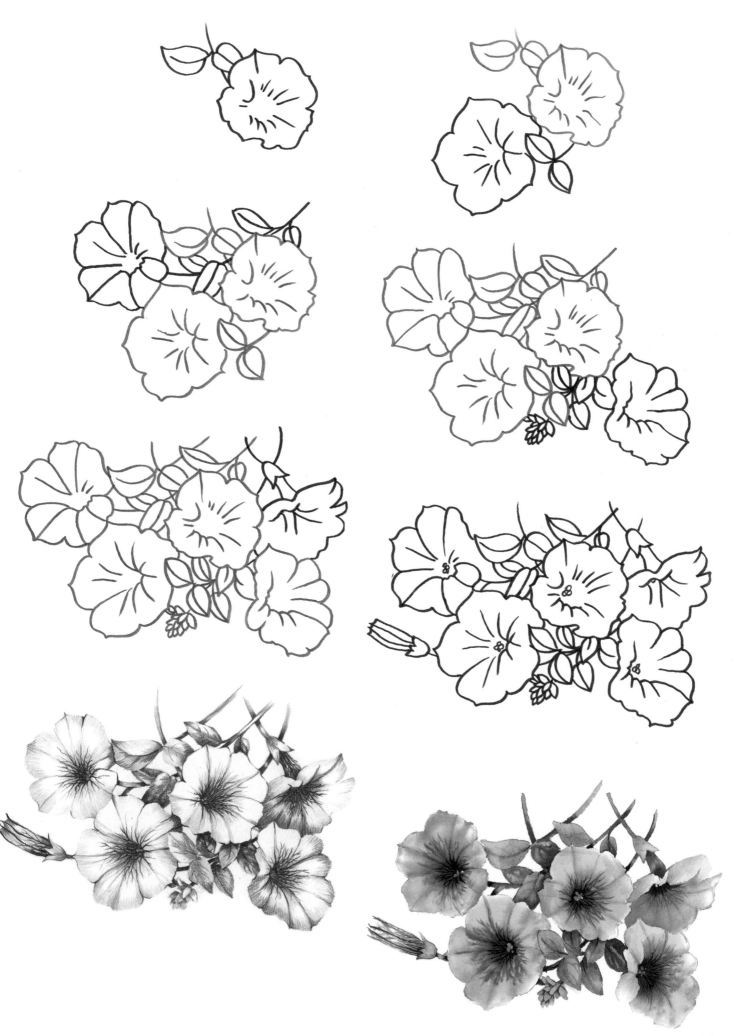

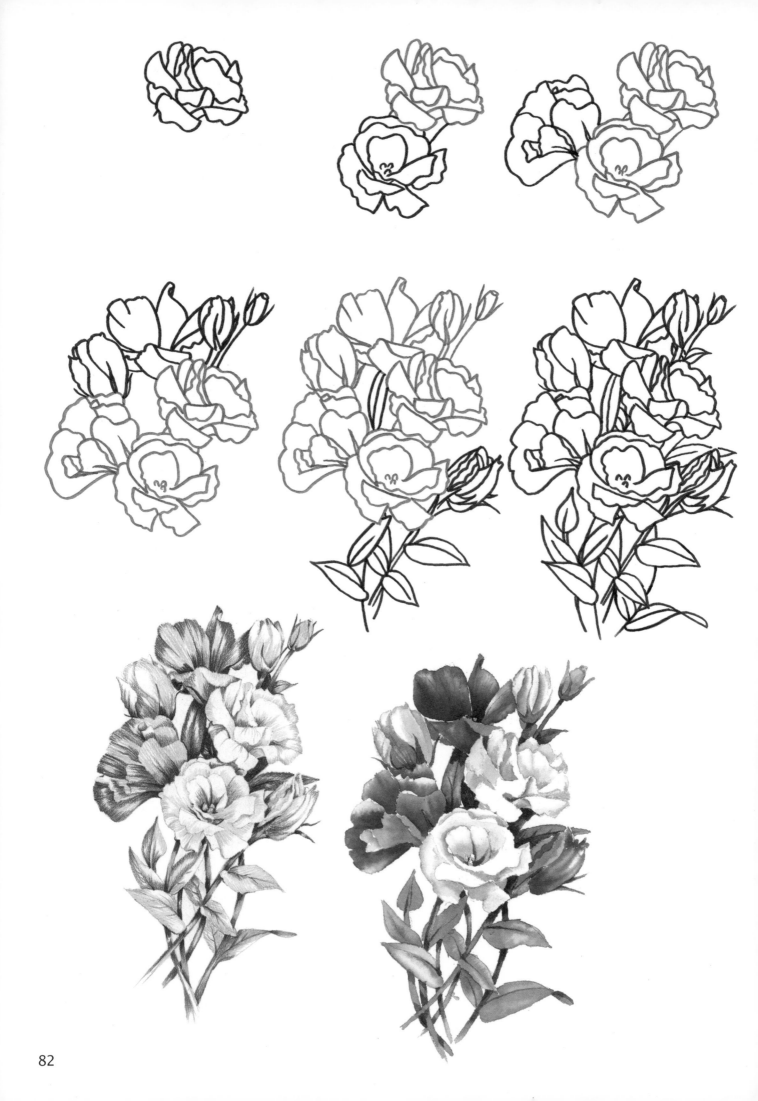

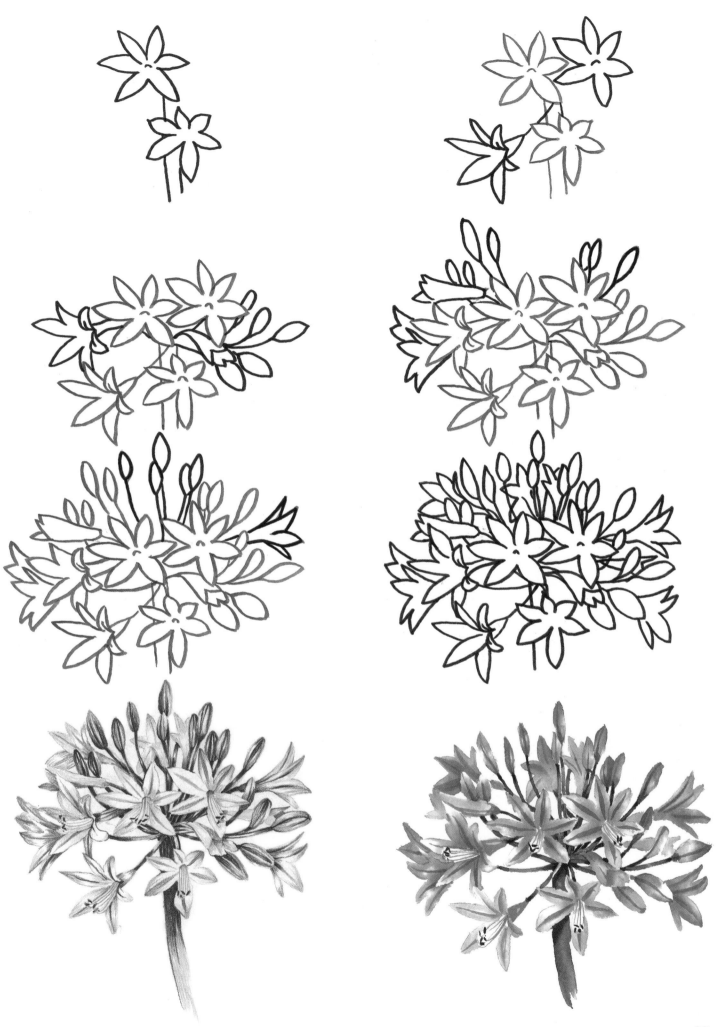

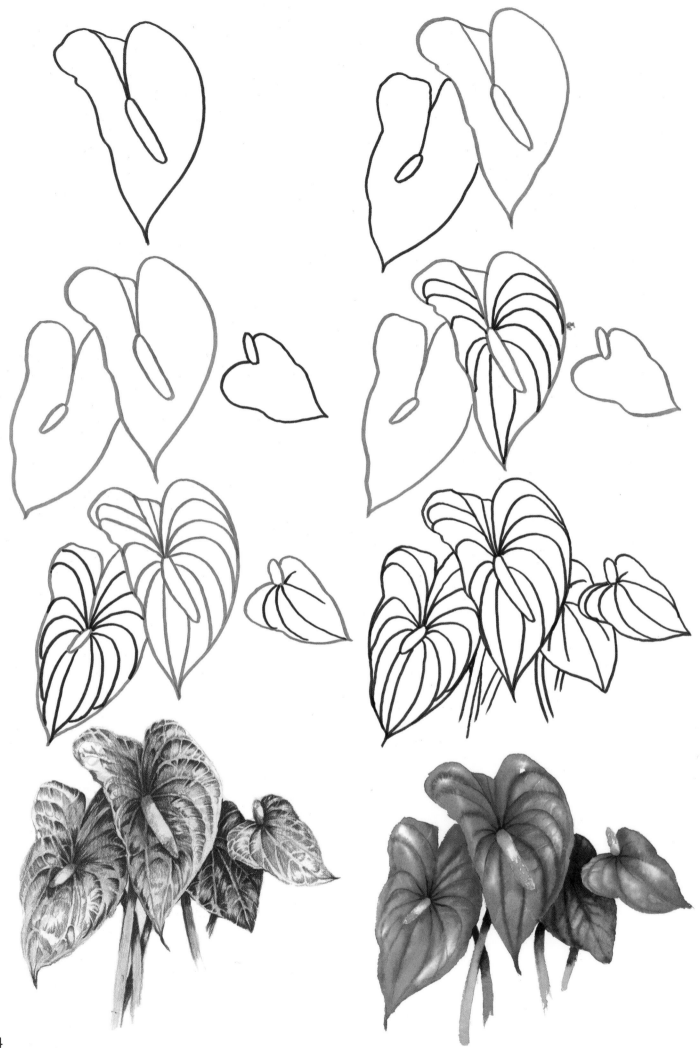

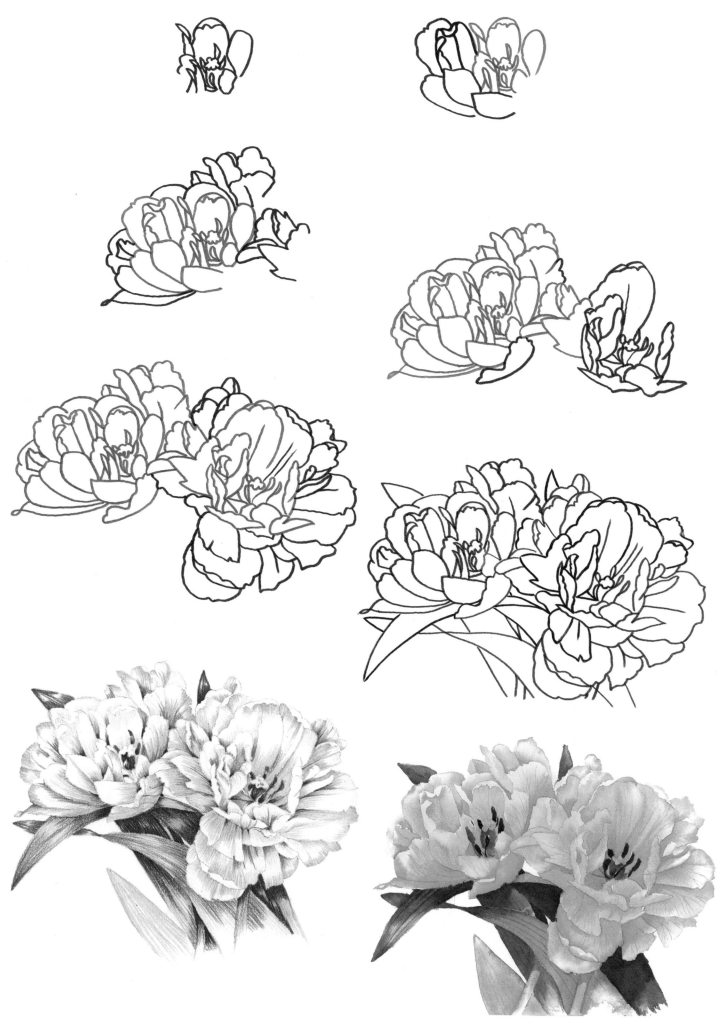

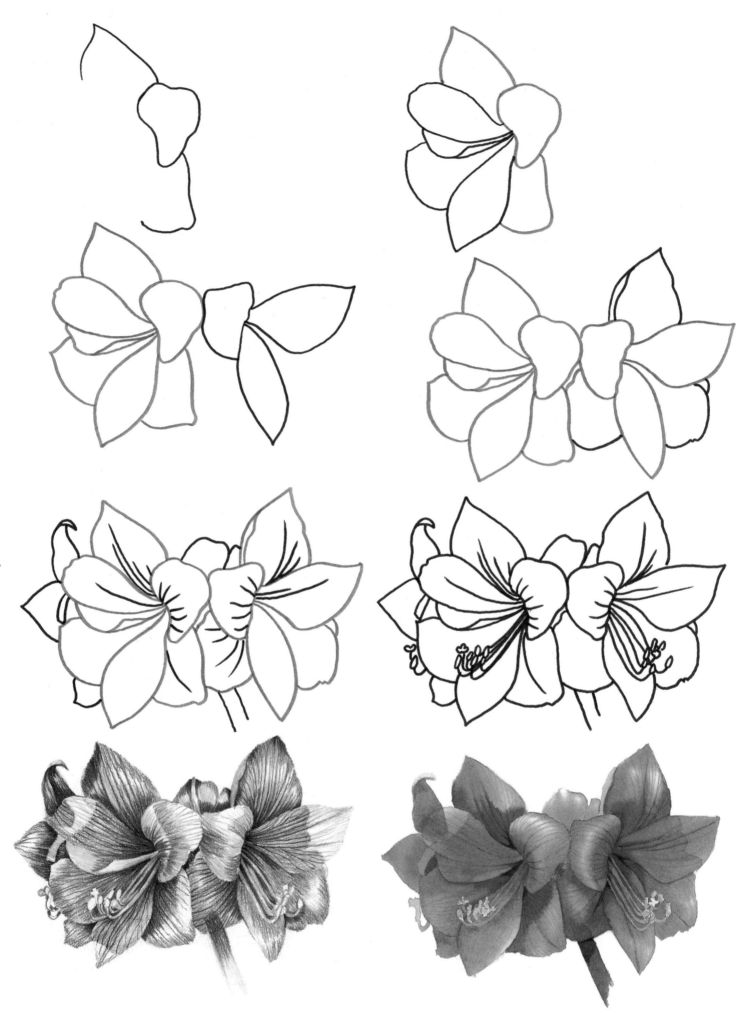

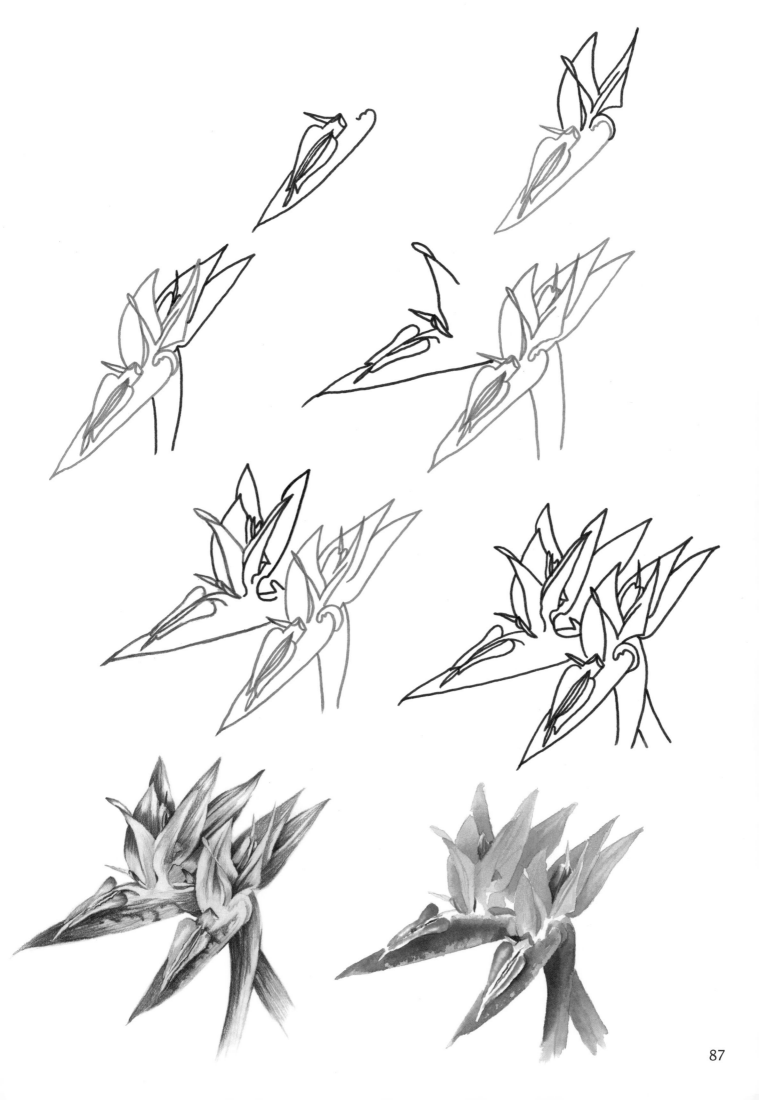

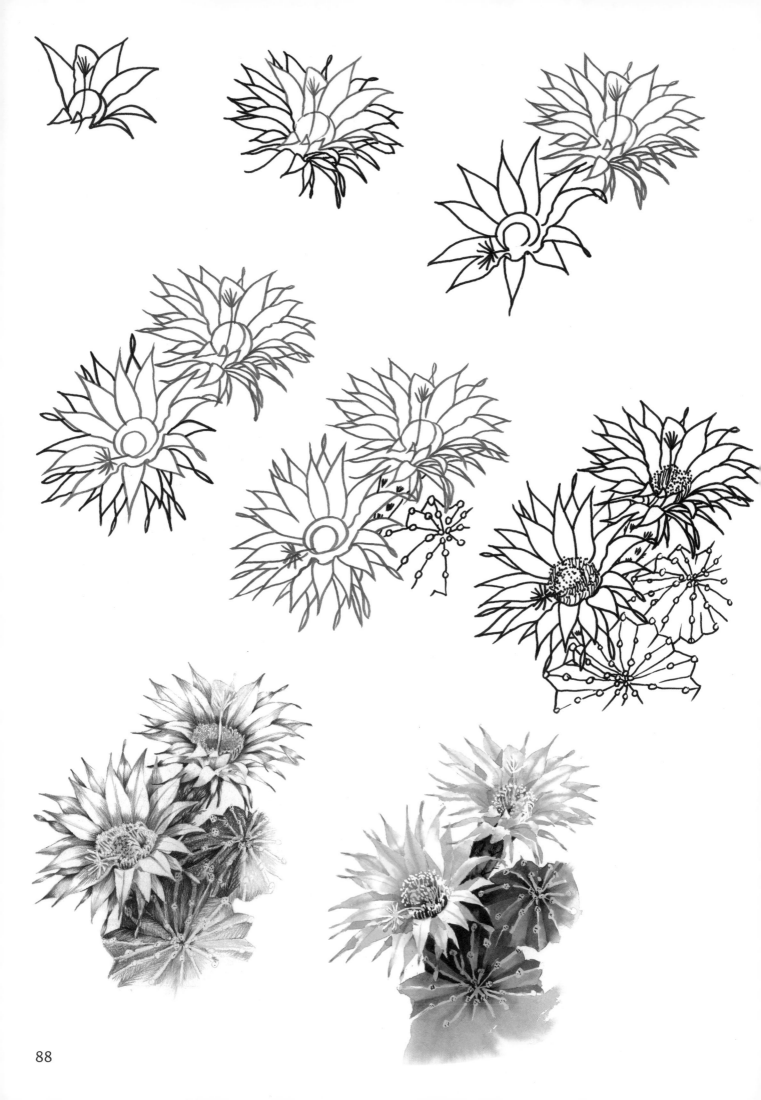

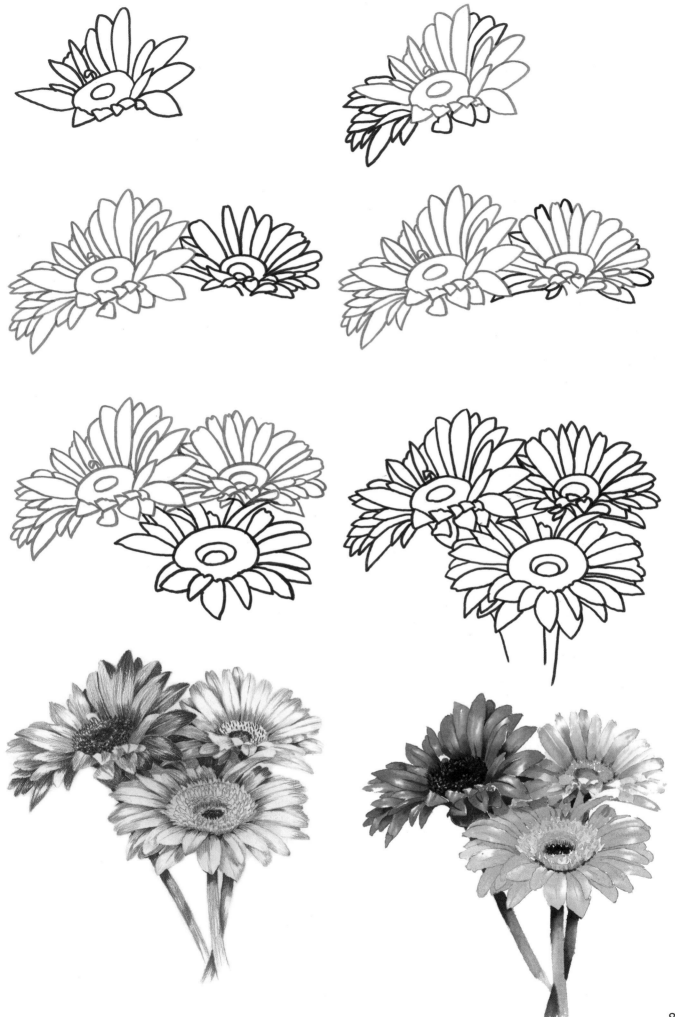

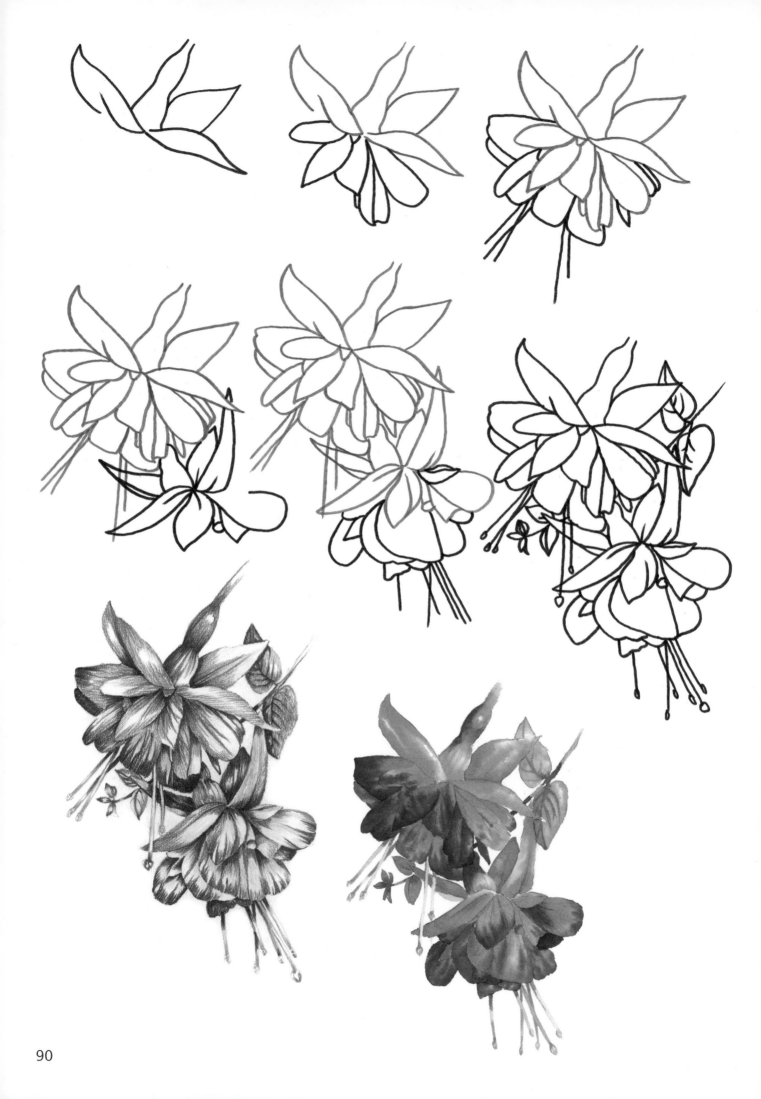

90

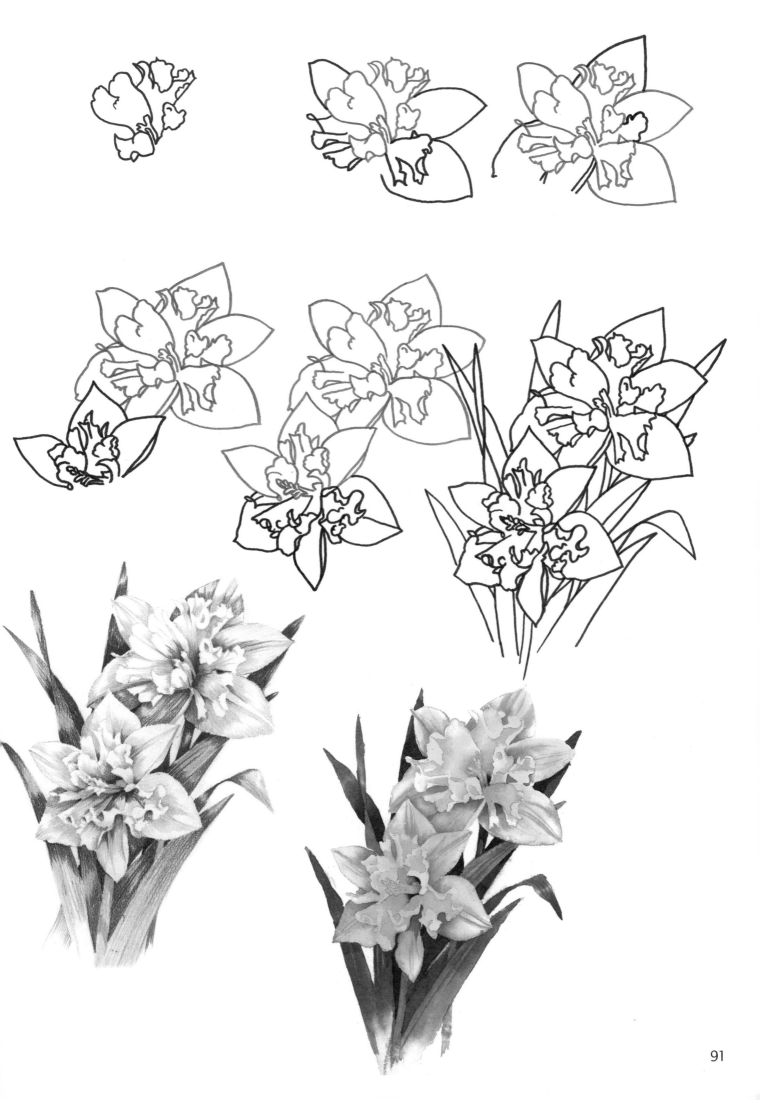

Wild Flowers

Apart from the more flamboyant species like poppies and bluebells, wild flowers in the landscape are often taken for granted. It is not until we look closely that we see a whole world filled with exquisite details that can often be missed. They may not grow in a place where you can sit and sketch them in peace, and they wilt and die quickly when picked. Do remember to check that they are not a protected species if you are thinking of picking them. The aim in this section is to give you a basic grounding in some of the most common species. Hopefully you will start to observe wild flowers in the landscape and be inspired to compose your own paintings after drawing some of the images in this chapter.

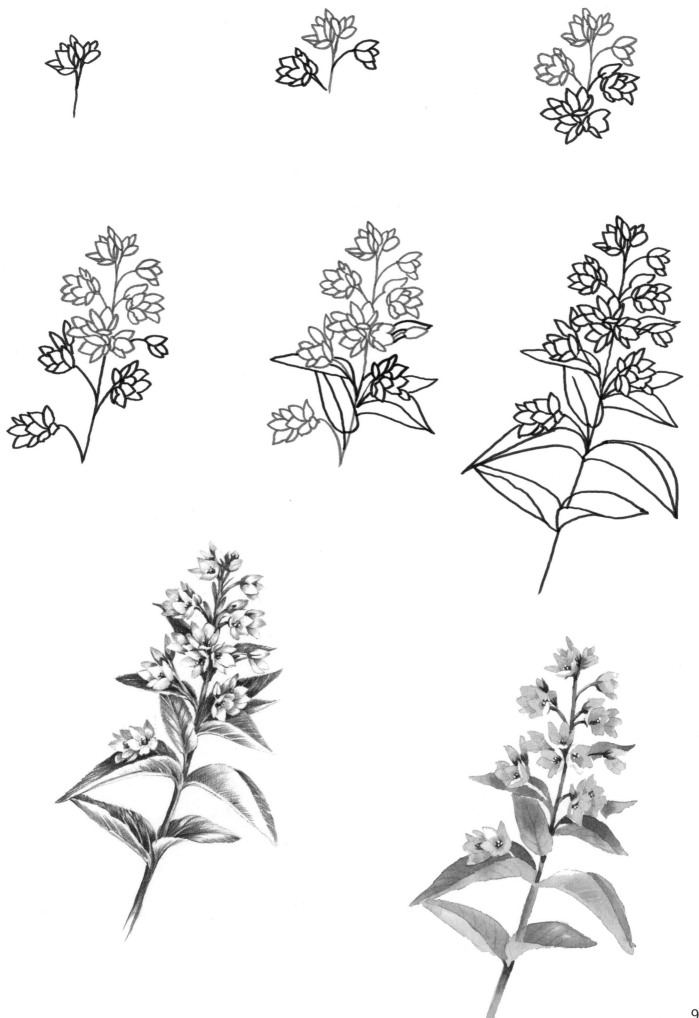

93

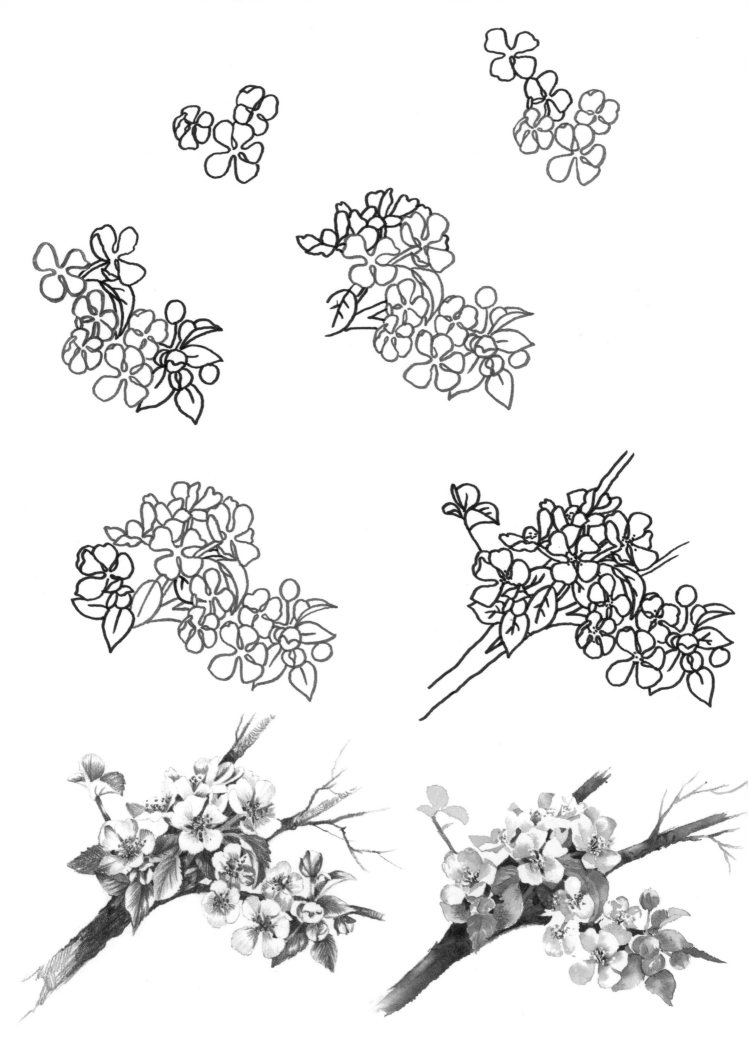

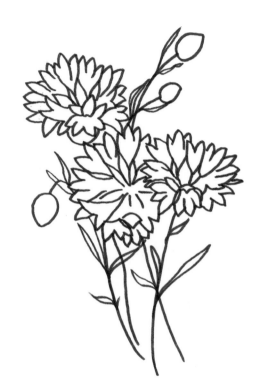

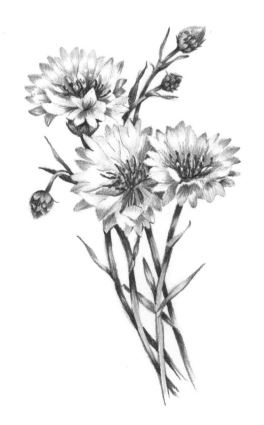

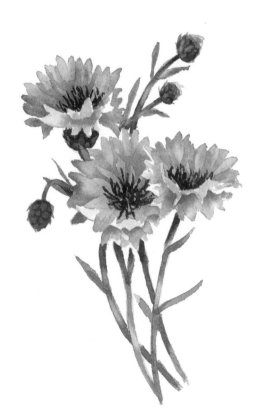

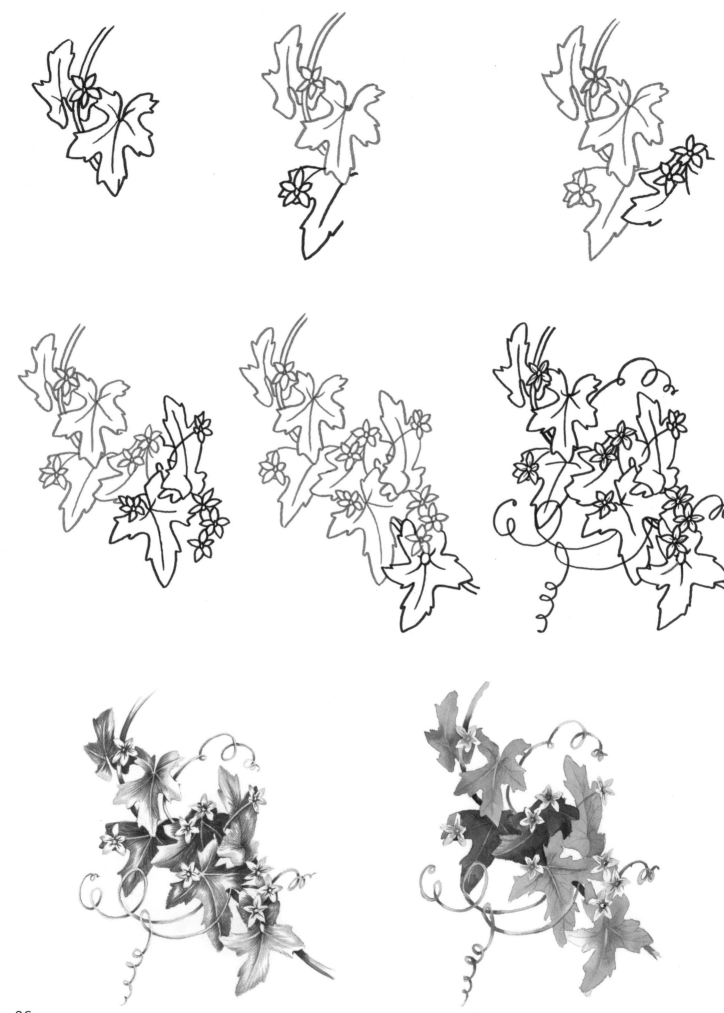

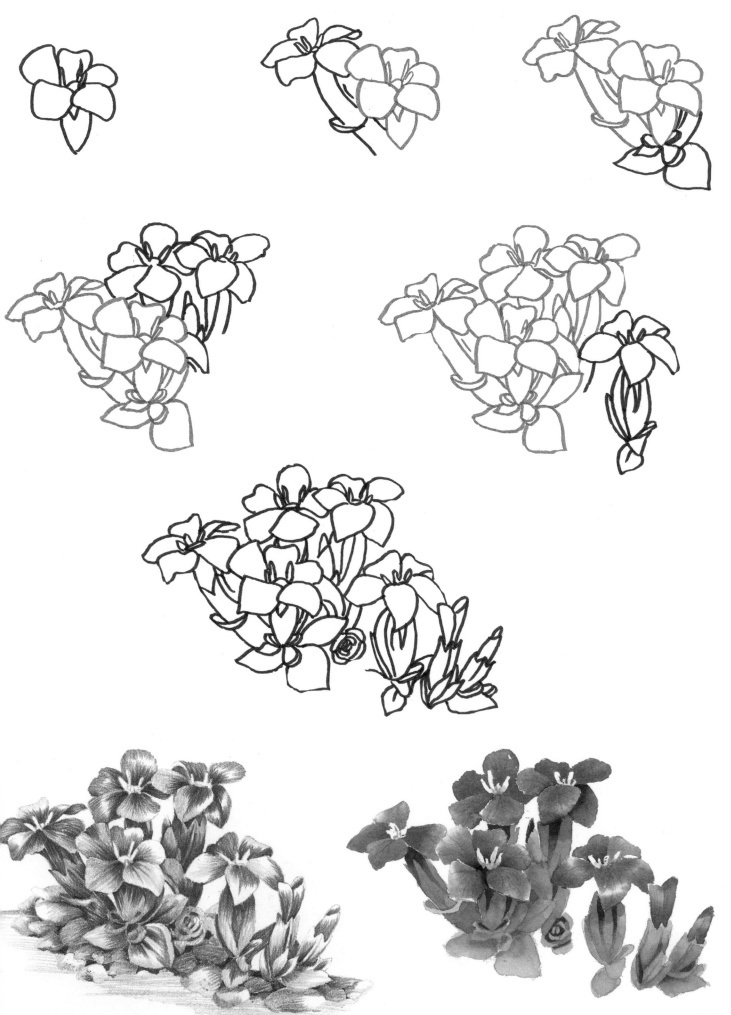

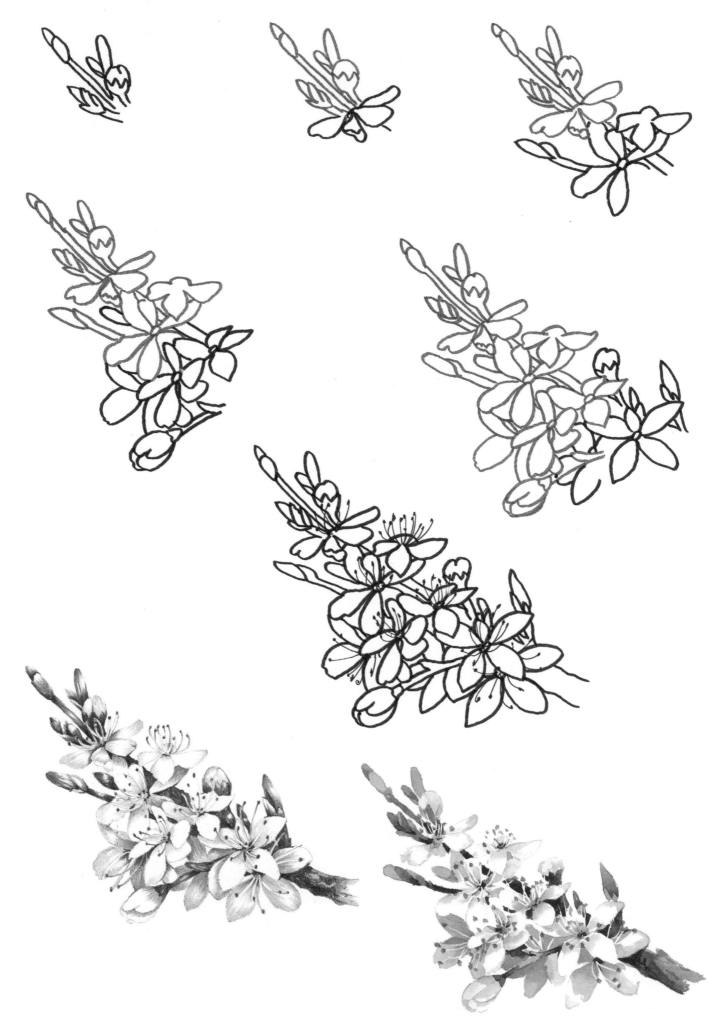

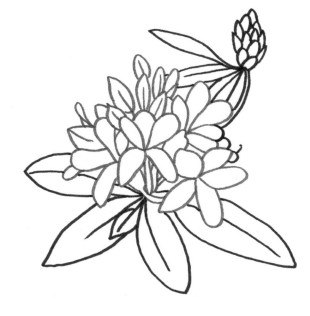
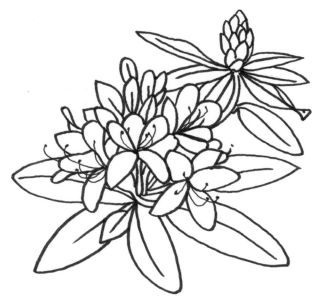

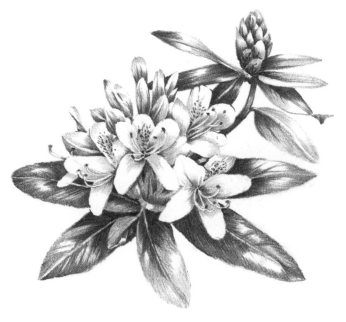
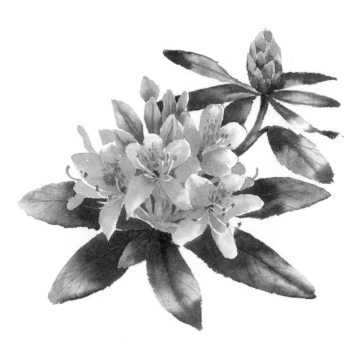

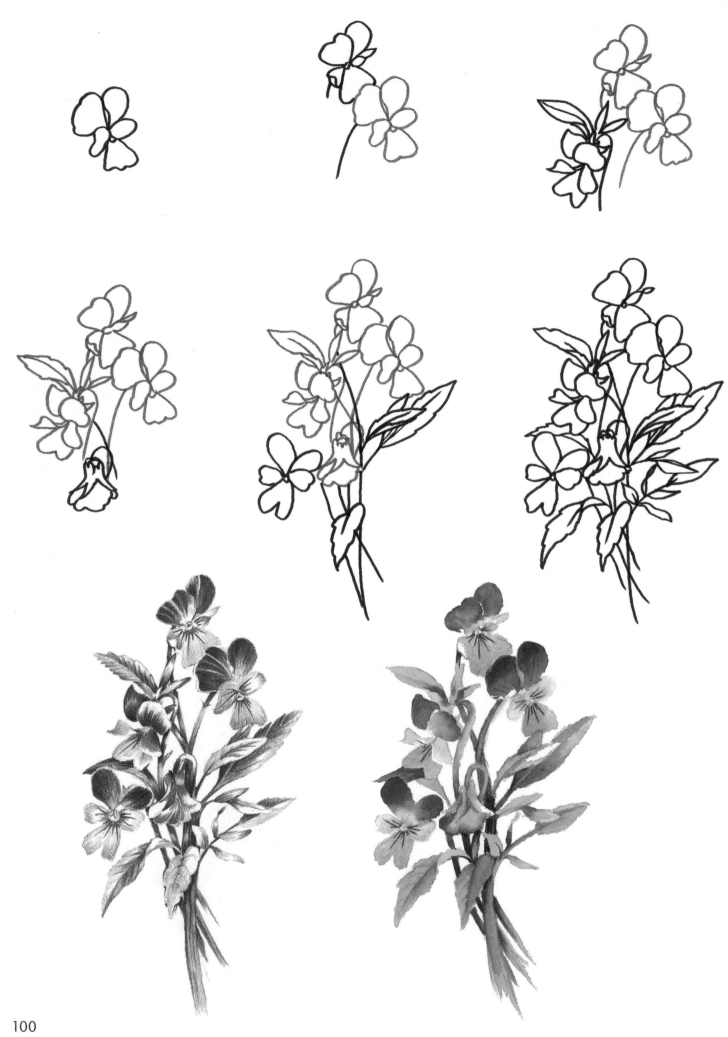

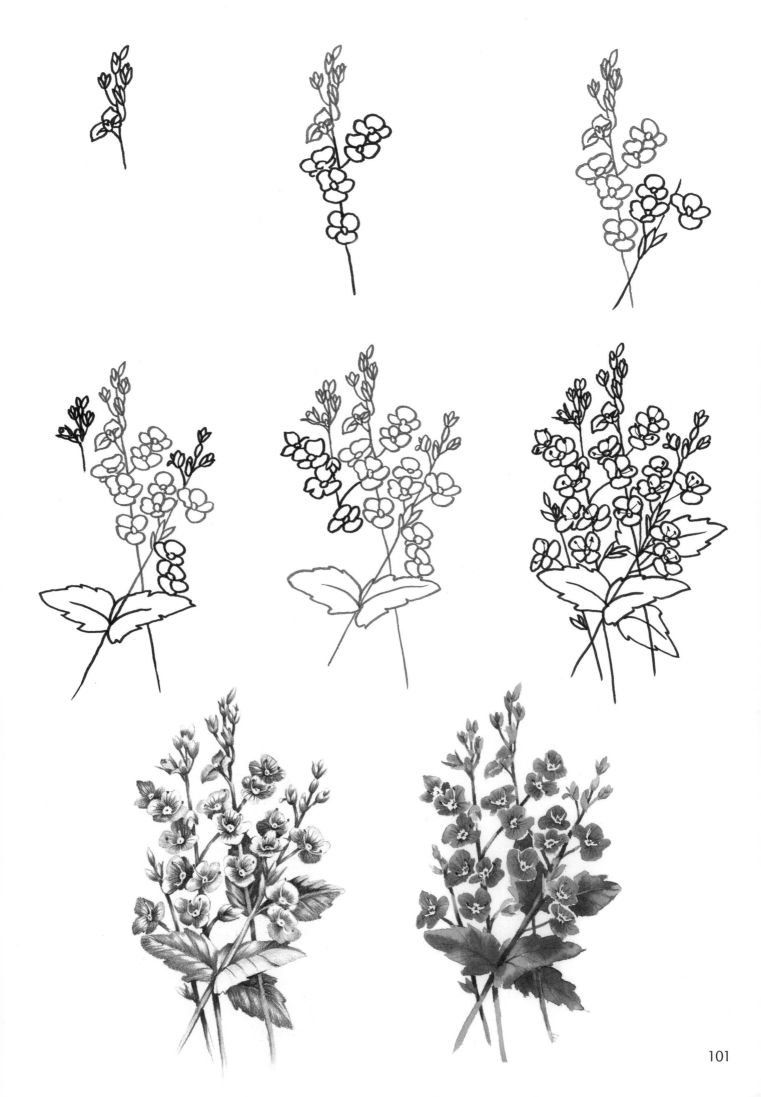

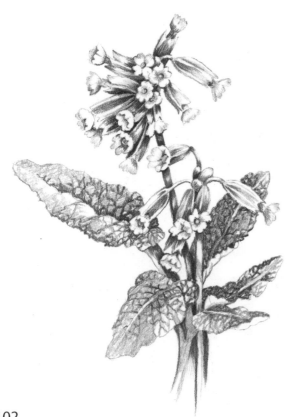

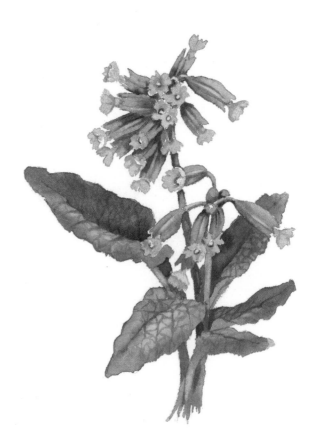

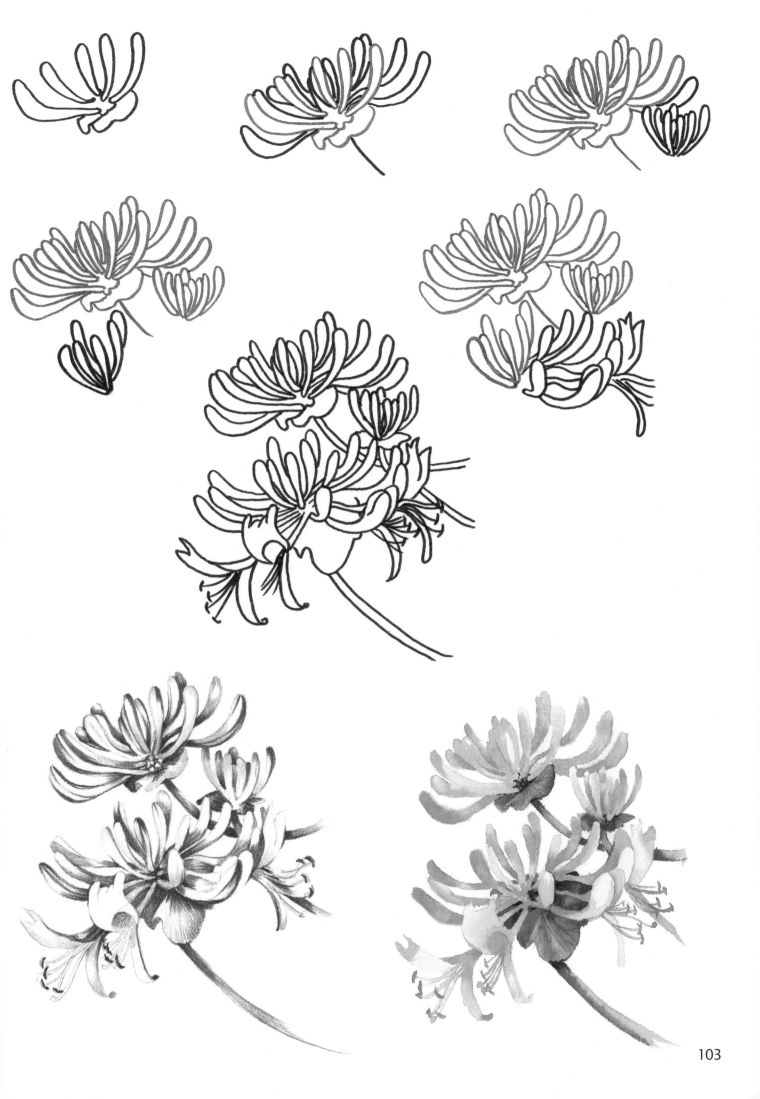

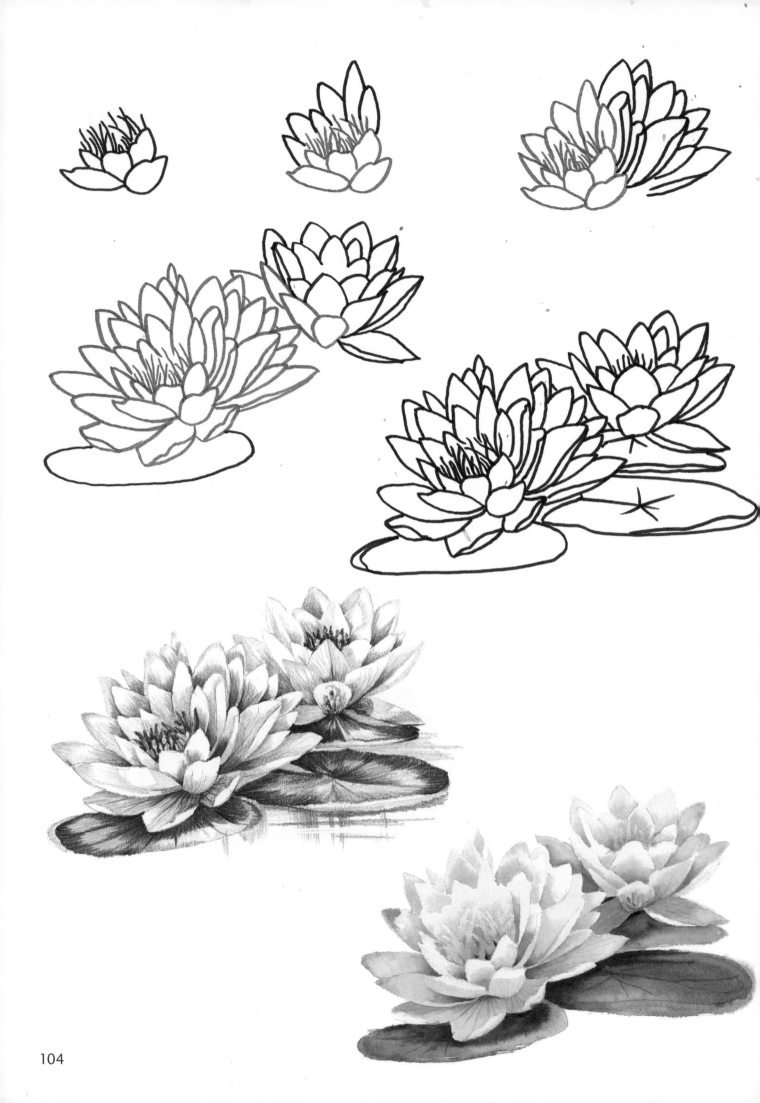

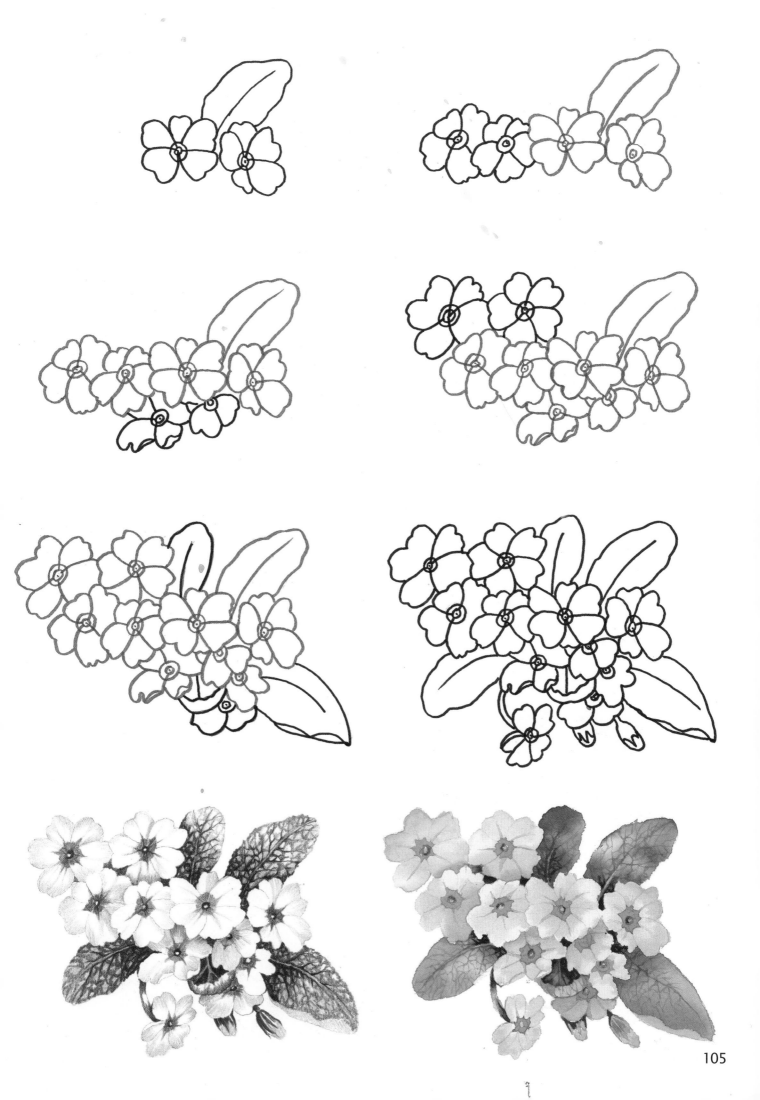

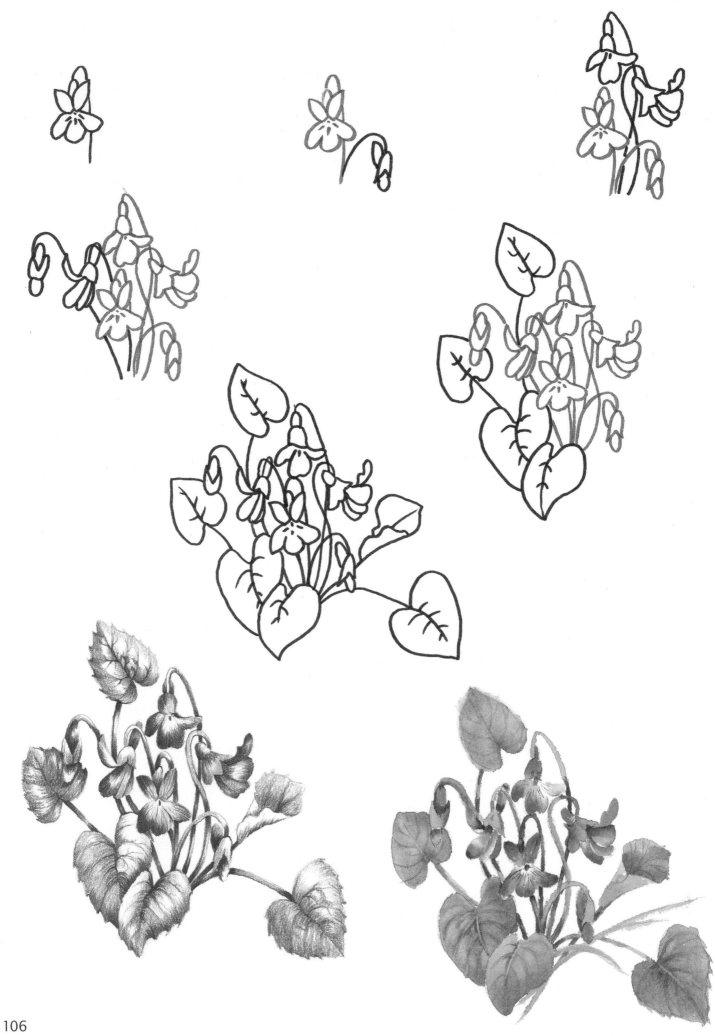

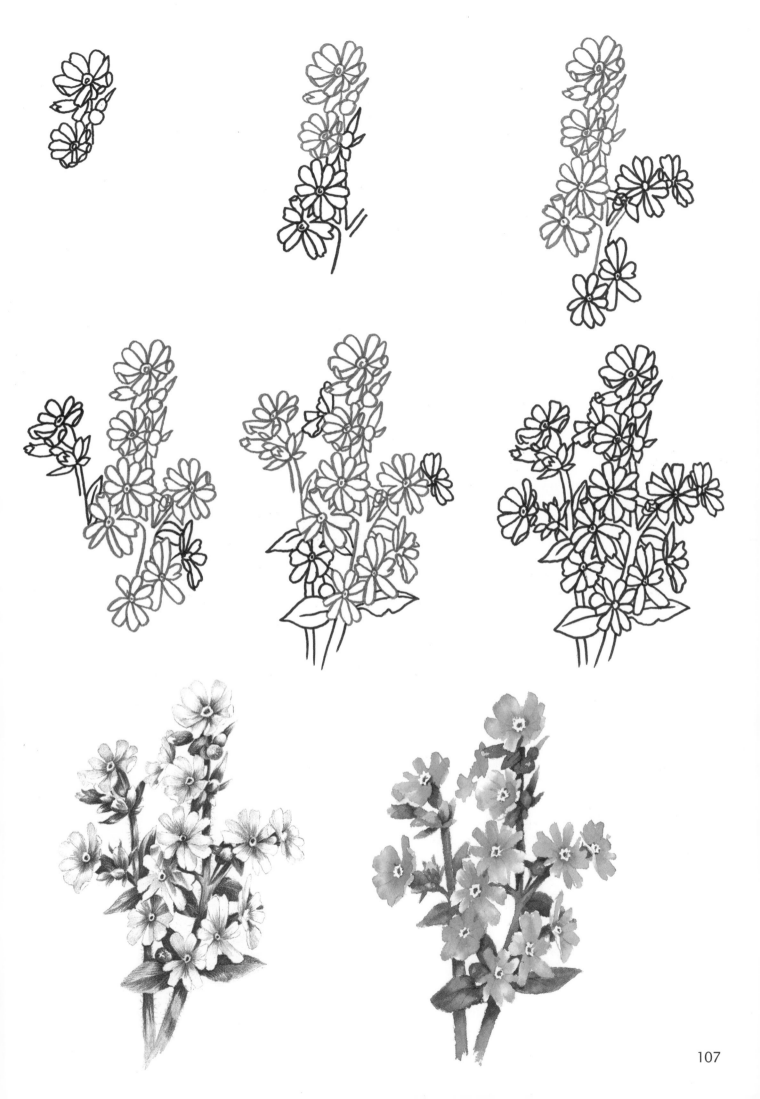

107

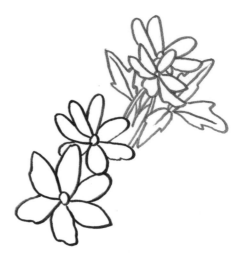

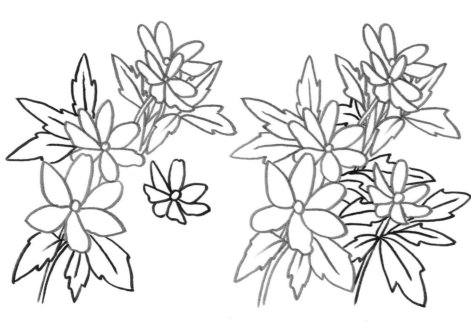
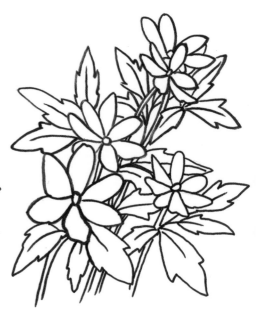

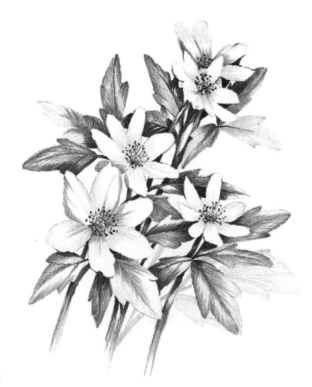
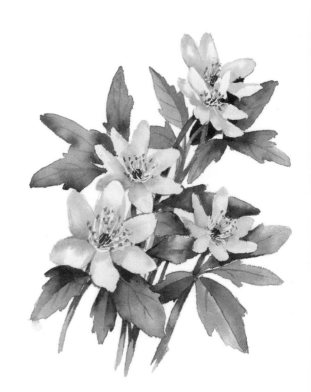

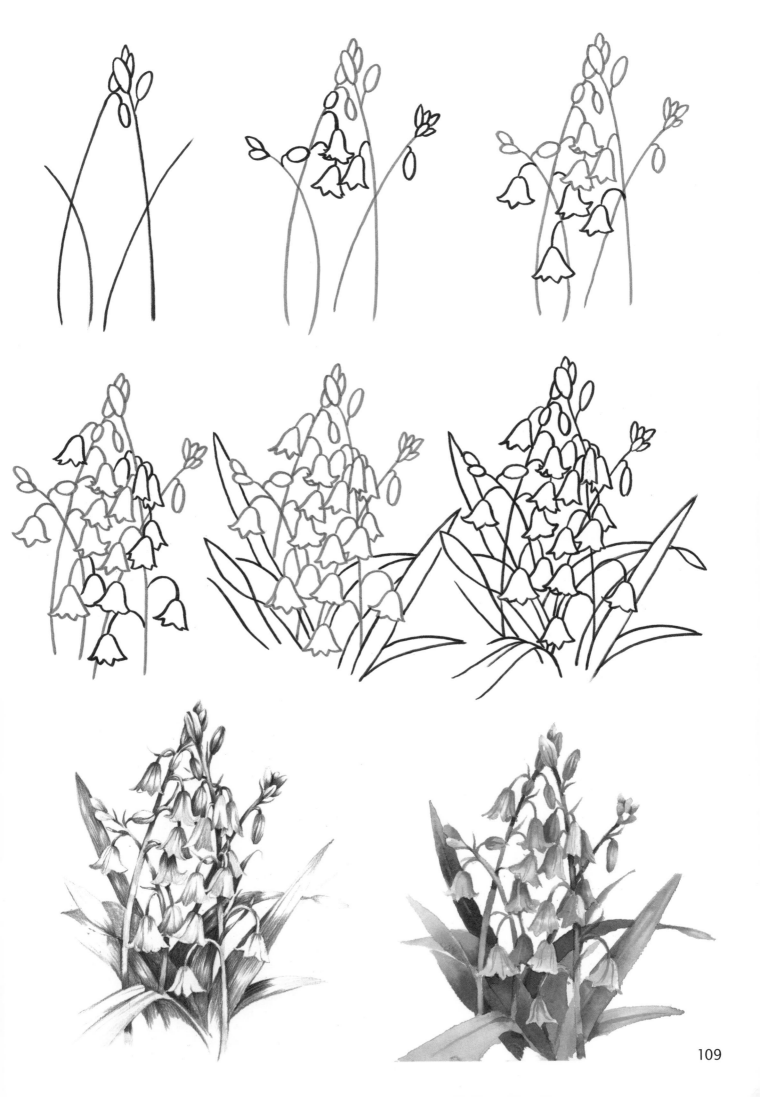

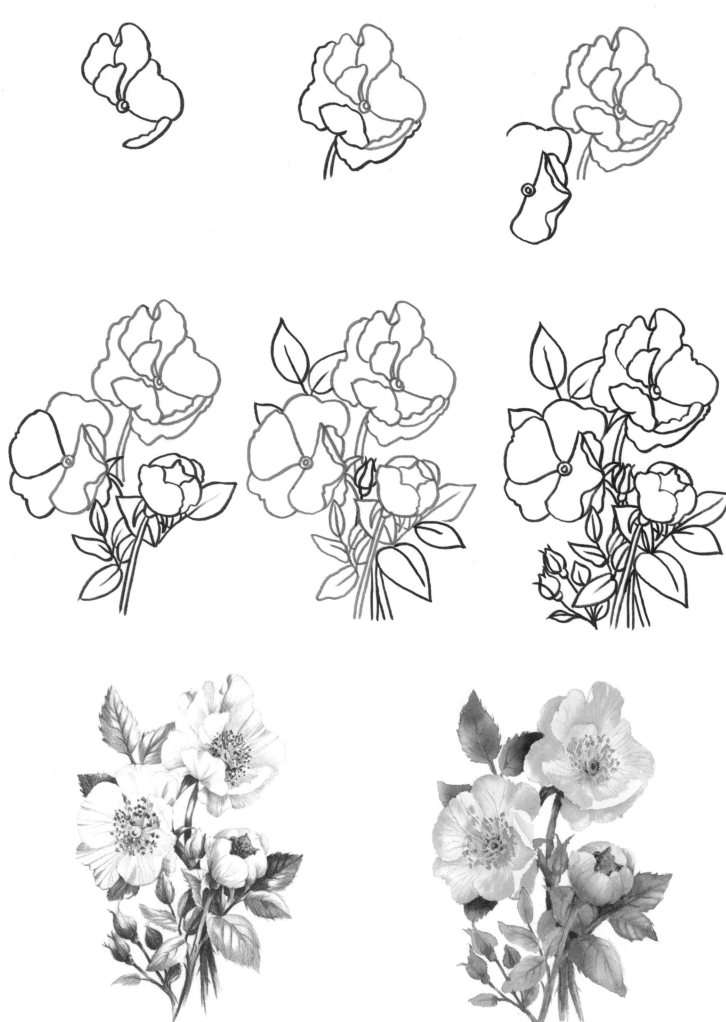

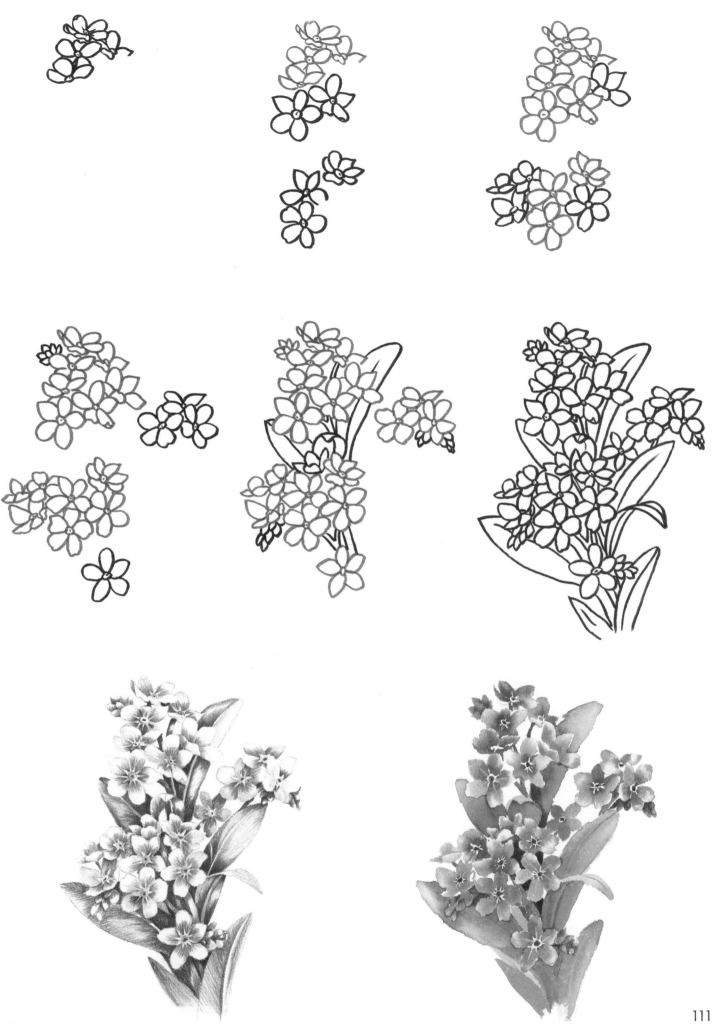

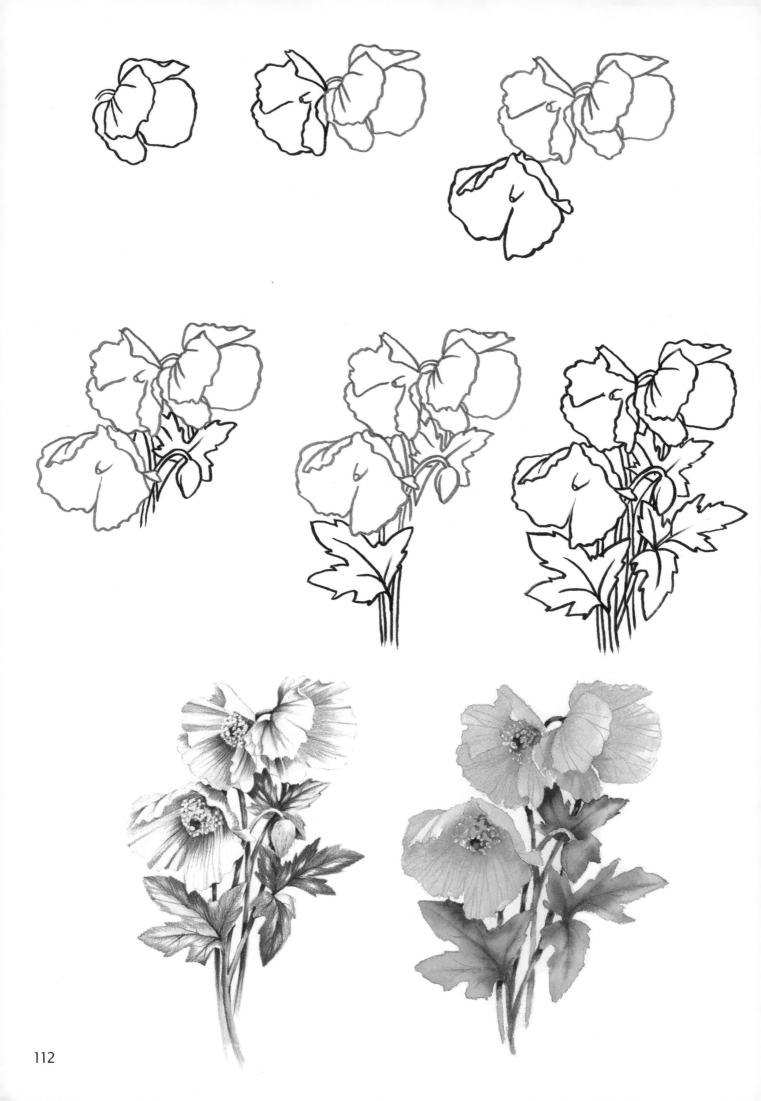

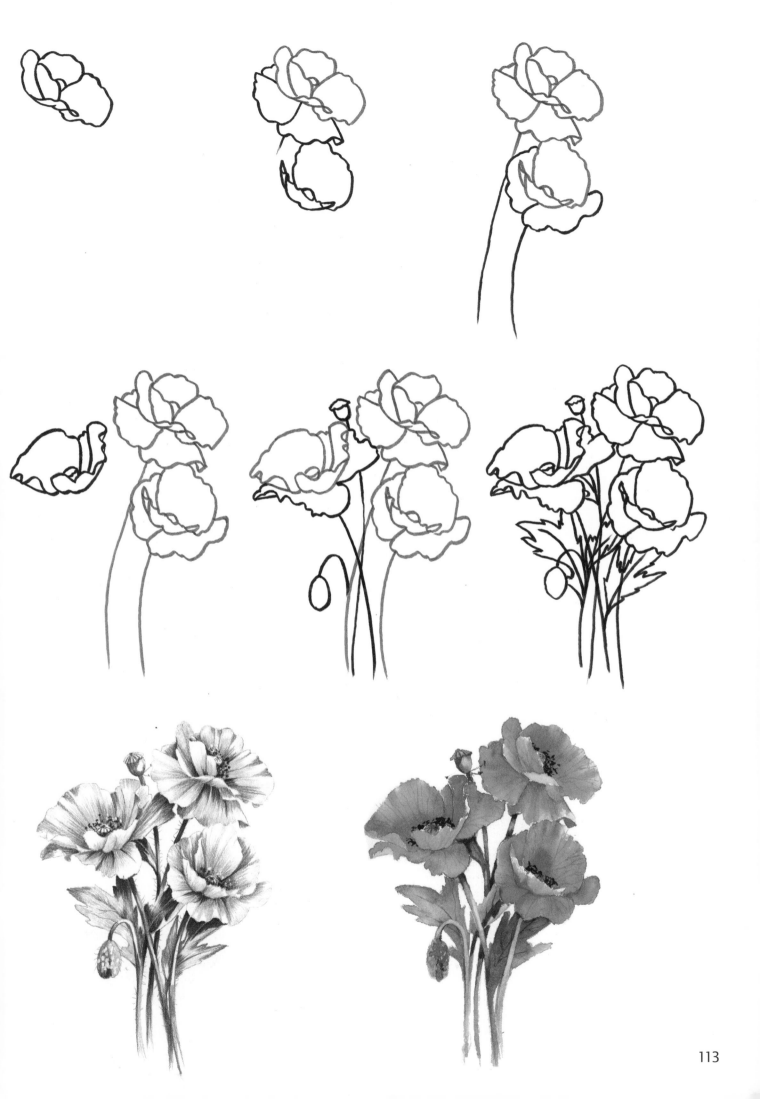

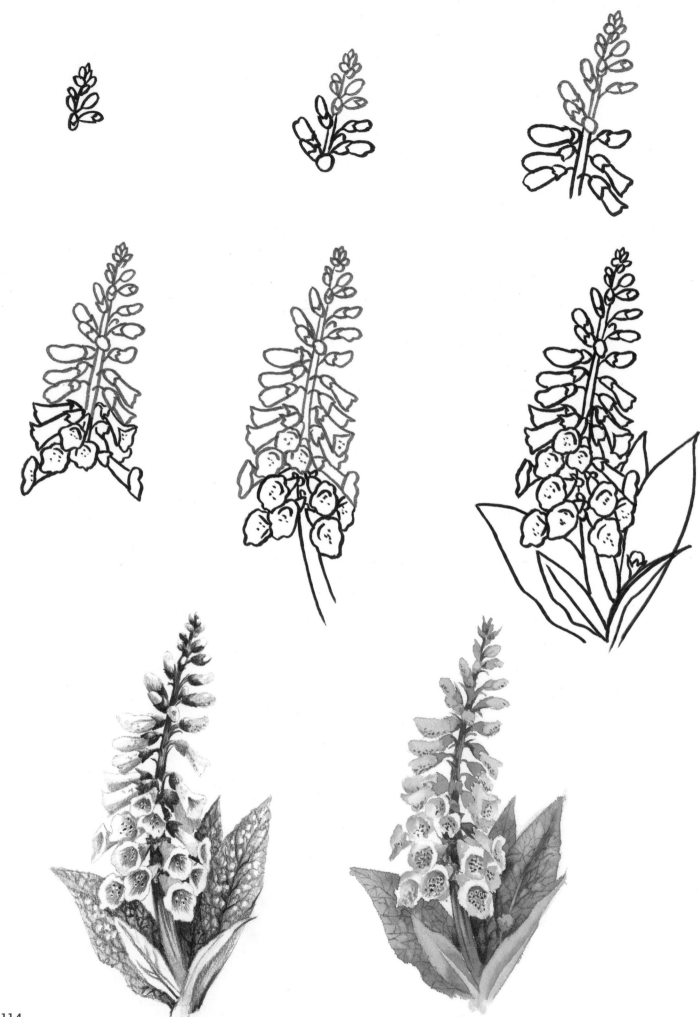

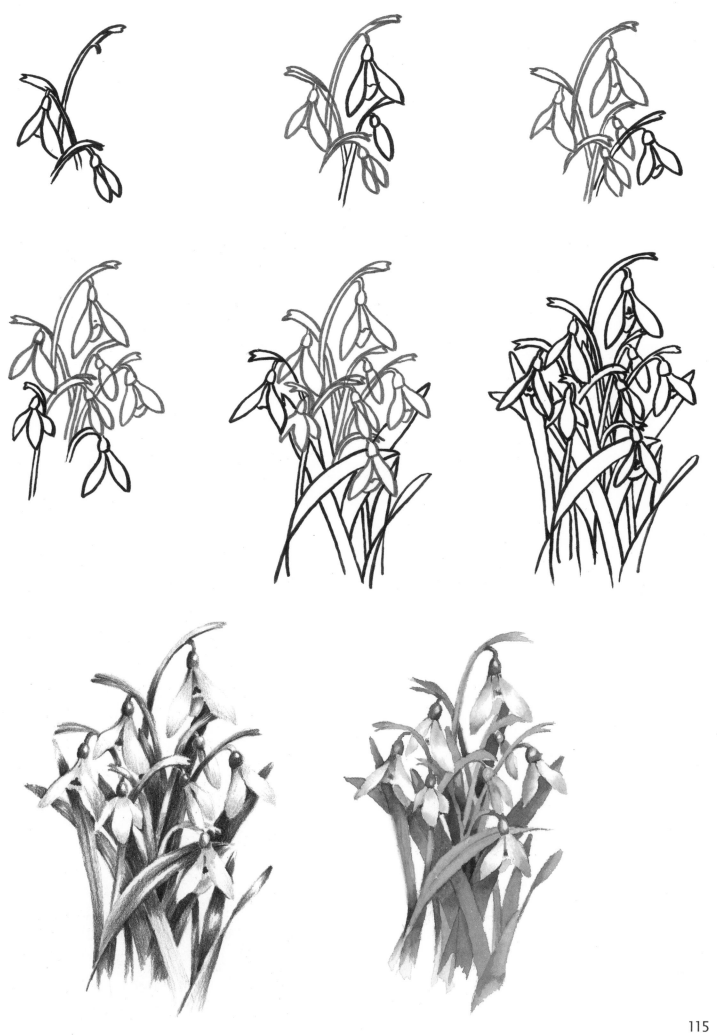

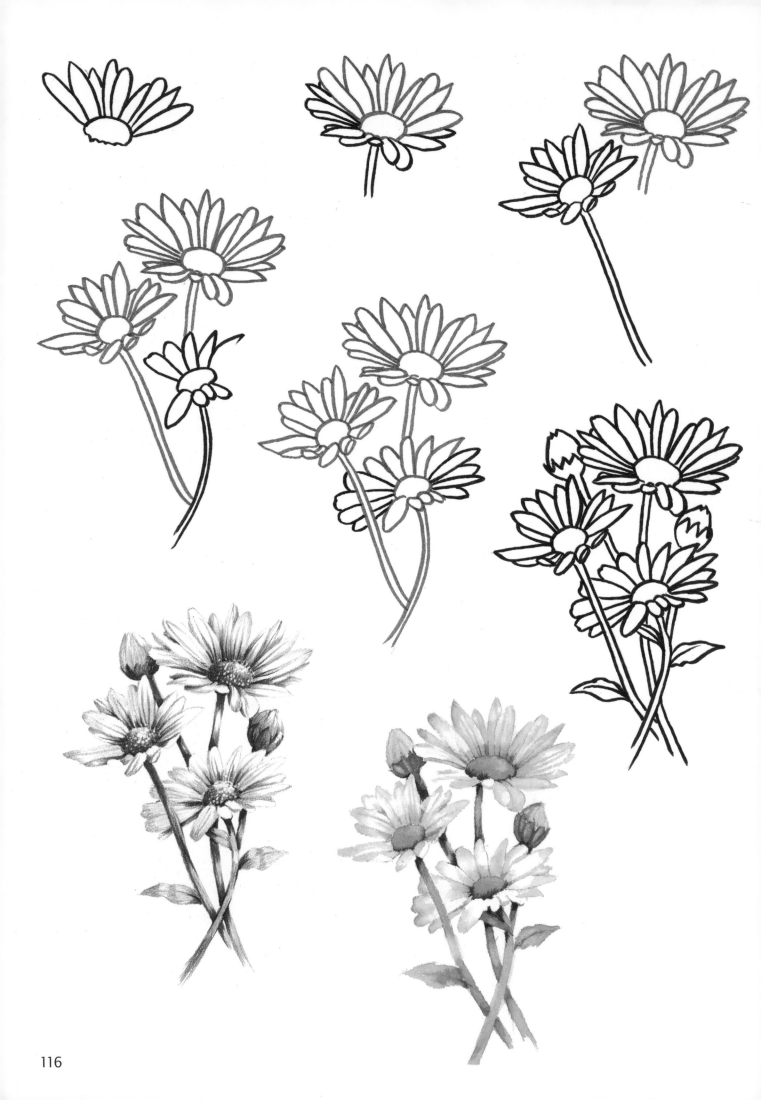

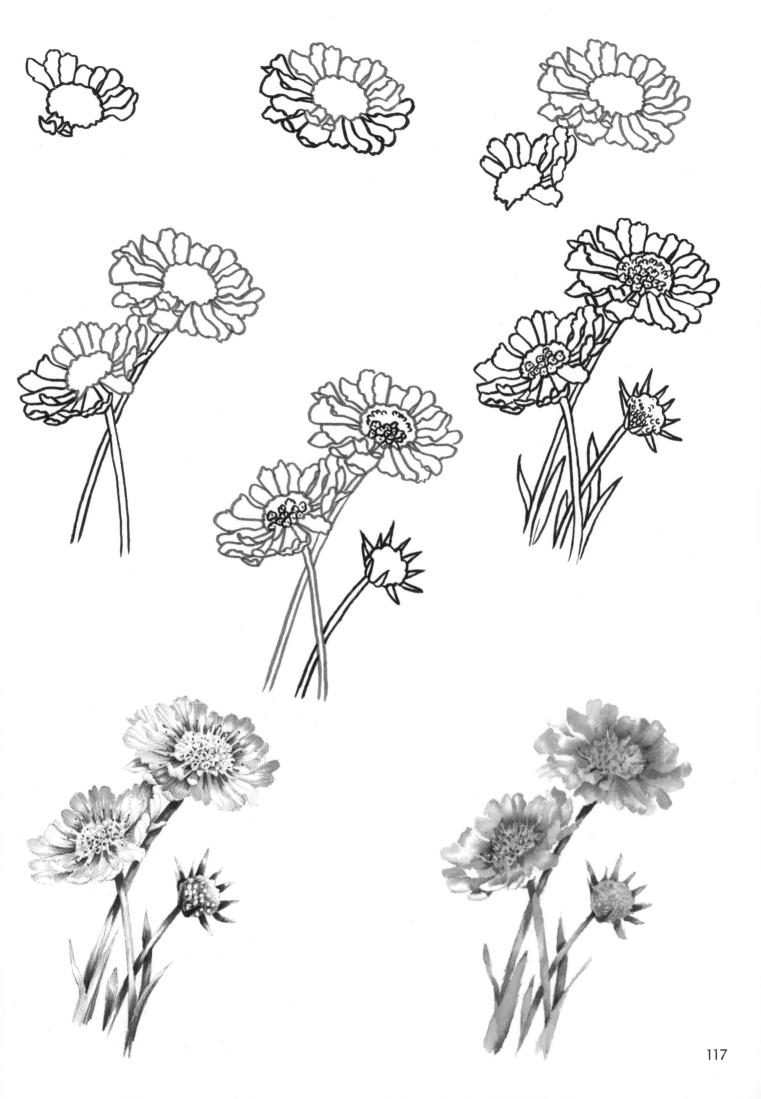

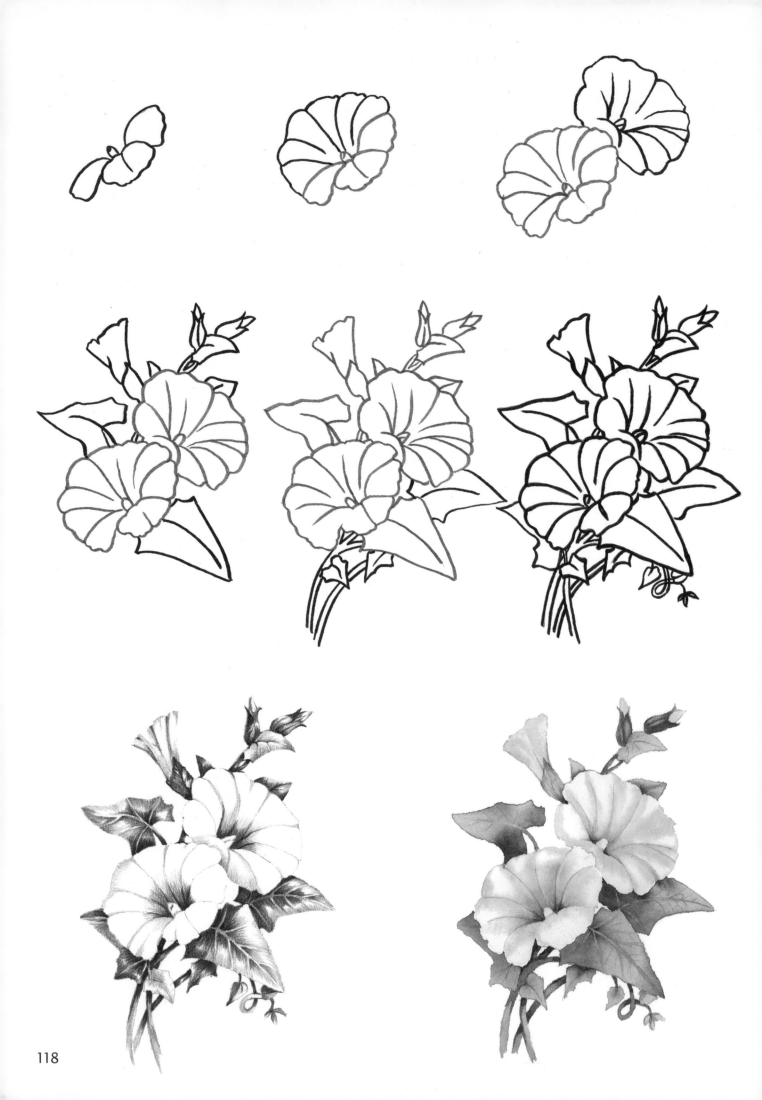

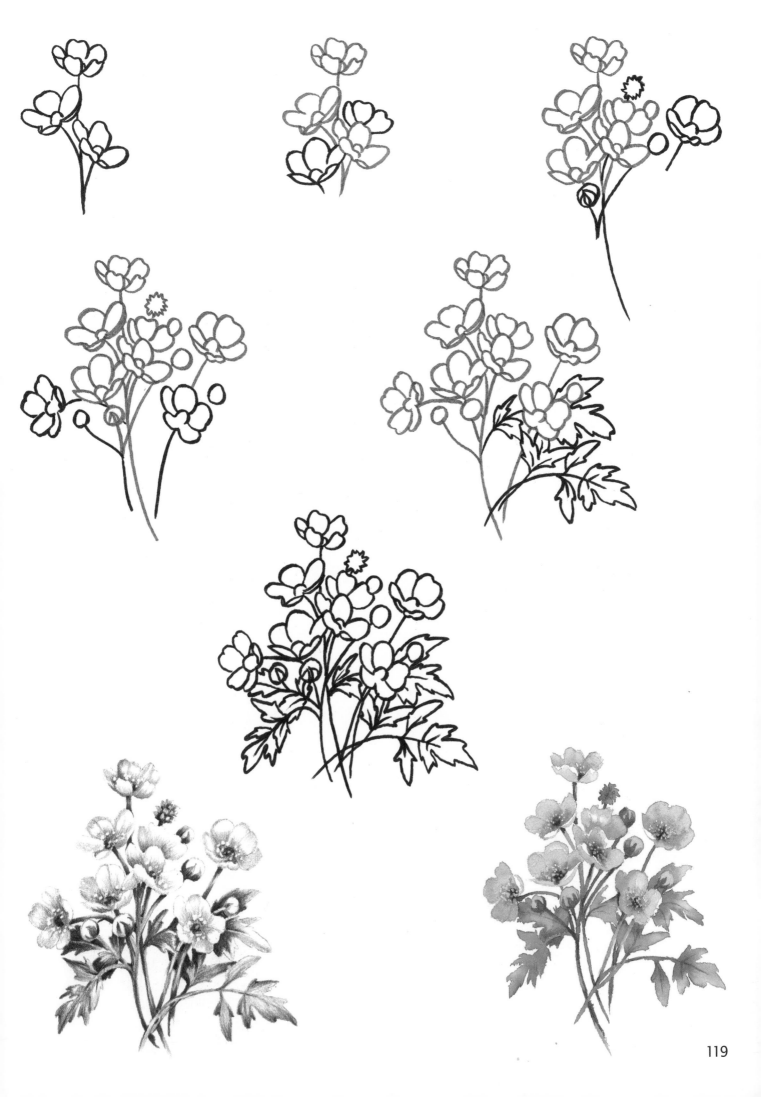

Trees

Trees have always been popular with artists of all skill levels, and there is a huge variety for us to draw as they grow and change throughout the seasons. They can be sketched displaying their early leaves or drawn during the rich summer months; different subjects are abundant as autumn yields its fruitful harvest and the starkness of winter strips the trees bare, revealing fantastic shapes and textures. Unlike many exotic plants, it is likely that trees are nearby, possibly within drawing distance, so make sure that you take the opportunity to observe them at first hand whenever and wherever you can.

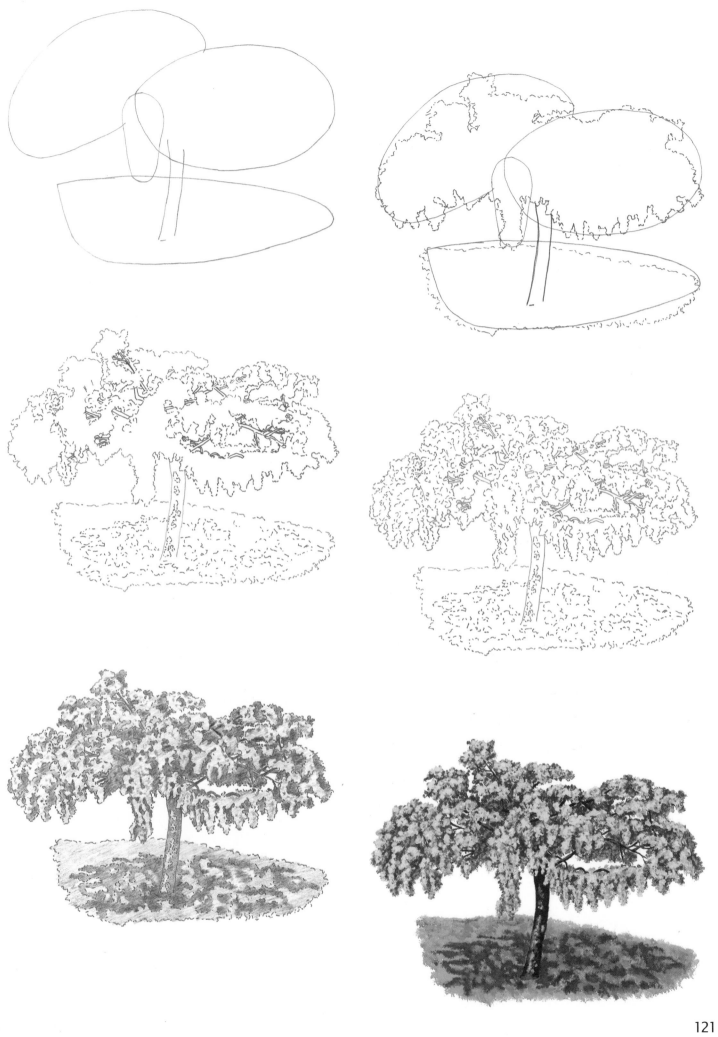

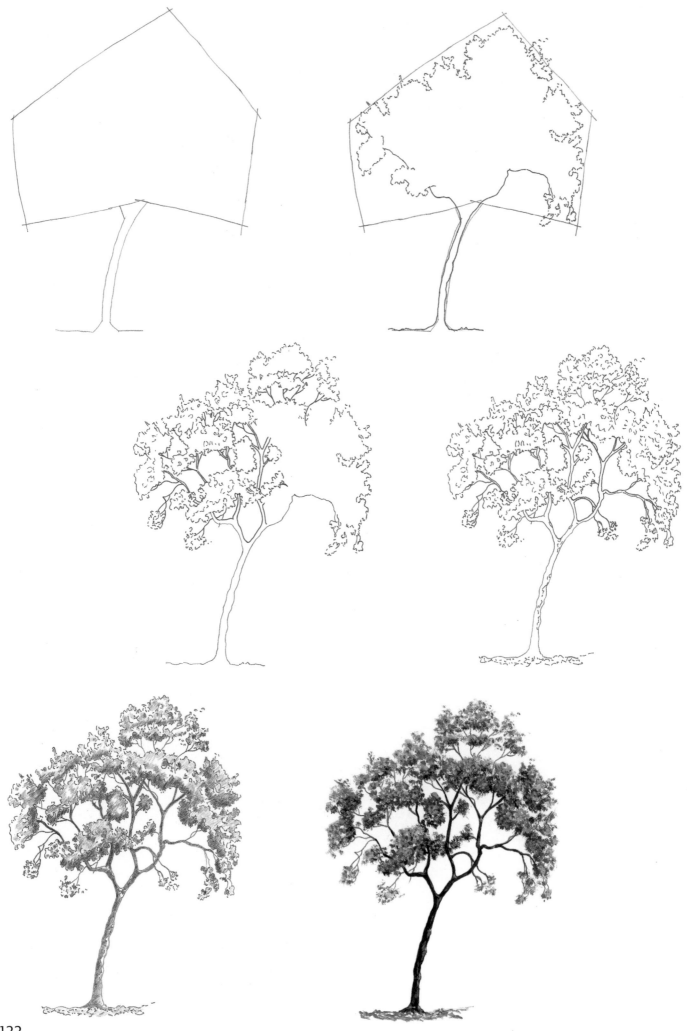

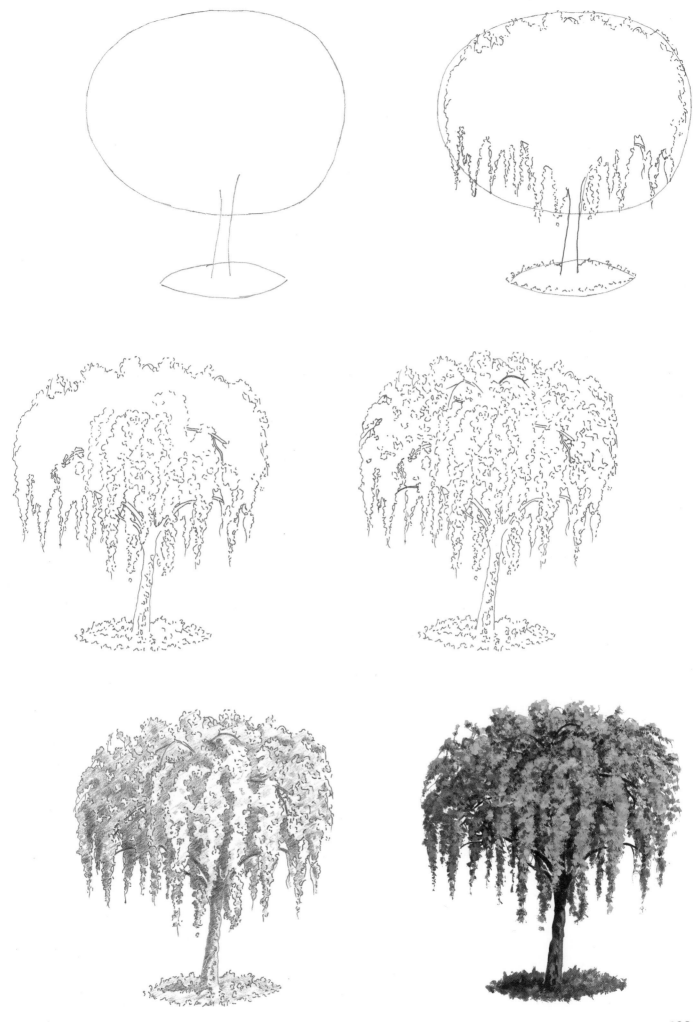

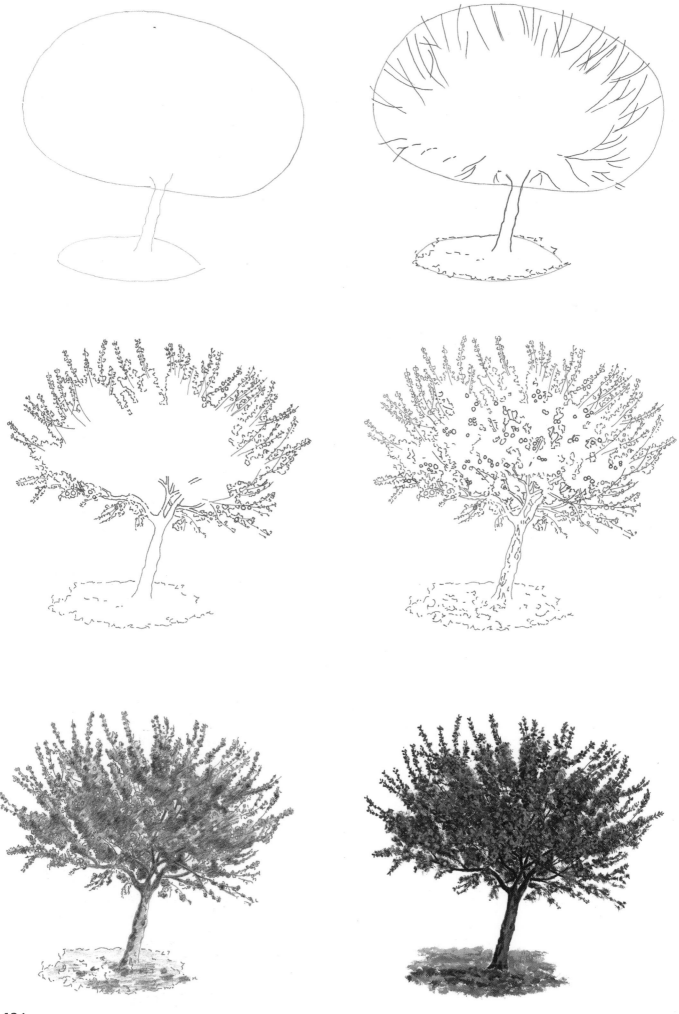

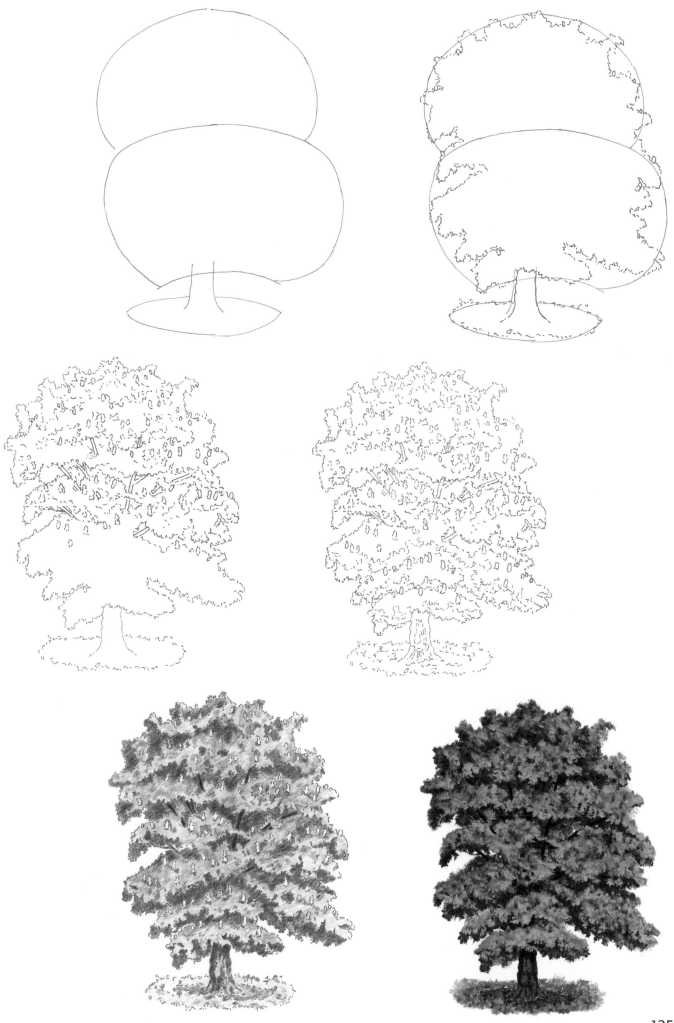

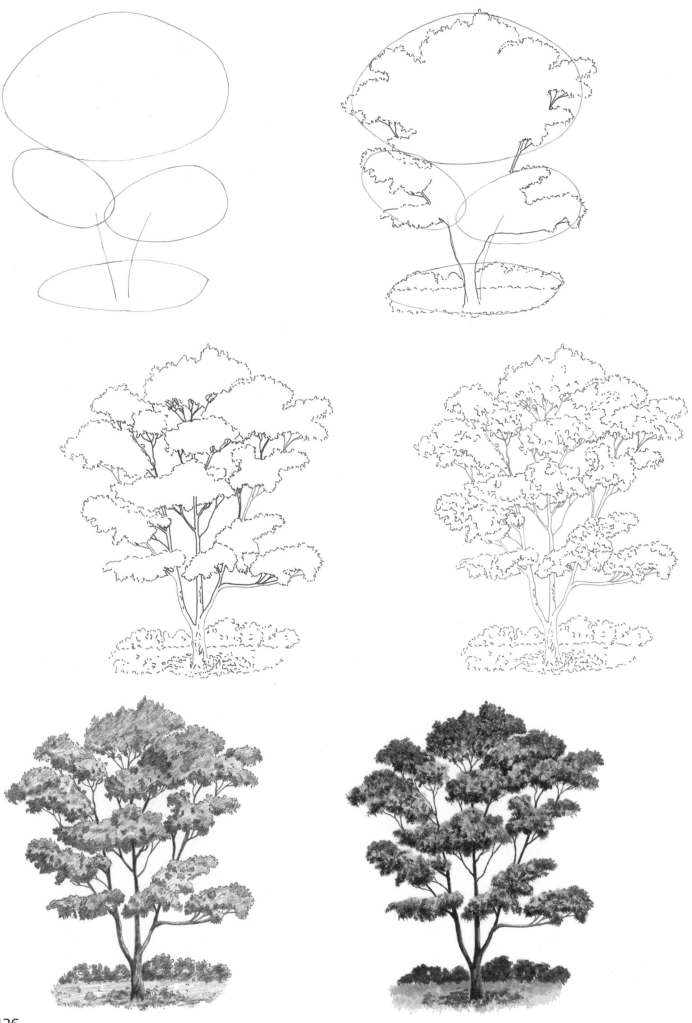

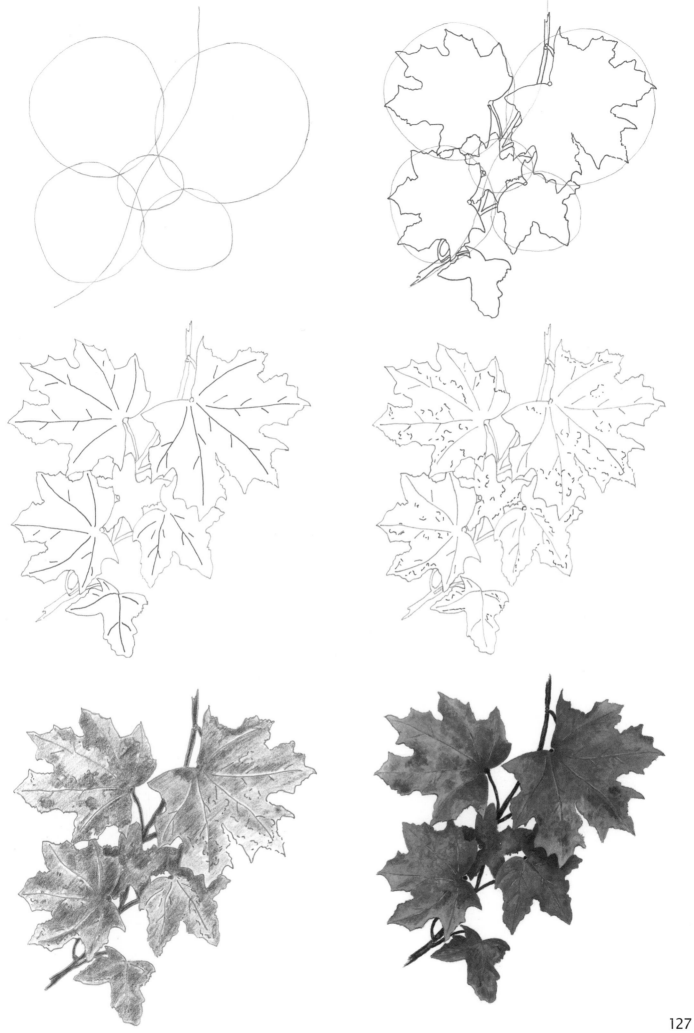

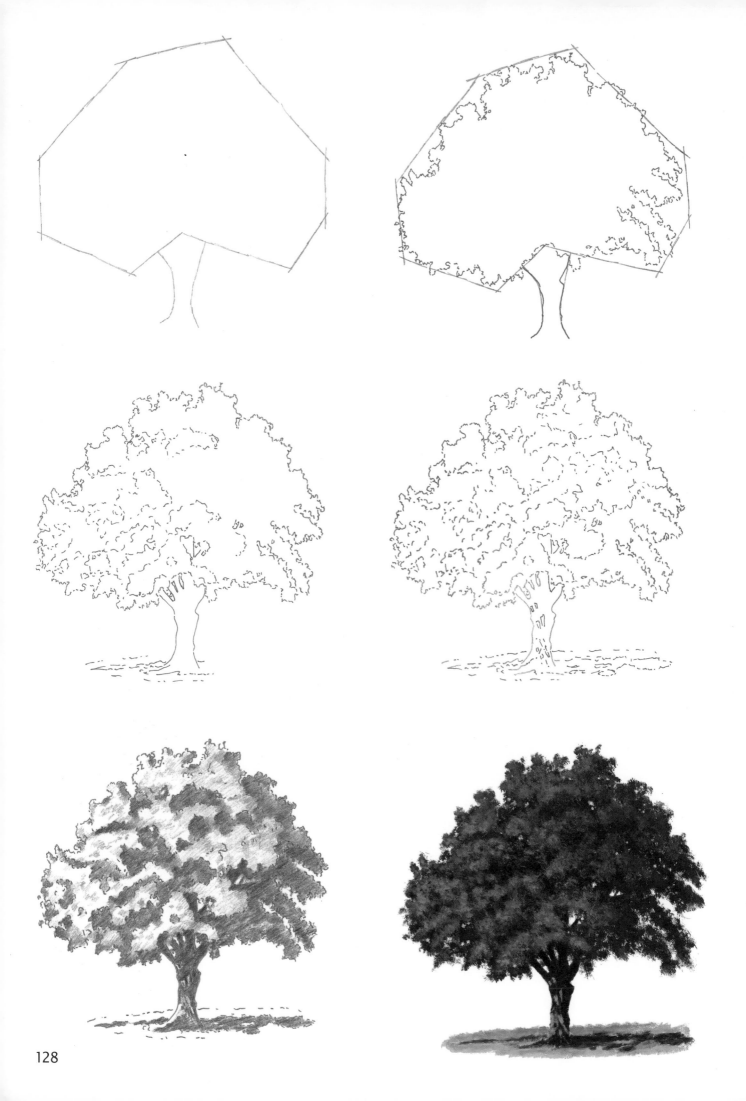

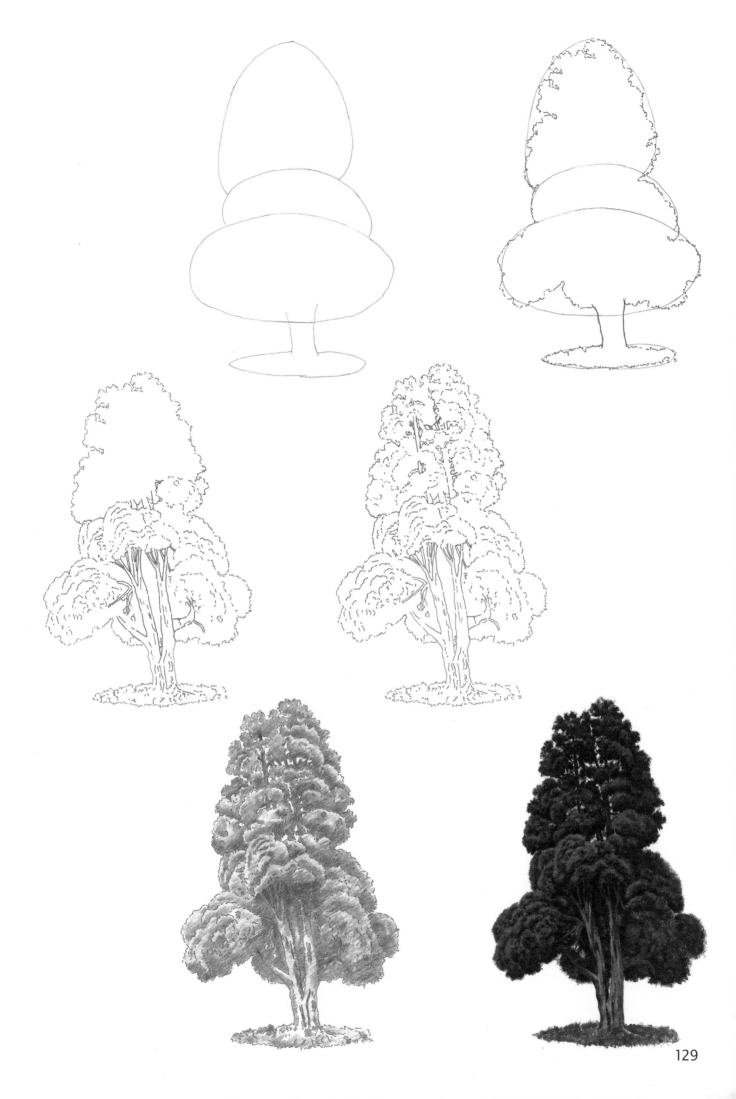

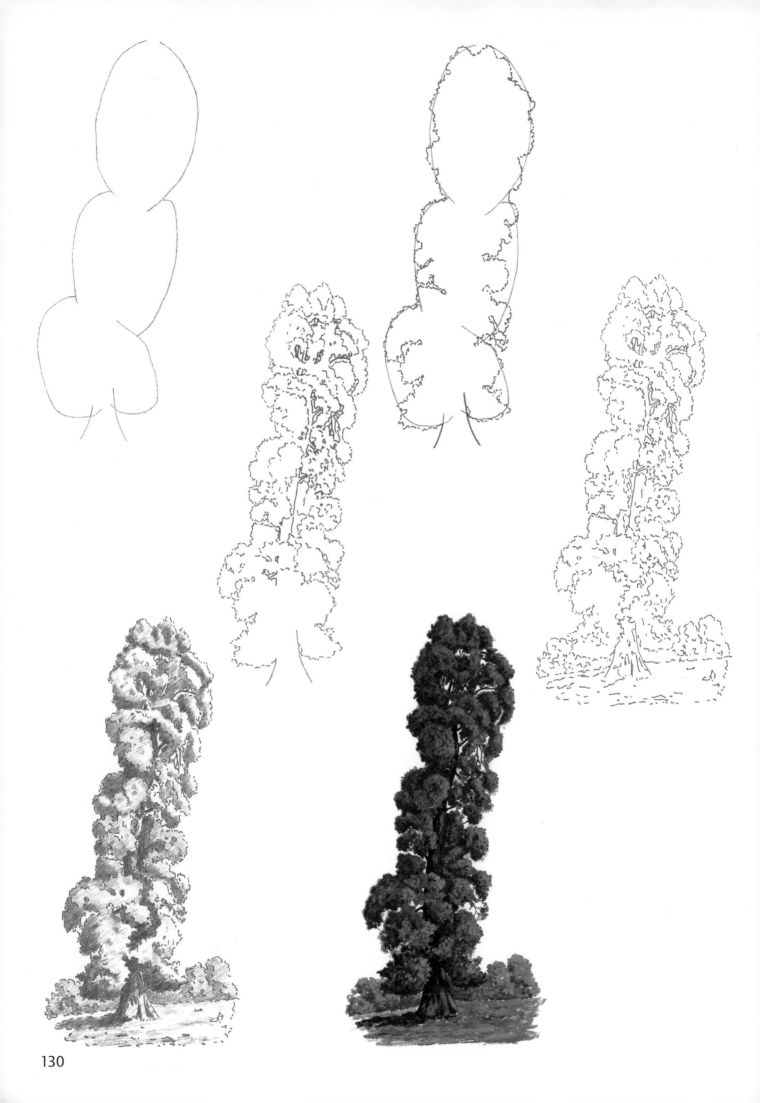

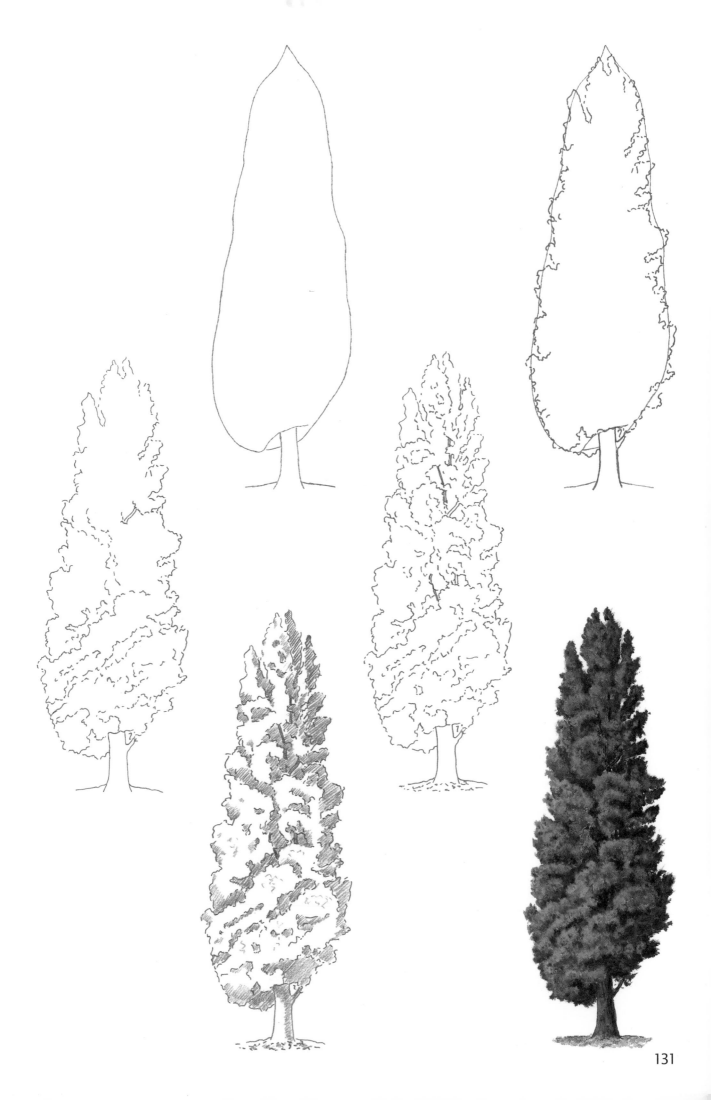

131

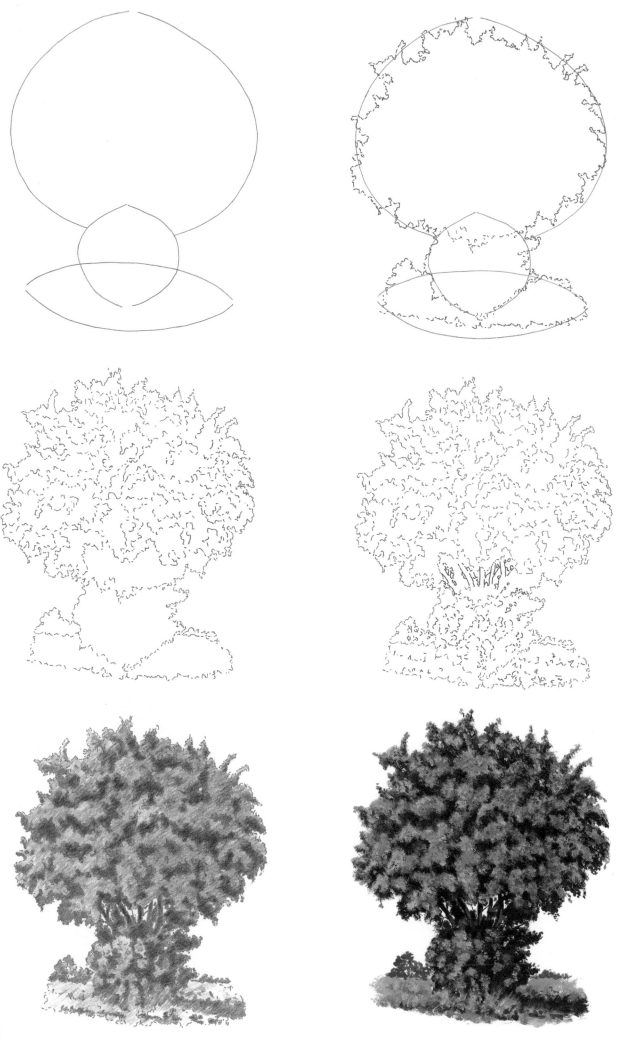

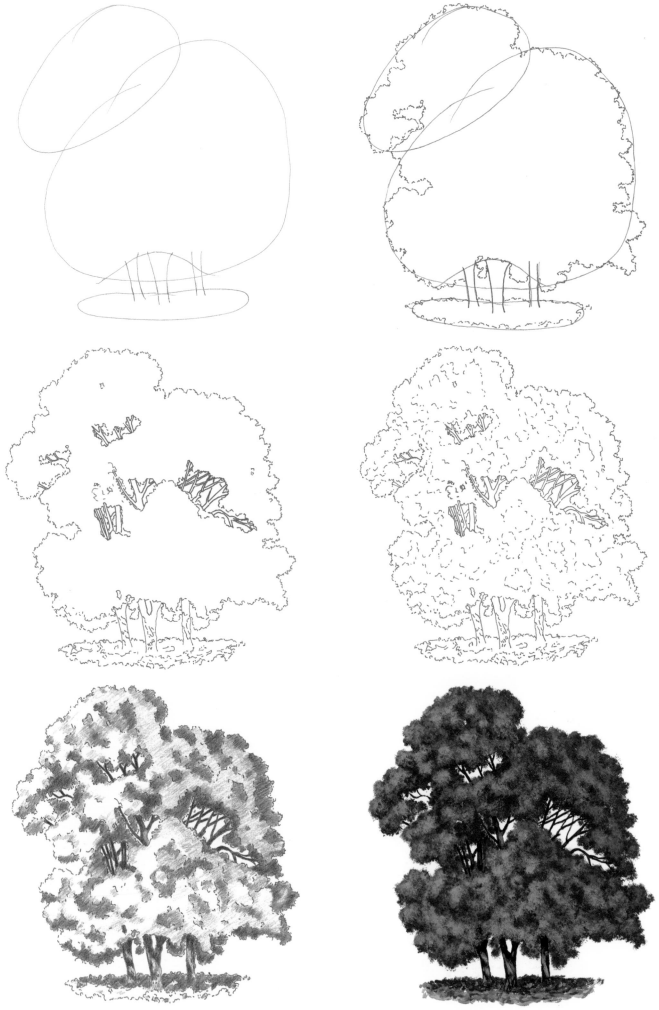

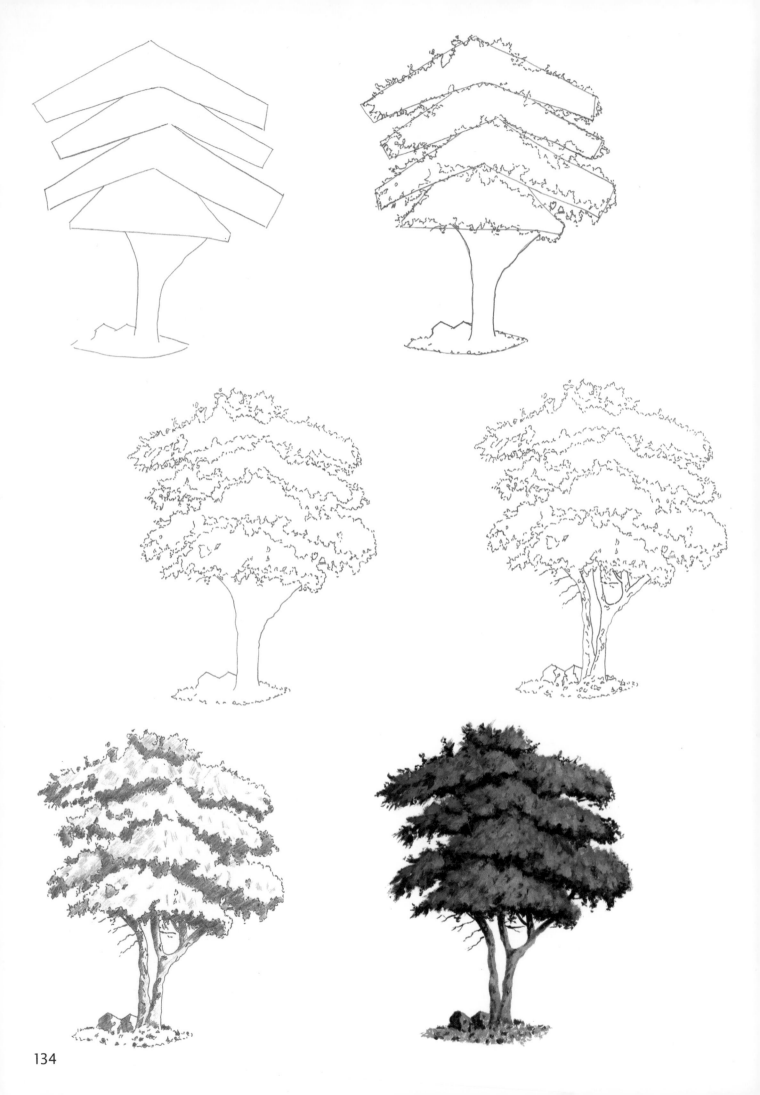

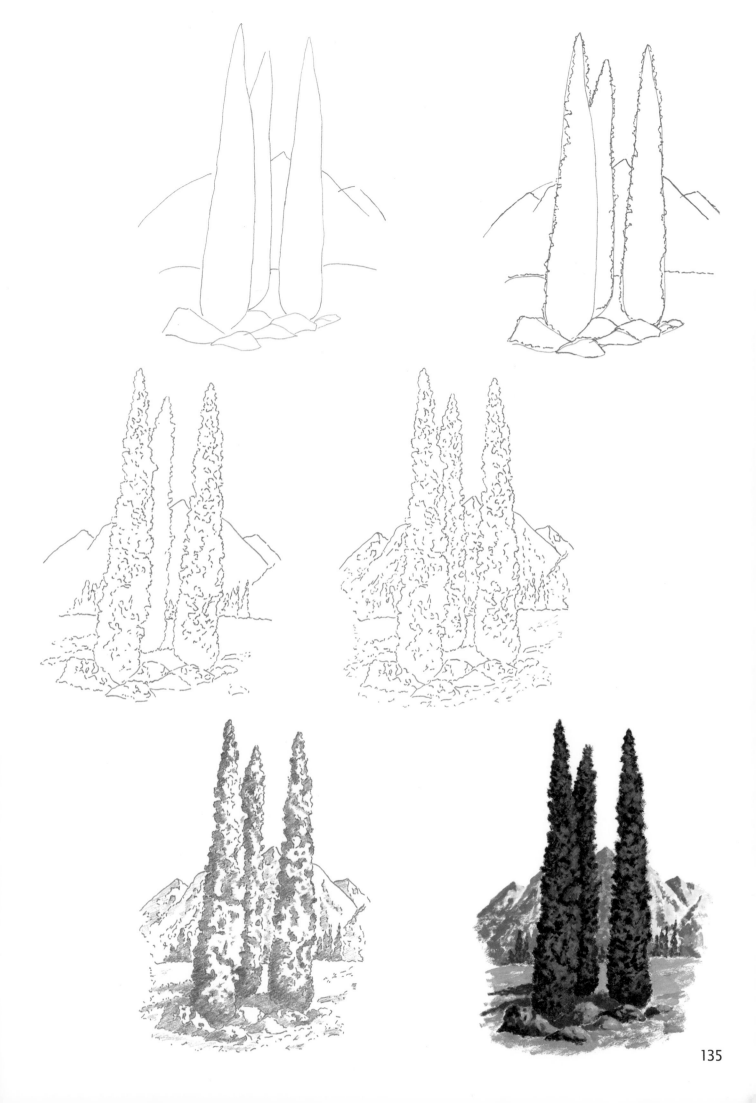

135

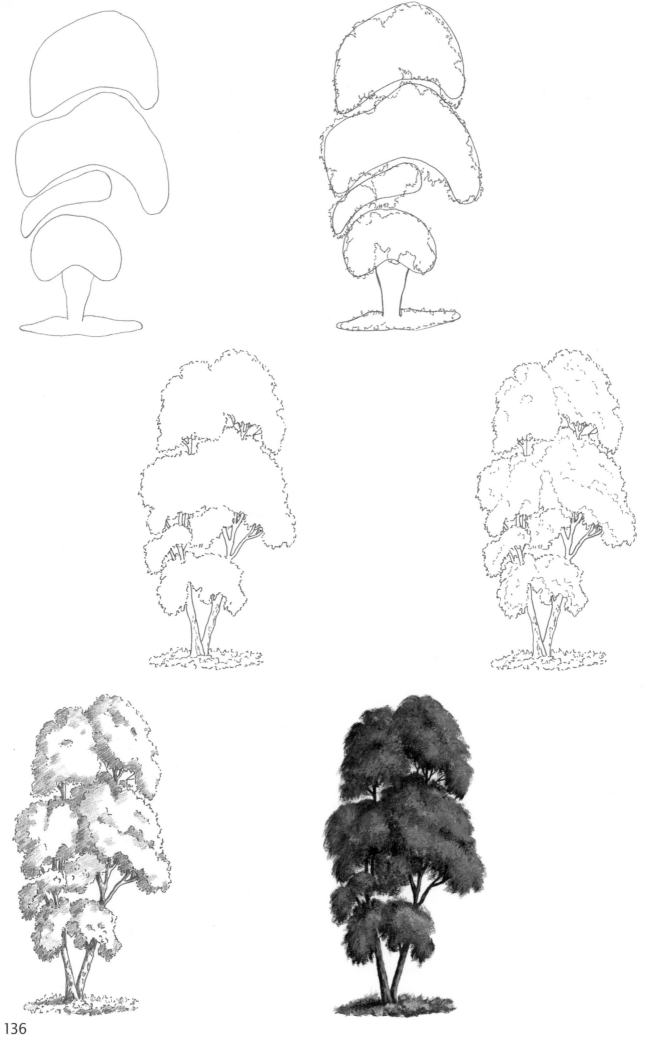

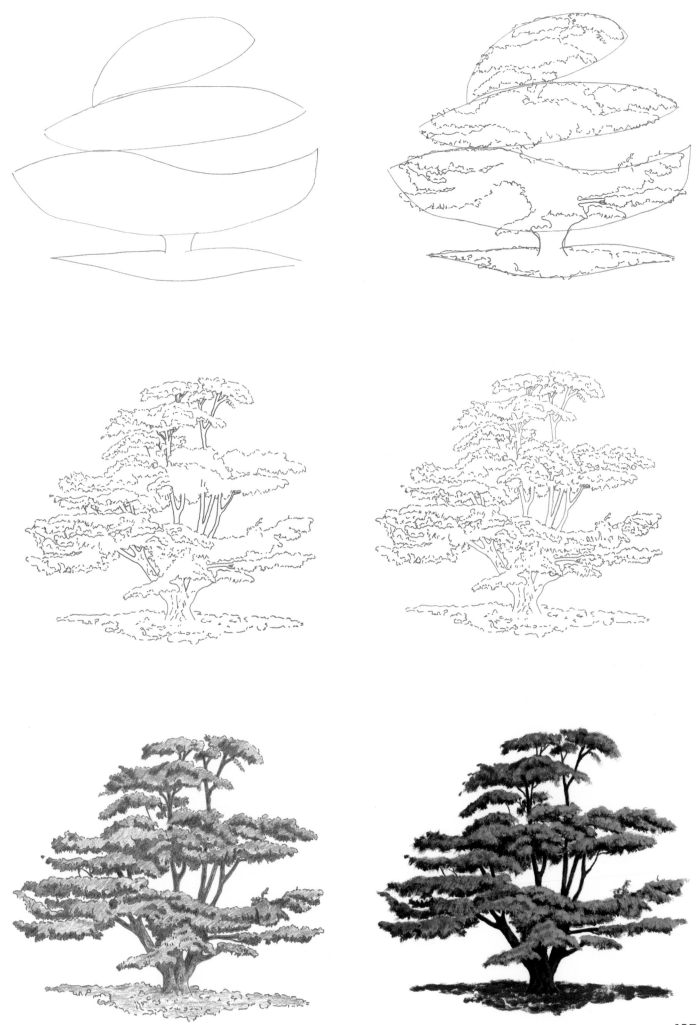

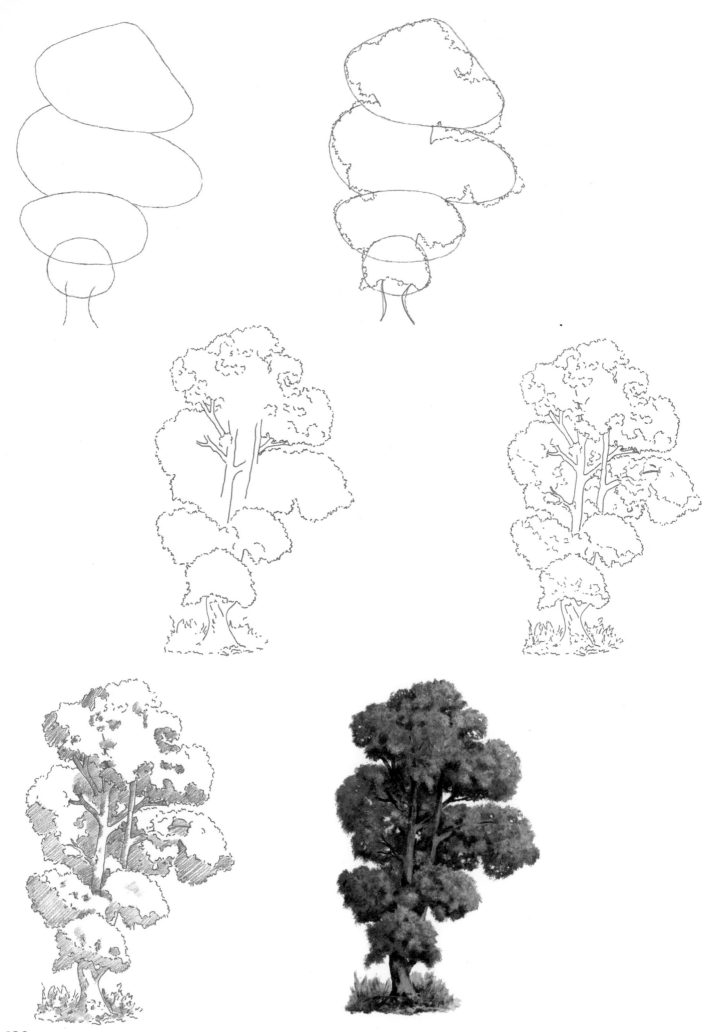

138

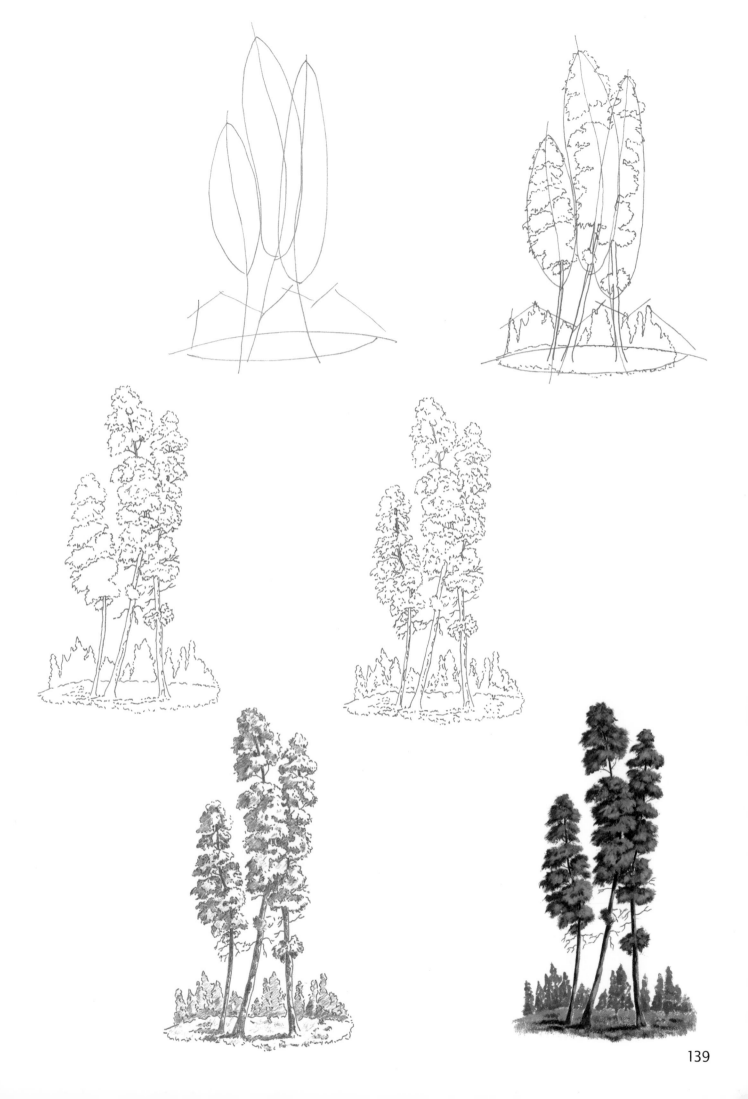

139

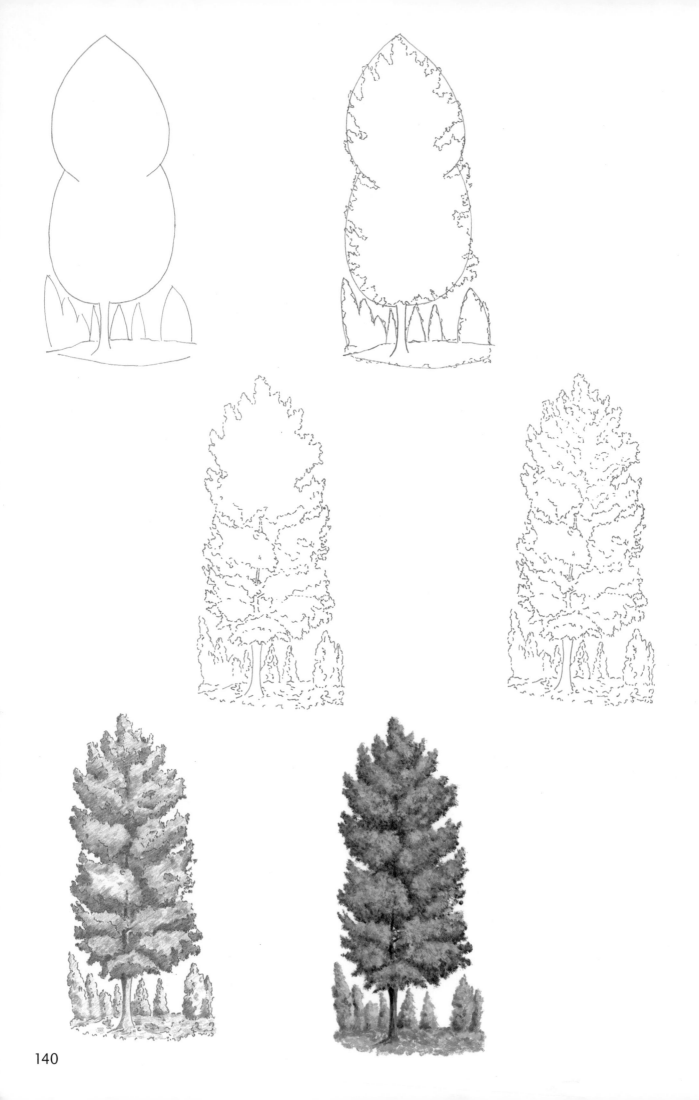

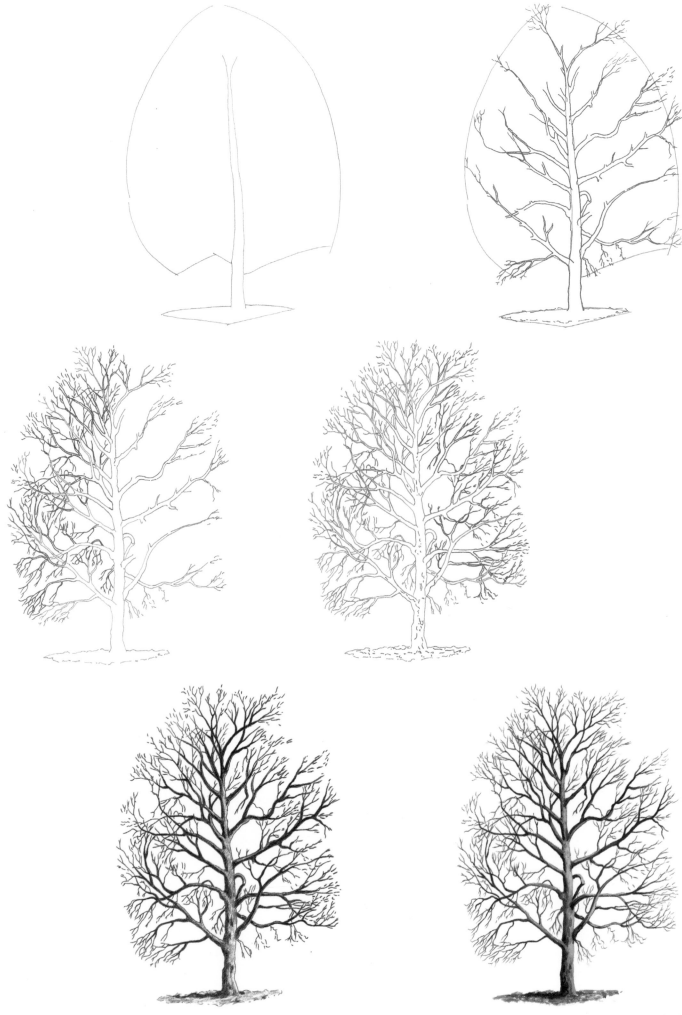

141

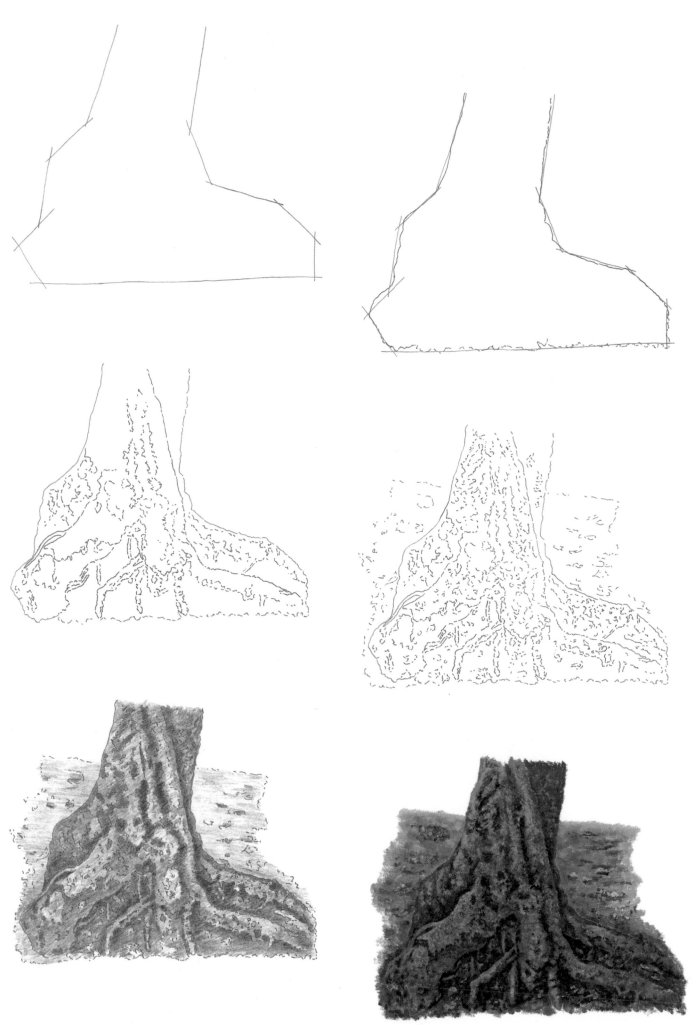

142

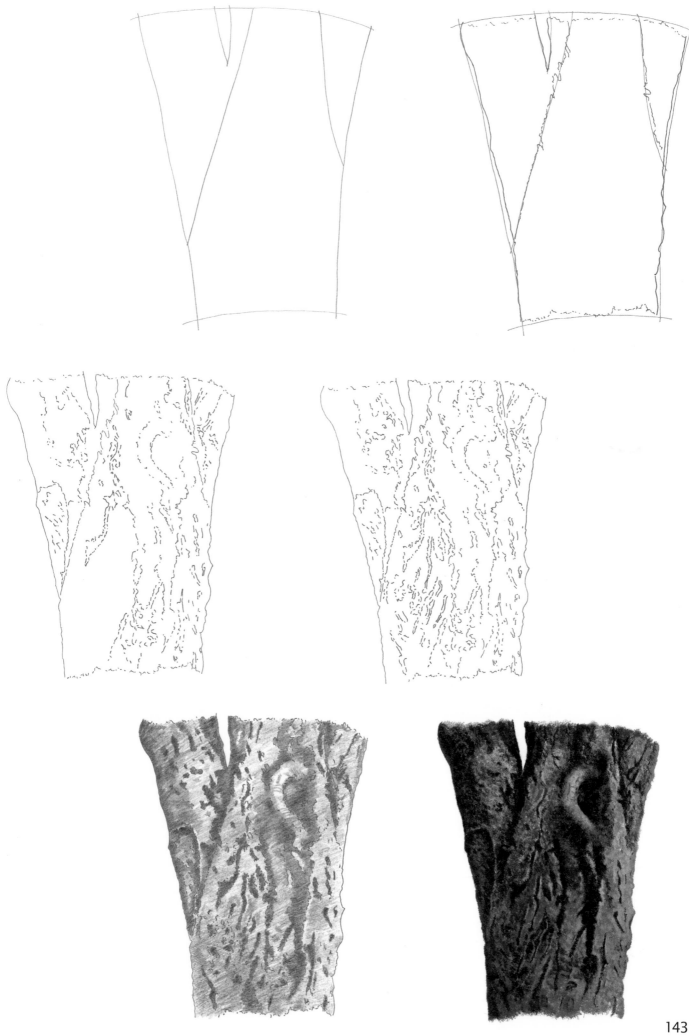

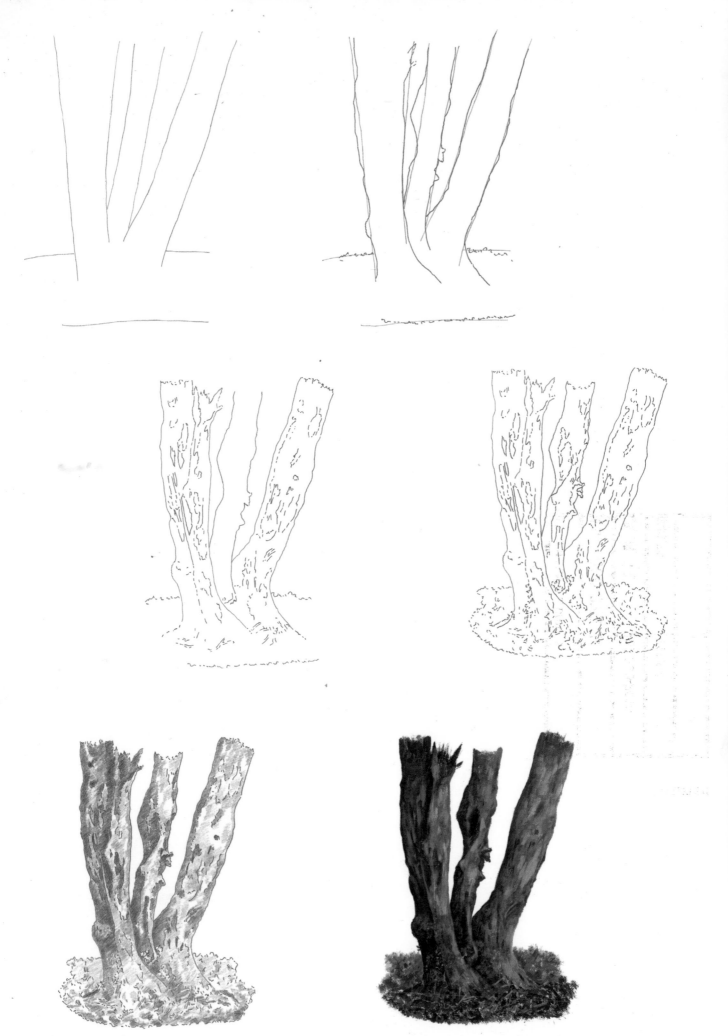

144